THE HOUSE & GARDEN BOOK OF
COUNTRY CHIC

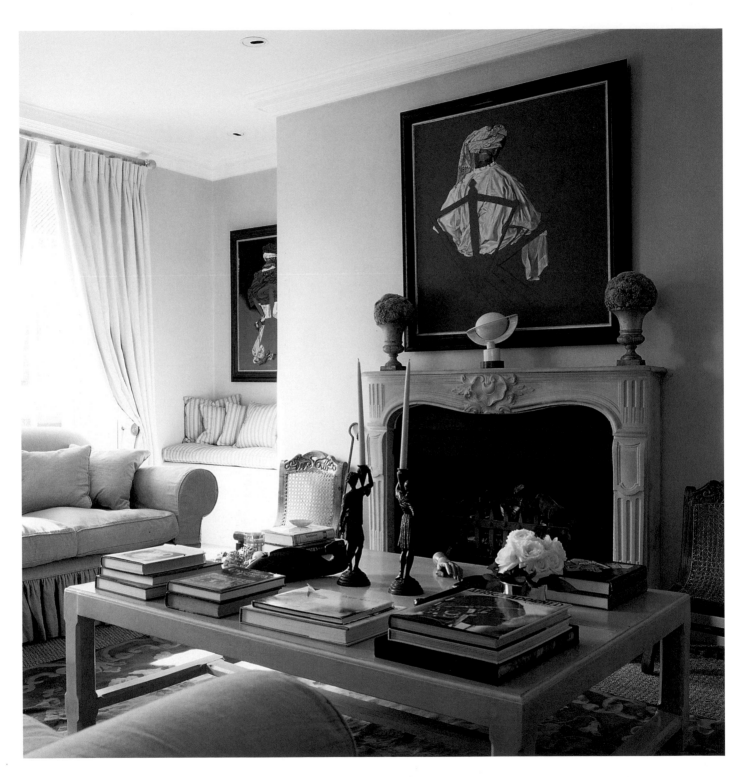

Successfully combining comfort with an updated, eclectic interpretation of the 'country-house style', this room in a Queen Anne house in East Anglia uses natural materials and neutral colours. (See page 212.)

THE HOUSE & GARDEN BOOK OF
COUNTRY CHIC

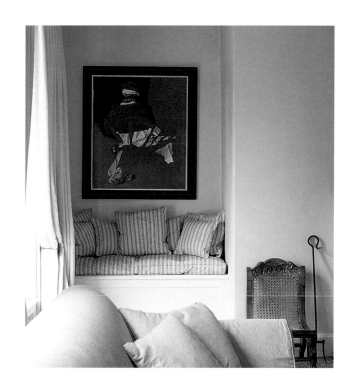

LEONIE HIGHTON

CONDÉ NAST BOOKS
LONDON SYDNEY AUCKLAND JOHANNESBURG

First published in 1997 by Condé Nast Books,
an imprint of Random House UK Ltd
20 Vauxhall Bridge Road, London SW1V 2SA

Reprinted 1998, 2002.

Random House Australia (Pty) Ltd, 20 Alfred Street,
Milsons Point, Sydney, New South Wales 2061 Australia

Random House New Zealand, 18 Poland Road,
Glenfield, Auckland 10, New Zealand

Random House South Africa (Pty) Ltd, Endulini,
5a Jubilee Road, Parktown 2193, South Africa

Random House UK Limited Reg. No. 954009

Designed by Alison Shackleton

Set in Bodoni and Walbaum

A catalogue record for this book is available from the British Library

ISBN 0 09 185327 3

Printed and bound in Singapore by Tien Wah Press

Contents

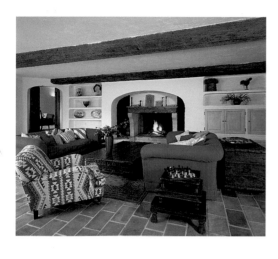

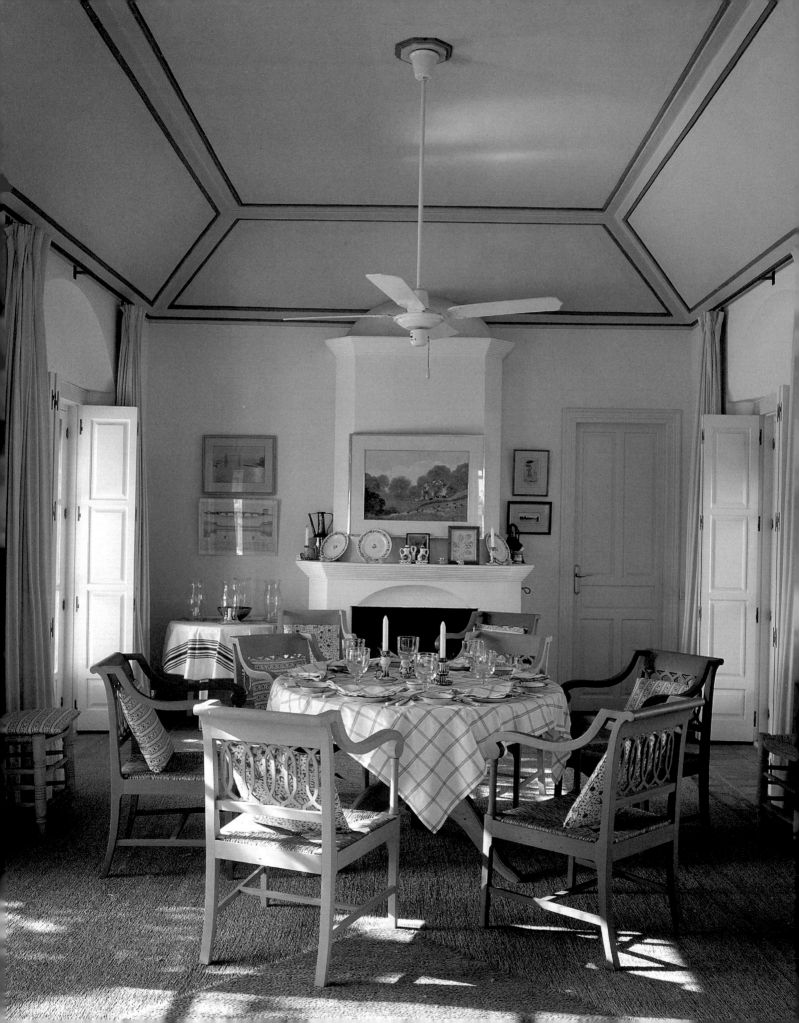

Introduction

Traditionally, country rooms were associated with all kinds of commendable qualities – not least, cosiness, comfort and informality – but they rarely set the pace in interior decoration. The usual image was of home-spun folksiness or over-chintzed fussiness, whereas fashionable rooms – the sort that had worldliness and originality – were in cities. But that is no longer the case: country interiors have taken the lead and become much more sophisticated. Whether they have a traditional or contemporary bias, they are distinctly chic and setting new trends in decoration.

Linking the words 'country' and 'chic' may sound contradictory – after all, the dictionary definition of 'country' includes the adjectives 'rude' and 'rustic', while 'chic' is synonymous with style and elegance – but there is no denying the fact that the latest rooms in country houses have an eclecticism and a professionalism which were rarely seen in their predecessors. Some of these new-look interiors are flamboyant, majoring on interesting finishes and mixing different styles of furniture and fabrics, while others are reticent in their colour and content, but the important thing is that they all retain an ambience of friendly casualness within a stylish design scheme.

This blend of eclecticism, professionalism and informality parallels a trend which prevails in many areas of our lives: smart 'modern' cooking uses humble ingredients, and expensive 'designer' clothes often have unstructured shapes and quirky trimmings. Refined, contemporary taste seems to enjoy hints of earthy character and relaxed individuality. In interior decoration, such touches can be provided by the typically country themes of vernacular materials and handcrafted artefacts. Once considered too basic to be beautiful, these are now highly prized by Western decorators and are gathered from remote places to create a chic 'look' back home.

International mobility and availability have made it all possible. Historically, the most obvious characteristic of country homes throughout the world was that their furniture and furnishings were made locally from local materials. Today, in the West, we have lost that tradition, but we have gained the luxury of being able to get anything from anywhere; we travel globally and we see at first-hand how other people live. Our holidays are spent increasingly in under-developed countries where ancient traditions survive – though for how long? – and natural finishes are the norm. Finding satisfaction in this ethnic heritage – in the irregularity of hand-thrown pottery and in the subtle vibrance of vegetable-dyed silk, for instance – we try to recapture that feeling in our own environment by incorporating some of those elements in our interior decoration.

But ethnicity is only part of the country story as it is currently unfolding. Imaginative designers see no reason not to juxtapose a primitive object with one that is the very essence of cultivated, Western art. Each artefact is recognized as having its own particular brand of beauty. Many earlier generations of decorators decreed that rooms should be 'all of a piece', but the latest country idiom oftens exploits contrast: it places a highly finished piece of antique furniture against a rugged stone wall, or suspends a rustic iron chandelier from a smooth-plastered ceiling. Thus intellectual and visual excitement is generated. The interplay of refinement and ruggedness, old and new, is stimulating – and fashionable.

In this new dining-room in the hills of southern Spain, the natural colour and texture of the seats and matting contrast pleasingly with the painted frames of the chairs and the plain white walls. The high, coved ceiling, which gives the room a sense of light and air, is outlined with bands of colour to create a symmetrical series of panels. Combining rusticity and regularity, the interior (designed by Mario Connio) is relaxed yet chic.

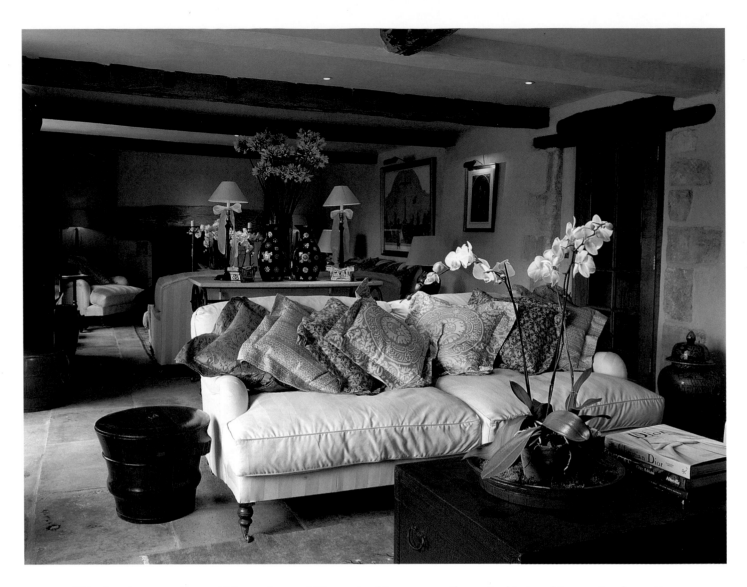

This drawing-room in an old house in rural Gloucestershire sums up the new, chic trend in country decoration. It conveys the atmosphere of informality which is traditionally associated with country interiors, but it also has sophistication. Decorated by Alison Henry, it exploits the contrasting qualities of robustness and refinement by using elegant sofas and exotic plants within a vernacular architectural setting. And it includes furniture and artefacts from different cultures, which is a recurring theme in many contemporary, country interiors. In this case, the foreign input is mainly oriental, making reference to the fact that Alison Henry and her husband spend part of their lives in Hong Kong. (More views of their home are shown on pages 14 and 186.)

Fashions come and go, of course, but what remains constant is the lure of the country itself. Gertrude Jekyll is remembered chiefly for her books on gardening, but she also wrote with great feeling about life in the old days in rural England. In her book *Old English Household Life*, published in 1925, she lamented the fact that the materials and crafts which traditionally characterized domestic interiors were disappearing, and she commented that the majority of people living in industrial cities 'look,

with longing, to the countryside and cherish the wish to end their days in its retirement'. I suspect her view is as applicable today as it was then, but the difference now is that town dwellers are more likely to fulfil their wish – and they do not necessarily have to wait until they retire. Greater mobility means that many people with jobs which compel them to live in town during the week have second homes to which they can escape for weekends and longer holidays. And, thanks to new communications technology, many

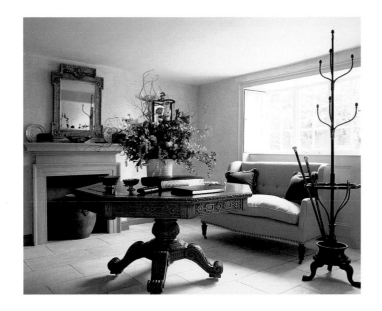

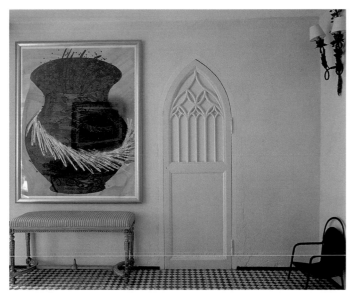

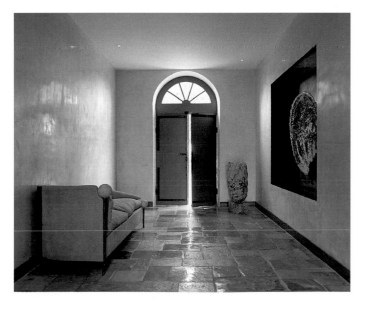

others, who previously would have been city captives because of their work, can now live full-time in the country and operate successfully from home. City centres, once the very hub of life, are in danger of dying as more and more of their inhabitants are moving to greener settings.

This demographic change has had a profound effect on interior decoration. City 'ex-pats', with tastes and expectations which are very different from those of 'real' country dwellers, may revel in their new-found, rural surroundings but cannot resist adding an urbane stamp to their houses. Many employ professional designers to help them achieve a habitat which they still regard as 'rural' but suits their peripatetic way of life and self-image.

Before being snapped up by urbanites, cottages were invariably lived in by people who worked on the land and spent their entire lives in the same village. The interiors of the cottages had an identifiably 'country' look, but it was one which had come about unselfconsciously. The rooms and furniture were, of necessity, simple but the natural materials and hand-craftsmanship had intrinsic dignity.

Even in bigger houses in the country, past styles of interior decoration were markedly different from those in town because the lifestyle made different demands. On the whole, day-to-day living in the country was close to nature and less formal, and households included dogs and cats, so no one could be too fussy about mud on the doorstep or paw marks in the hall. For practical reasons, the entrance was better floored with flagstones than with carpet, and it needed a place for boots and walking-sticks. Washable loose-covers were more sensible than fitted ones for sofas and chairs, and these contributed to the pleasantly rumpled ambience which permeated the

Unlike halls in urban houses, which tend to be long and narrow, country halls usually have better proportions for a room-like furnishing scheme. In the West-Country example (top), traditional furniture – including a softly cushioned sofa – is used in a fresh, uncluttered manner. The other two examples, both of which are in France, juxtapose modern art and old architecture. A hall in a converted farmhouse belonging to Catharine Warren (centre) has one of her own paintings above an antique stool. In Jenny Hall's home (below), the entrance is dominated by a huge, rugged ceramic dish by Claudi Casanovas.

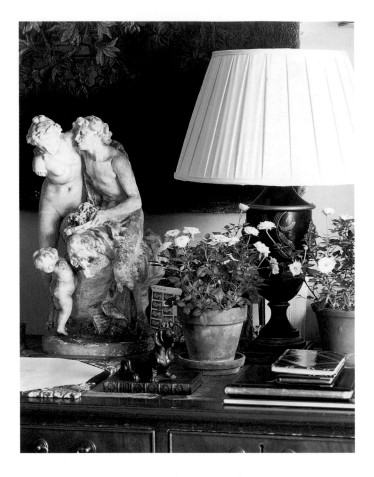

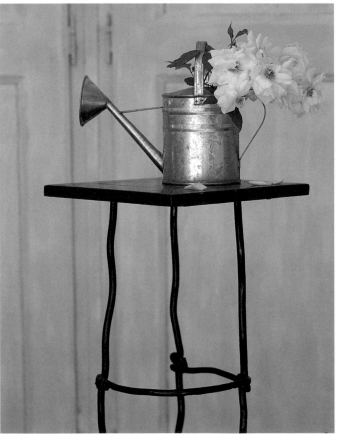

house. And then there was the 'feel' of the place. This suggested flowery fabrics and good, unpretentious furniture made in woods such as oak and pine. It all added up to another kind of 'country look', which was quite different from the cottage one, but again it had come about by accident rather than design.

The first time a country look was consciously developed in Britain in a really big way was in the 1970s when people living in towns began to identify something in rural interiors which they thought rather nice. The rooms may not have been the ultimate in fashion, but they were comfortable and appeared more welcoming than those in stiff, city homes. These qualities made city people think that, after a day in a machine-filled office, it might be restorative to go home to a cosier, more bucolic world. It was also a relatively inexpensive world. Victorian pine did not demand the same sort of money in antique shops as Regency rosewood. So townsfolk latched on to the cottage ambience – as they perceived it – and created a formulaic country look based on stripped-pine dressers, patchwork quilts, dried flowers and spriggy fabrics. It became all the rage in urban terraces and suburban semis, and although the effect was hardly authentic, it satisfied a rural fantasy.

This interpretation of the country mode tended to be rather folksy, sometimes even crude, and it never really found favour with stylish interior decorators. The latter had their own 'country' agenda going on. They were developing the grander, more elegant 'English country-house look' (which had started, in a much subtler way, as far back as the Thirties). This used lots of floral chintz, a medley of patterns, yards of frills and cloth-draped tables cluttered with pretty bits and bobs. It spawned rooms which were very comfortable, if sometimes rather overwhelming in their fullness, and it, too, was employed just as frequently in towns as in the country.

Informal flowers and plants make a significant contribution to the country theme. These two still lifes show quite different approaches but both have a touch of rough-with-the-smooth quirkiness which fits today's 'look'. The one at top (see, too, page 42) has rustic, terracotta flowerpots on an antique chest-of-drawers. The one below in François Catroux's house in southern France (see page 74), features an old-fashioned, galvanized-metal watering-can on a modern table.

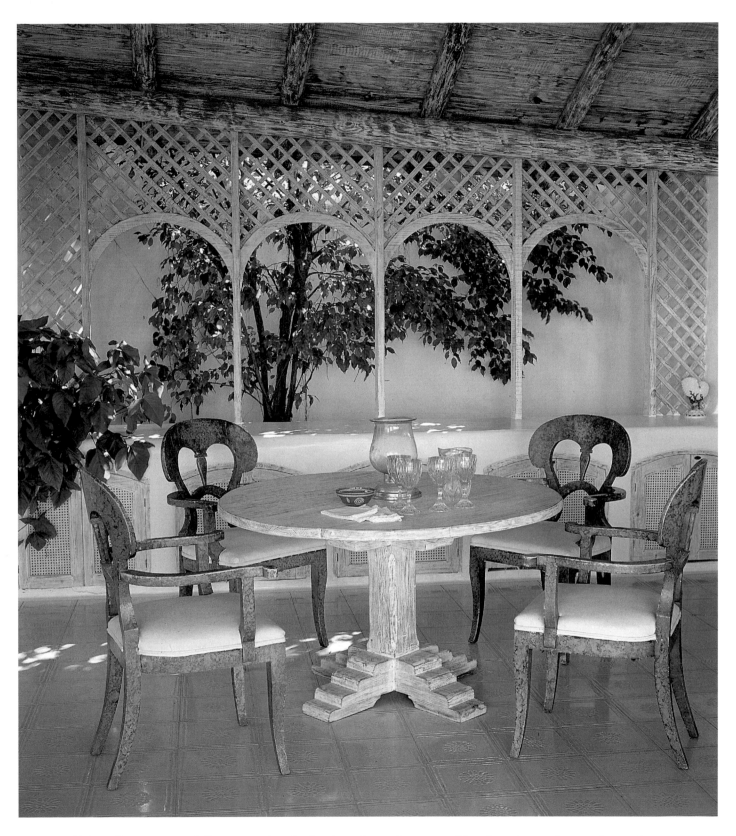

Paint effects are especially appropriate for furniture in garden rooms. They introduce a degree of casualness and flamboyance without debasing the inherent style and interest of the furniture – as can be seen here, where the unusually handsome chairs have been given a green lacquer finish. The table has been limed to echo the wooden ceiling and trellis screen. This semi-outdoor room is not treated as an after-thought but designed with as much flair as if it were entirely indoors. (More views of the house are on pages 68 and 146.)

The genre was fantastically popular in the 1980s, but when done badly – which, alas, was too often the case – it was fussy and predictable, so fashionable decorators had to move on to new design realms. But not entirely. The siren call of Arcadia still beckoned, and the lovely, reassuring image of the country could not be abandoned altogether. What was needed was something to bridge the gap between rural solace and urban sophistication.

No single, hard-and-fast look has emerged but there is a definite trend encompassing two country themes: one could be loosely described as vernacular (but it is far more glamorous than the old stripped-pine look) and the other has tokens of the country-house style but is more eclectic and less twee than in the over-frilled chintz era. Both themes are chic – and international. Decorators worldwide now acknowledge that good, country antiques – simple furniture made by craftsmen less effected than townspeople by passing fads – are practical and characterful. This type of furniture is especially exciting to contemporary eyes when given a new twist by being featured in an unexpected way. In her home in Atlanta, designer Nancy Braithwaite has done just that: she has used Southern States vernacular furniture and traditional colours to evoke the erstwhile ambience of 'plain, country living', as she describes it. As you can see on pages 34 and 122, she has achieved that mood – but in a refreshingly up-to-date manner. American artist Catharine Warren has been equally successful in creating a stimulating and sophisticated environment in her home in southern France. Within an old farmhouse and vaulted barn, she has devised a glorious set of interiors, including an exquisite drawing-room (page 32), dining-room (page 112) and bedroom (page 180). These rooms could only be in the country but they are stylish and more original than almost anything you would find in a city: antique French chairs are covered with *toile de Jouy* cotton rather than grand silk; terracotta floor tiles are left bare; a chandelier of metal leaves hangs above a painted,

Louis XVI-style dining-table, and one of Catharine Warren's own modern paintings faces a pair of nineteenth-century tôle hollyhocks.

To some extent, the thrill of Catharine Warren's drawing-room derives from the unusual character of the architecture. Converted from an ancient barn, the room exudes a feeling of agrarian history whilst being an agreeable place in which to live today. Many other interiors in this book are in interesting, old farm buildings, and this gives them an advantage over prosaic rooms in towns. They range from barns in the Cotswolds to a converted watch-tower in Italy. They are varied, not only in their settings but in their character. A few are in towns and are included here because the influence of the country is so apparent.

The interiors which use vernacular building styles and materials – wood, stone and brick – are most likely to be furnished with natural, unpretentious textiles such as cotton, wool and linen. These rooms often have colour schemes which are directly inspired by, or 'answer', the landscape (see page 156). In other instances, the surroundings of the houses are virtually part of the interiors, a concept spectacularly exemplified by the drawing-room on St Lucia (page 68). Congeniality is the key in this room – as it is in the interiors seen in the chapter devoted to open-plan living, starting on page 150. Adapted to the country lifestyle at its most easy-going and welcoming, these interiors combine many different functions and are very sociable rooms. The rooms in the other chapters are more specific in their purpose and have been grouped accordingly. There are sections on halls, sitting-rooms, dining-rooms, libraries and studies, kitchens, bedrooms and bathrooms, and garden rooms. Some are grand in scale; others are modest. Some of the schemes are in old settings; others, surprisingly, are in brand-new buildings. Selected from the best and most stimulating features to have appeared in recent issues of *House & Garden* magazine, these rooms have now been brought together to form an inspiring compendium of country chic.

Constructed from warm-toned, vernacular materials, this bedroom is in a new chalet but already has a mellow charm. At first sight, the overall character of the furnishing scheme is Swiss but the constituent elements are in fact international in provenance: the antique quilt and most of the furniture are French, the rug is Eastern, the fabrics are mainly Italian. Because they all have ethnic associations, either in their handcraftmanship or patterns, there is harmony in the mix. The scheme was devised by London-based decorator, Emily Todhunter.

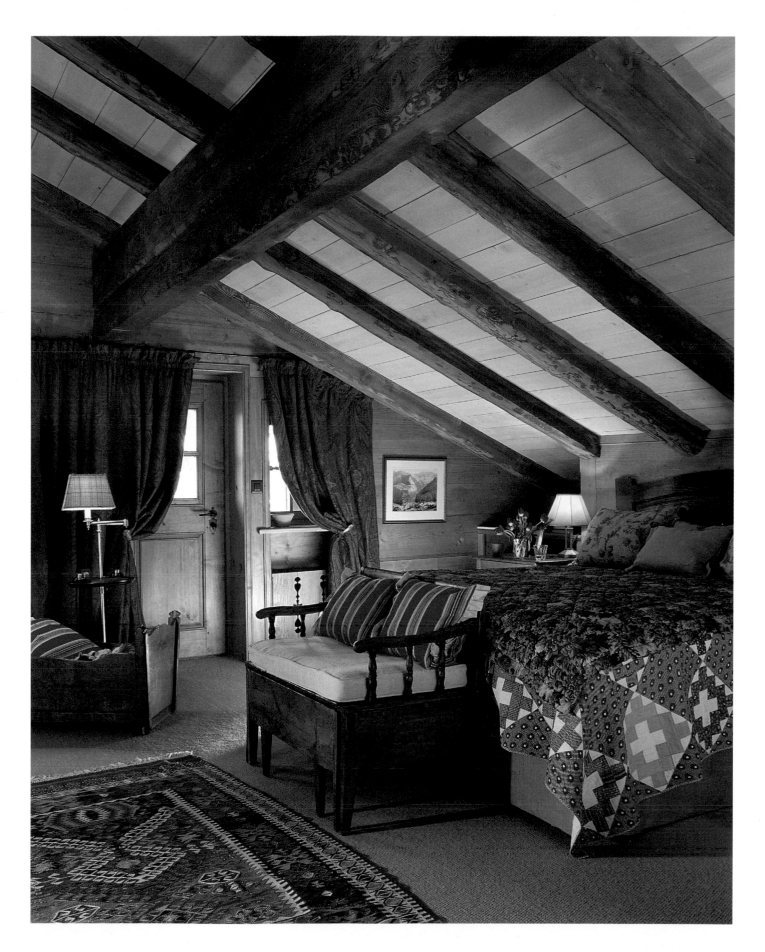

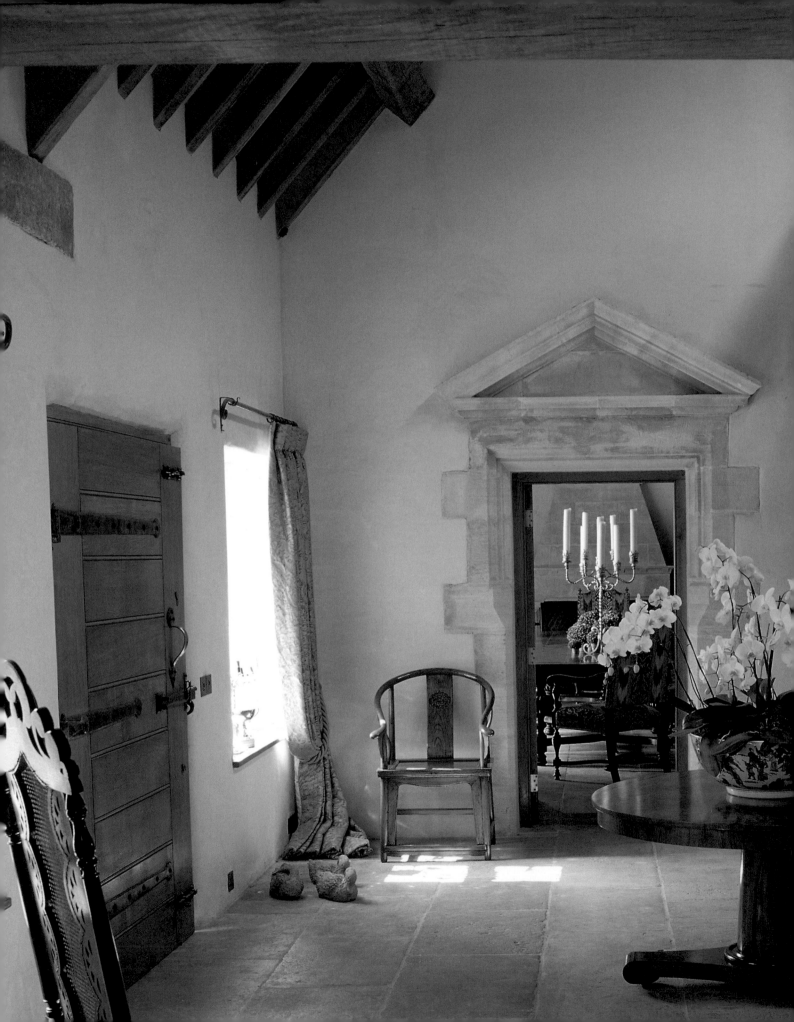

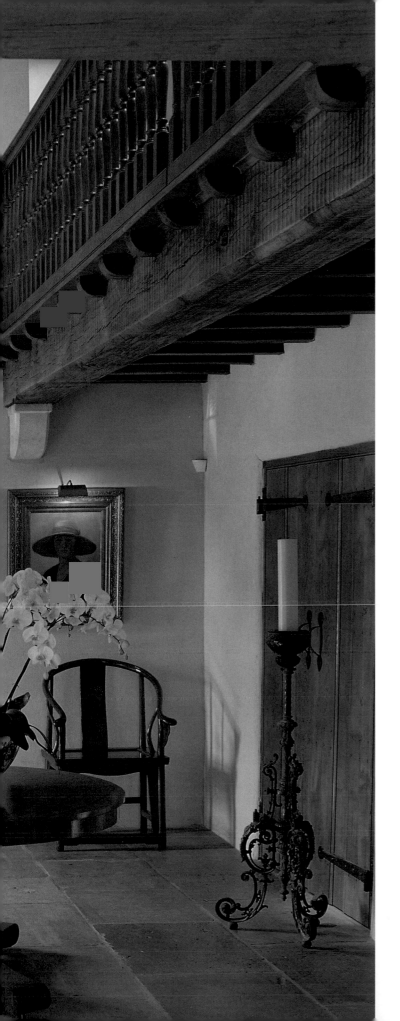

HALLS

The size and shape of the entrance hall are two of the features which distinguish most town houses from country houses. In cities, the hall is rarely more than a corridor connecting the front door to the rest of the house, whereas in the country there is a good chance of having a comfortable amount of well proportioned space. Given this luxury, you can embark on an interesting and inviting style of decoration. Isabelle de Borchgrave's decoration of a staircase-hall in Belgium (overleaf) has *trompe l'œil* wall decorations, one of which simulates a colourful quilt, and the other depicts shelves filled with decorative objects. Totally different is the dramatically resolved staircase in Portugal, designed by David Hicks (page 21). This space is elegantly austere and classical, but the metal watering-cans used ornamentally on the side-tables are rustic, producing a satisfying equilibrium between 'rough' and 'smooth'. Equally skilful is the choice of architecturally inspired artworks which provide modern counterpoints within a traditional-looking, though recently-built, setting.

In this galleried hall in the Cotswolds, the sense of space has been maximised by keeping the colour scheme and furnishing extremely simple. All the architectural finishes are neutral – stone for the floor, antiqued plaster for the walls, unpainted timber for the joinery – and furniture is used sparingly. Sharing similar tonal values, Chinese chairs and an English Regency table co-exist happily. The hall is in the Gloucestershire home of interior designer Alison Henry, which was renovated with architectural advice from Robert Franklin. (See, too, page 186.)

Seaside informality

Isabelle de Borchgrave is an artist, textile designer and interior decorator. All three aspects of her work are seen in the entrance and inner halls of a 1930s house she transformed for friends in the Belgian seaside resort of Zoute. Since this is the family's principal home, Isabelle de Borchgrave's scheme had to be comfortable for year-round living. However, the seasonal character of the town, and the relatively casual lifestyle of the owners of the house,

inevitably influenced the style of decoration. There is a natural vitality and informality about it, derived largely from the sense of colour. In the small hall (opposite) between the dining-room and library, *trompe l'œil* shelves are enlivening echoes of the owners' collections of books and objects in the adjoining rooms. In the staircase hall (above), there is another piece of illusory paintwork in the form of a colourful quilt.

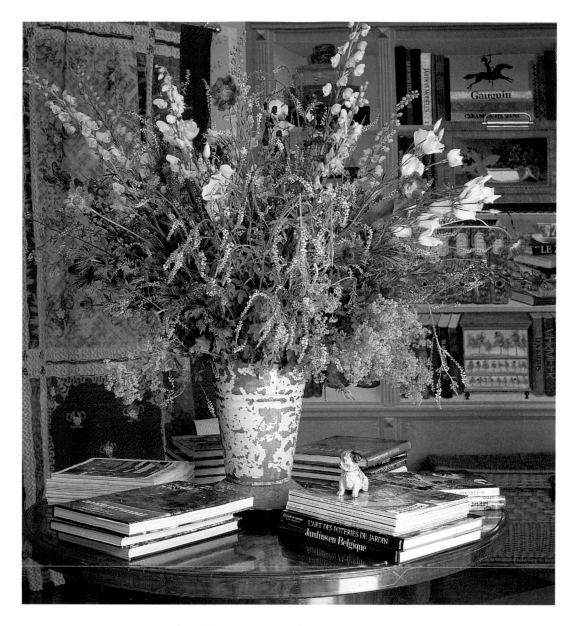

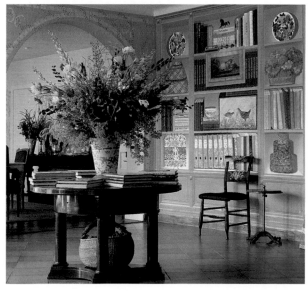

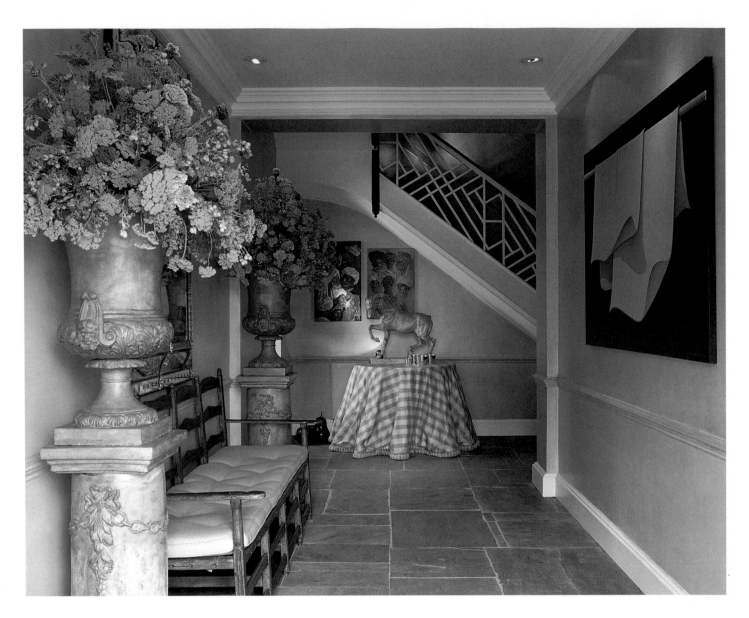

A simpler intepretation

A new, simplified variant of the English country-house look was the thinking behind the redecoration of a Queen Anne house in Suffolk (shown above and on page 212). The entrance hall makes the point with a bare, stone-flagged floor, glazed walls and robustly moulded terracotta urns flanking a French settle. At the far end, in front of the stairs with an unusual balustrade, is a circular table draped with a checked cloth. As well as having a softening influence on the

hall, the fabric harmonizes the tawny colour scheme and is a foil for the muscular horse sculpture. Similarly, in a house in Oxfordshire (opposite and on pages 40 and 92), Robert Hering has used a round table with a heavily fringed cloth as a luxurious counterpoint to the painted stone walls and as a support for a single, magnificent object, creating maximum impact. Both halls have modern paintings – an interesting and effective choice in traditional settings.

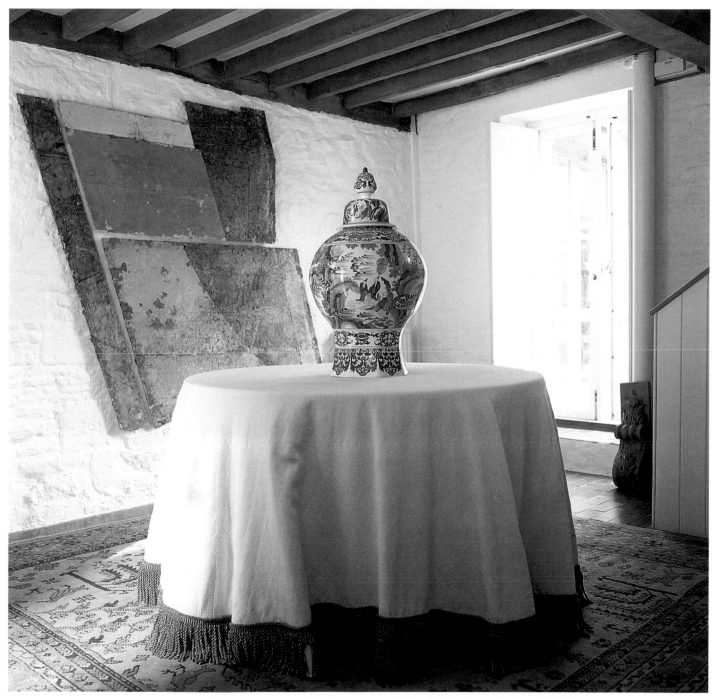

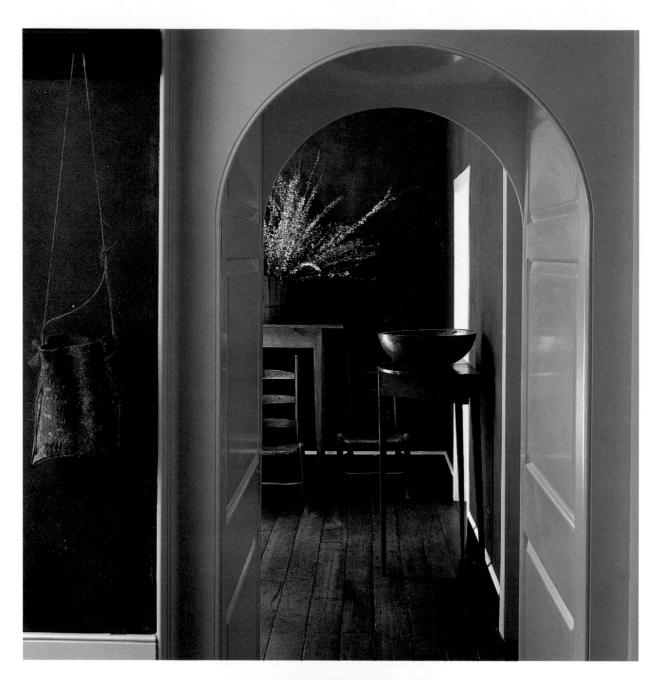

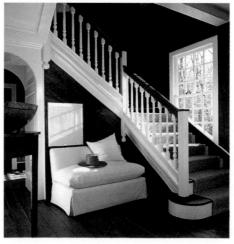

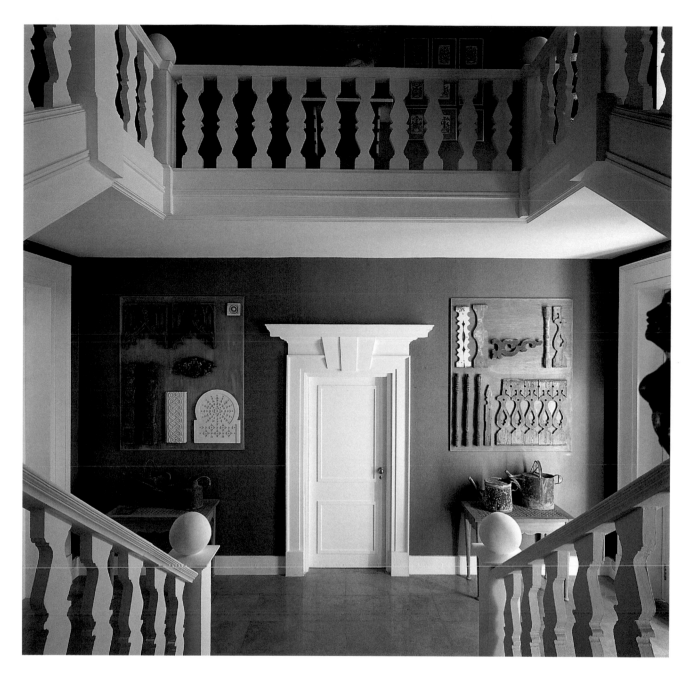

Plain and purposeful

Designer Nancy Braithwaite is a collector of nineteenth-century American vernacular furniture – the sort of pieces made for yeomen farmers who lived in utilitarian wooden houses in the Southern States. The designs of the furniture are simple, but certainly not primitive, and there is an nobility in their straightforward shapes and functionalism. Nancy Braithwaite has a sympathy for the honest character of this furniture and has put her collection in settings with subdued, rural colours played against white. The entrance hall and adjoining corridor (opposite) in her home in Atlanta (see, too, pages 34 and 122) are indicative of the style of the rest of the house and include two pine 'hunt boards'. These

tables are recognisable as Southern because of their height, which comes almost to shoulder-level. The galleried hall seen above is similar to Nancy Braithwaite's in that it has large planes of a single, deep colour contrasted dramatically with white. This interior is in a recently built Palladian-style house in Portugal designed by David Hicks, a master of disciplined design. The doorcase opposite the stairs uses simplified classical forms on a bold scale to heighten the dramatic effect and give greater weight to the scheme. A pair of modern architectural artworks and still lifes of watering-cans on side-tables complete the precisely formulated, symmetrical interior.

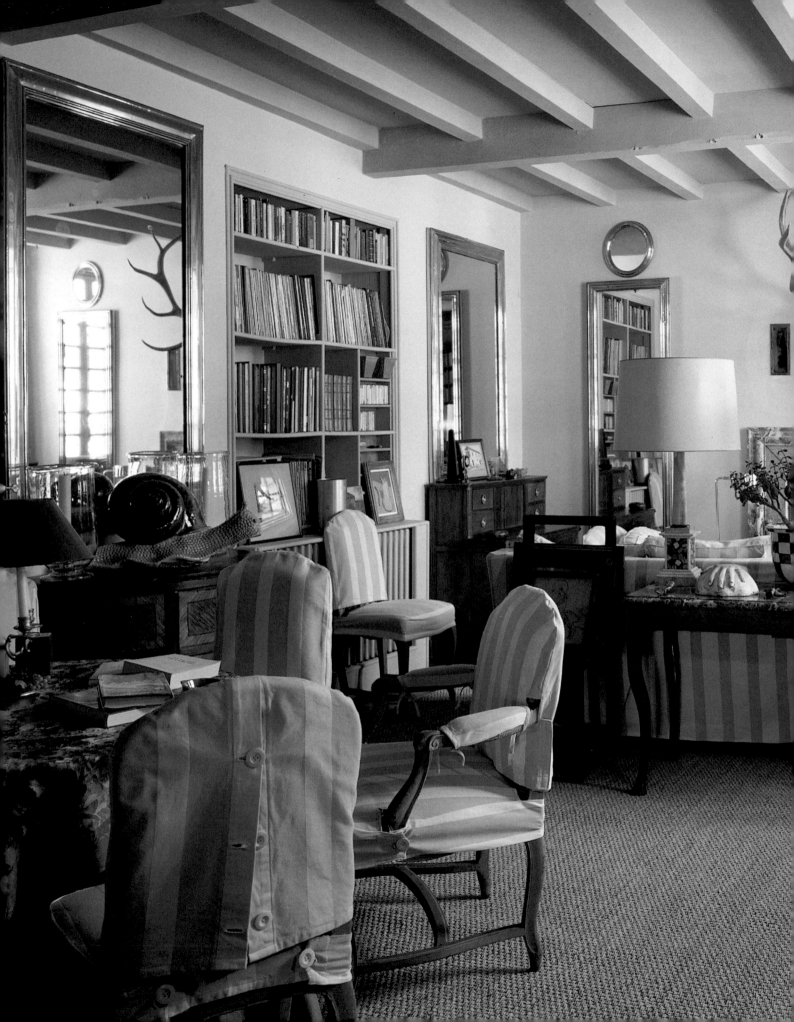

SITTING-ROOMS

Many of the rooms in this section are in buildings with a utilitarian past: a coach-house, a school-house, an artist's studio and three barns. Quirkier and much more unusual than purpose-built domestic interiors, these conversions lend themselves to bold styles of decoration which take advantage of high ceilings, tall windows and hefty beams. Other transformations include rooms in a diminutive, eighteenth-century gothic folly (pages 44) and a monumental, fourteenth-century farmhouse (page 74). In contrast, at least six of the most interesting interiors are in new buildings, ranging from a Palladian-style villa on the Italian coast (page 50) to a modernist house in the Belgium countryside (page 80), a cliff-side retreat on the island of St Lucia and an extension to a gardener's cottage in Hampshire (page 46). One of the rooms is not, in fact, in the countryside but in a hidden, green corner of central London (page 42). It figures here because it is a particularly delightful example of a certain sort of country chic which is reminiscent of the traditional 'English country-house look' but, like the room on page 36, fresher, more eclectic and more substantial in its interpretation.

This room, decorated by Dick Dumas, is smart but cosy and is used mainly in winter. A large sofa hugs the fireplace, while gilded mirrors in a variety of shapes and sizes decorate the walls. The chairs surrounding the circular table at left have loose covers decoratively fastened with buttons, the bottom two left undone like a waistcoat.

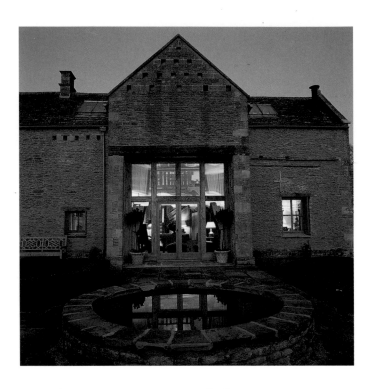

A converted barn in the Cotswwolds

In reorganizing the interior of an existing barn conversion in the Cotswolds, architect Peter Yiangou took an Arts and Crafts approach, using oak joinery to divide the 27-metre (89-feet) long main building into a series of interconnecting spaces which serve different purposes but are only loosely separated. The divisions between the spaces are apparent enough to give a sense of privacy and comfort but not so obtrusive as to spoil the barn's astonishing internal volume. Opening off the central hall is a cosy sitting-room (shown on the following pages) with a star-spangled ceiling painted >

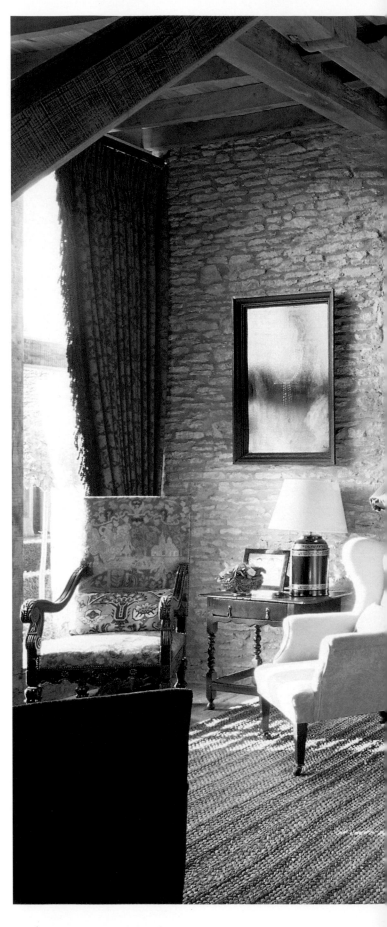

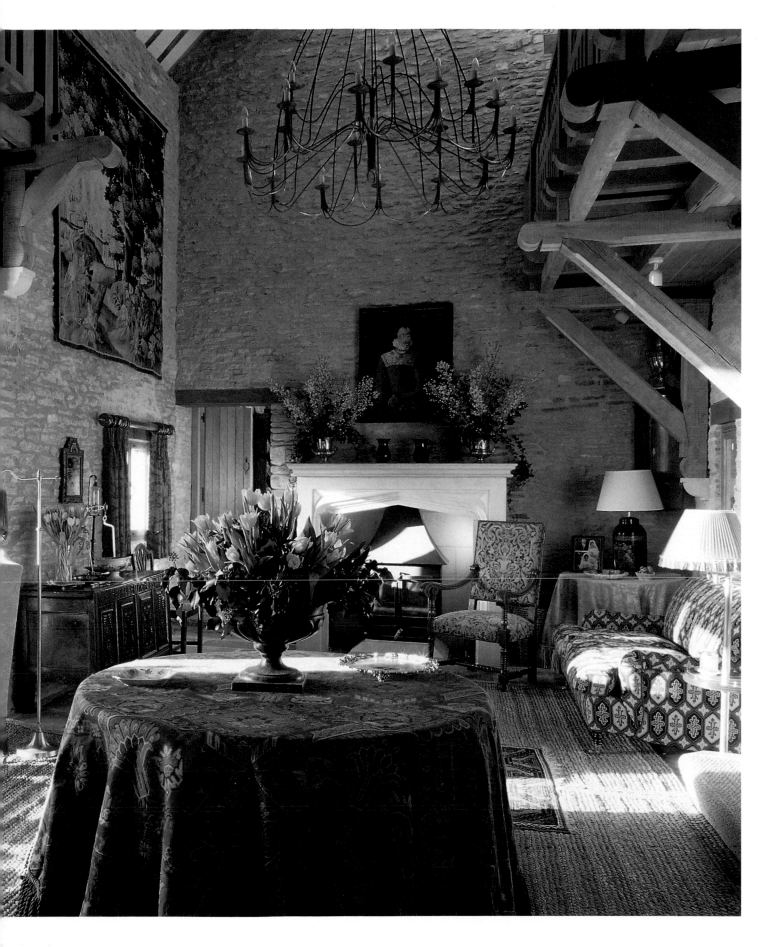

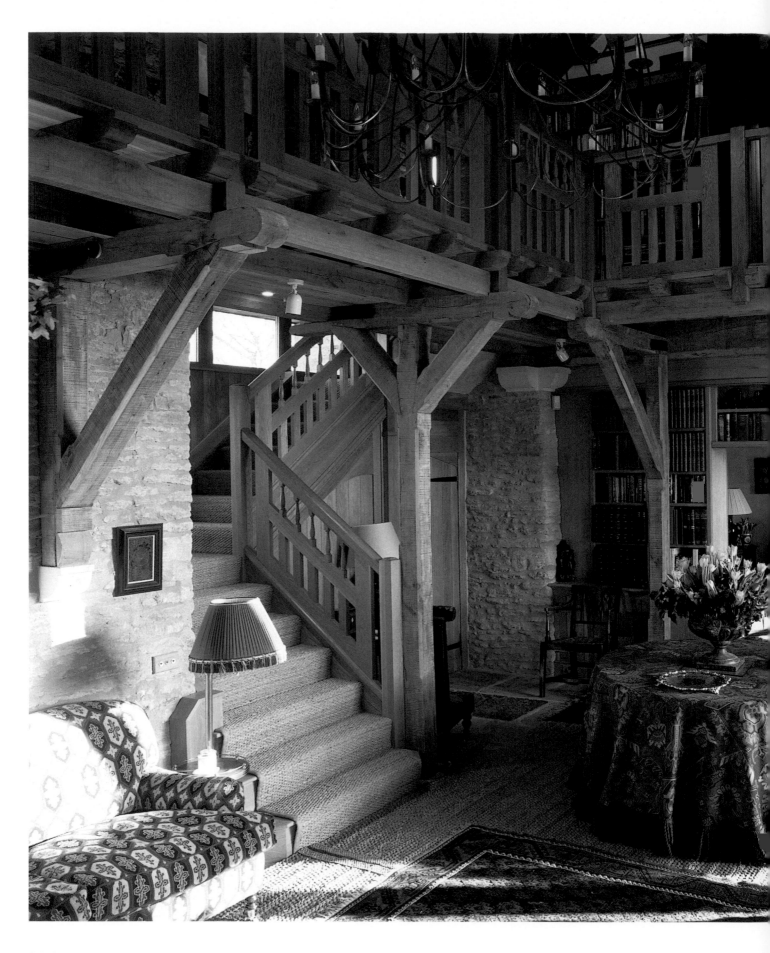

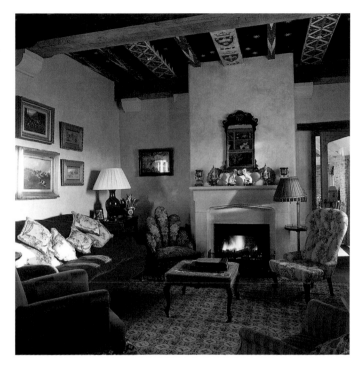

< by Tanya Backhouse and Toby Hill. The barn's new joinery, carried out by Derek Elliott, includes a magnificent oak staircase leading to a book-lined gallery which is supported on massive posts and beams, and which leads to bedrooms and bathrooms. Complementing the barn's structural materials, interior designer Henrietta Holroyd has used heavy-weight rush matting on the stone-flagged floor, furniture with good scale, and fabrics which have strong patterns and colours.

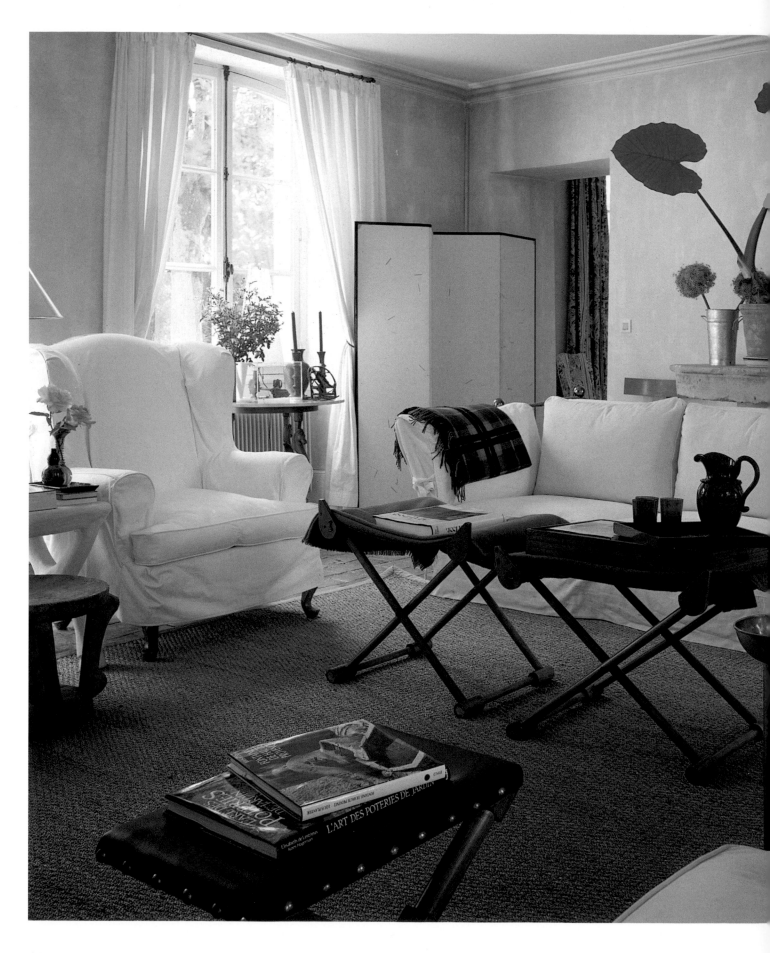

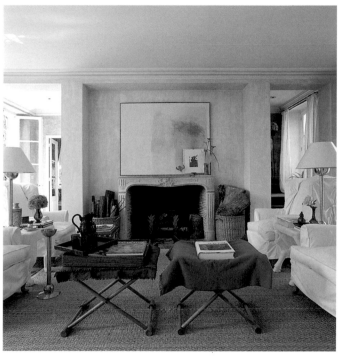

Linking inside and outside

Yves Taralon's house in the French countryside is built *à la lanterne* – that is, one-room deep, with each room leading directly into the next, and with windows on both sides. At the centre of the row of rooms is the sitting-room, a cool, airy space with beige ragged walls evocative of the natural stone of the region. 'I wanted the room to be restful, with restful colours – white, ivory and beige. I've tried to make the furniture unobtrusive so as not to detract from the room's openness, paintings and objects.' The stone console table designed by Pierre D'Antan was chosen for those >

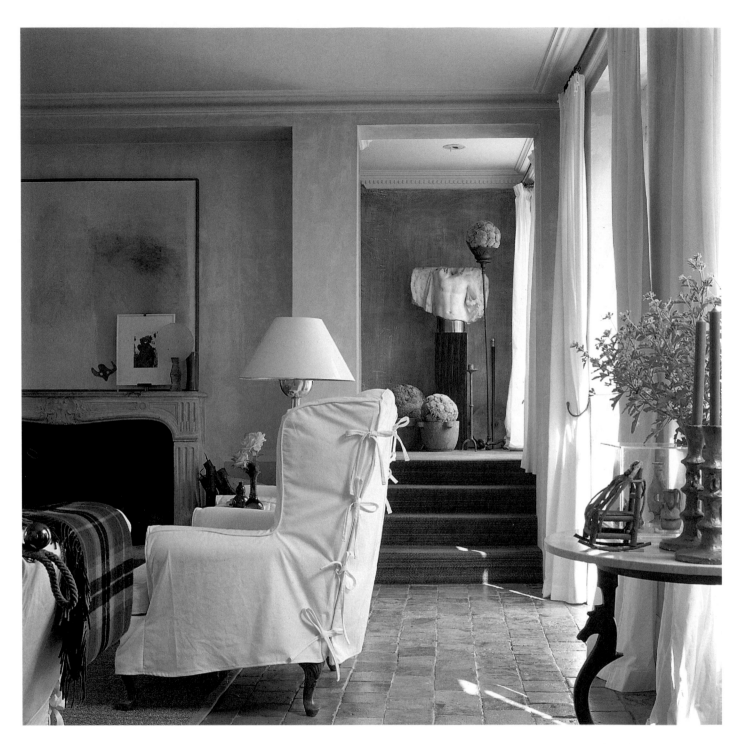

< reasons: integrating with the architecture by simply jutting out from the wall, like a ledge, it carries a bold arrangement of plants and flowers in terracotta and aluminium pots, plus a Venetian mirror on a wooden easel. The seating comprises a long, low sofa and four wing-chairs placed in pairs to either side of the fireplace. The plain white covers are fastened at the back with stylishly large ties. X-frame stools double as occasional tables. (See, too, pages 102 and 188.)

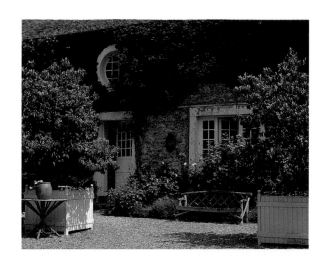

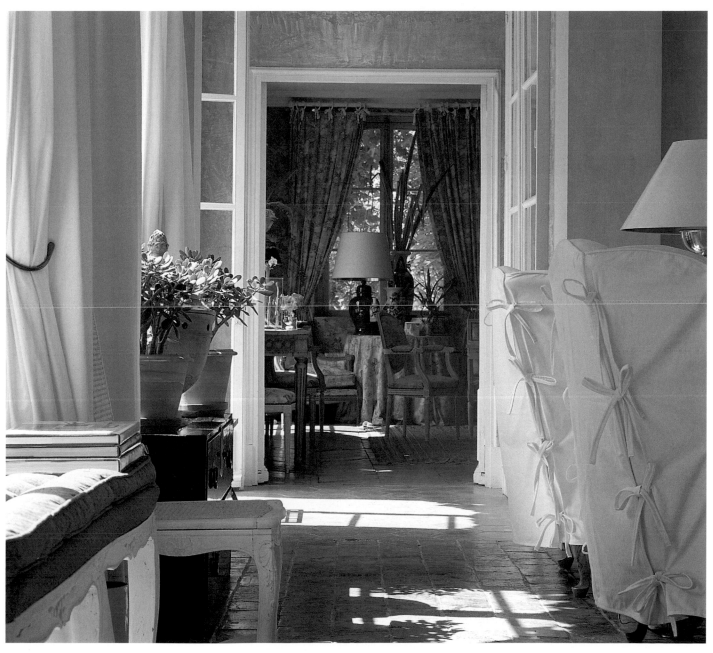

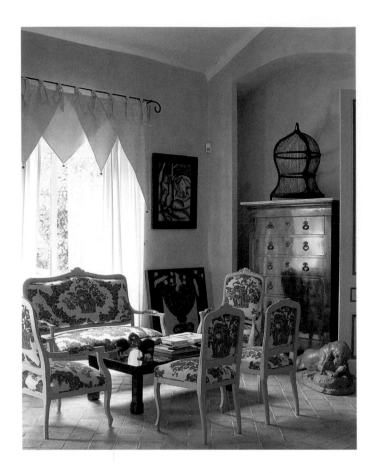

Painter's paradise

Artist Catharine Warren divides her time between an apartment in New York and the traditional stone house in Provence shown here. In contrast to her city home, which is predominantly Venetian-red and has a night-time ambience, her country retreat has a light, open feeling. During the restoration of the house and the conversion of the outbuildings, she was careful not to eliminate the sense of an agrarian past. The glorious, yellow-ochre drawing-room was originally a barn, and though now furnished in an elegant vein it retains the noble shape and proportions characteristic of many old farm buildings. The architectural surfaces have appropriately unpretentious finishes: terracotta tiles for the floor and an uneven paint effect in an earth pigment on the walls. Against this background, Catharine Warren has introduced an eclectic array of furniture, much of which is painted. To match up to the rise in height in the centre of the room, she has hung a tall mirror above the chimneypiece and flanked it with a pair of branched sconces. Seating is arranged in two groups – one by the fireside, the other by a window – which are cross-referenced by the vivid fabric used for the upholstery. The neutral-coloured fabric at the French windows has been cut into pennant shapes and hung from simple wrought-iron rods.

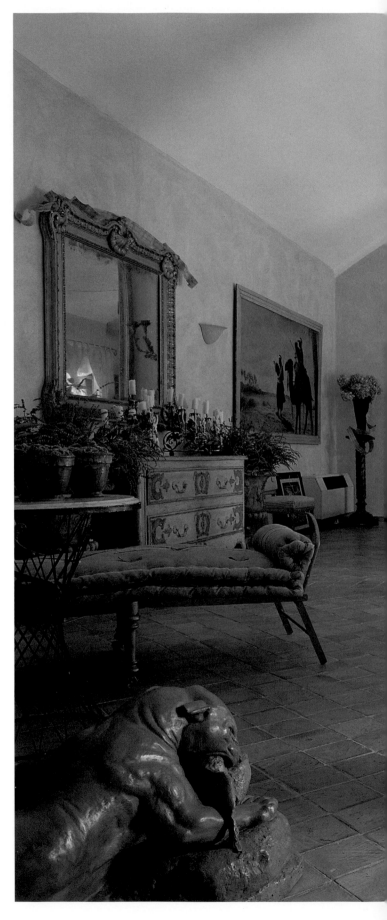

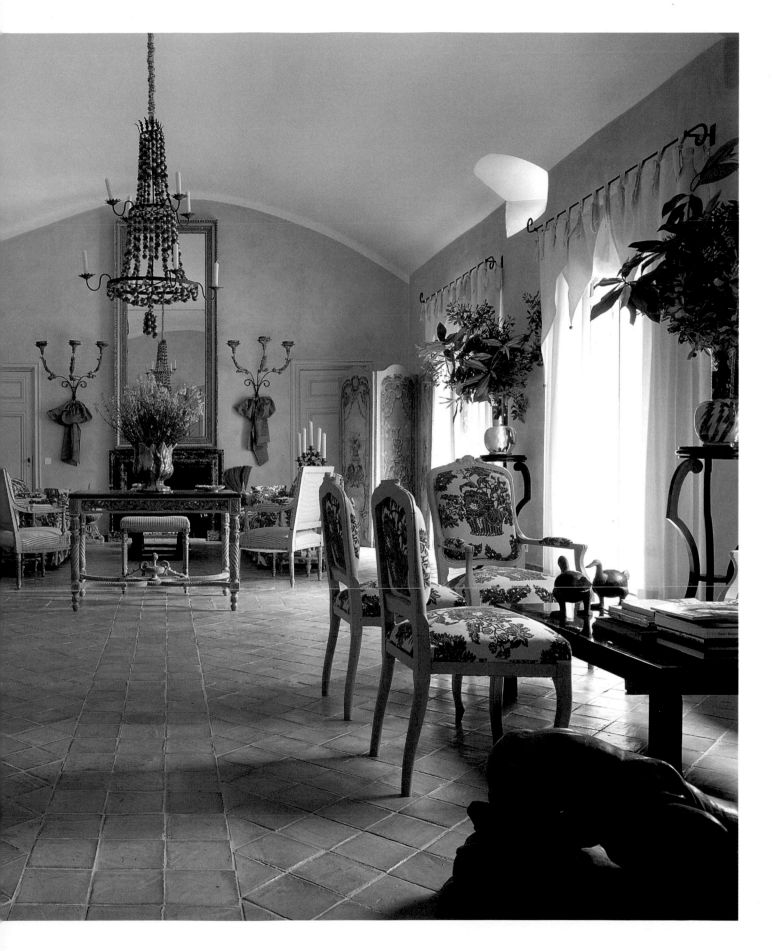

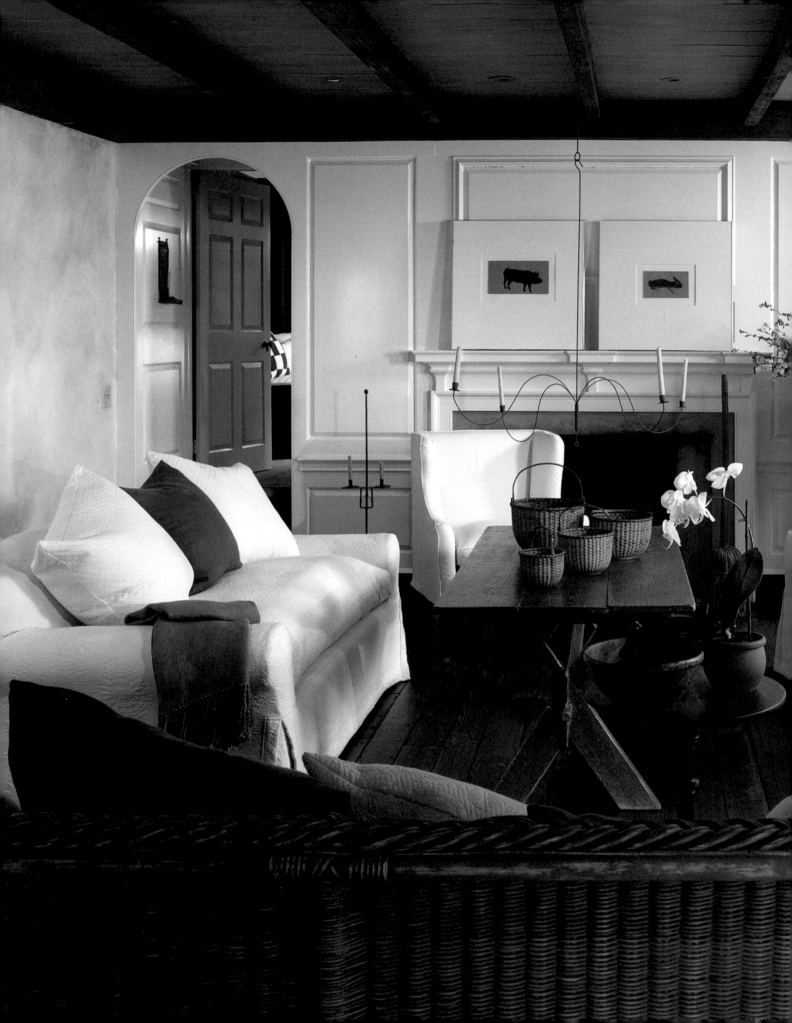

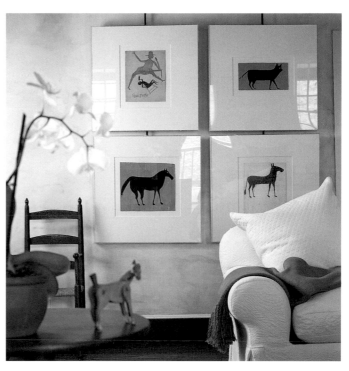

Back to their roots

When Atlanta designer Nancy Braithwaite moved into her present house (built in 1964 to a design by James Means) her aim was to take her wonderful old pieces of American vernacular furniture 'back to their roots as functional, tailored objects'. Avoiding the sort of stylised American country decoration which involves masses of quilts and pine dressers, her more subtle approach is seen here in the living-room which has a calm poise and timelessness. The room retains its original panelling, chimneypiece and floorboards, establishing a simple, early-looking architectural setting for the antique wooden furniture. There are no curtains to blur the purity of the interior, and the thin metal candelabra is distinctive but unobtrusive. The animal drawings by Bill Taylor have enormous, plain mounts which give the pictures an extra degree of presence in the room without looking heavy. (More views of the house are on pages 20 and 122.)

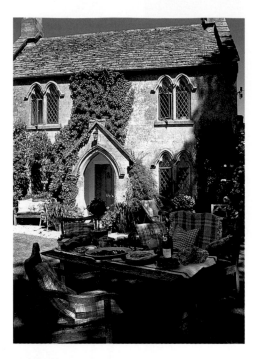

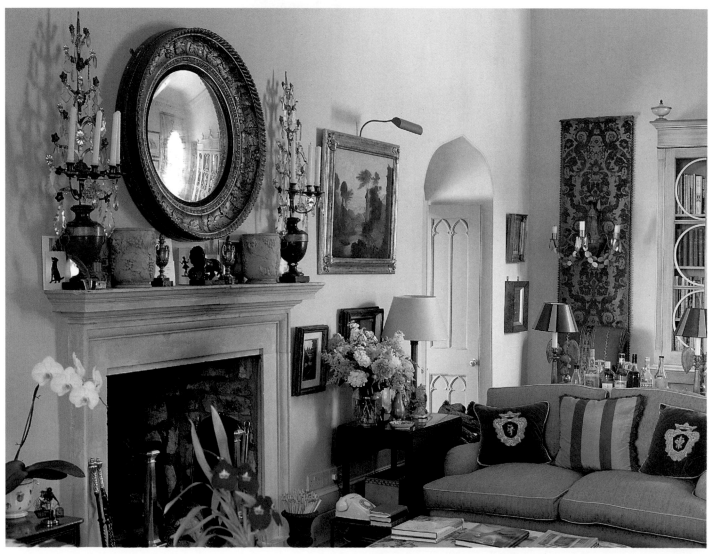

Gothic novelty

When a building undergoes a change of use, it is not always a happy transition, but this former village schoolhouse has been turned successfully into an unusual and charismatic home. The drawing-room occupies the space that was once the school hall and therefore has a scale and architectural grandeur which surpass any room in the average village house. Particularly notable is the tall, triple-lancet window (seen overleaf) which looks across the garden to a fine view of fields and distant hills. The curtain and pelmet treatment, though elaborate, does not overpower the window and is designed to reveal as well as frame the gothic arch. In keeping with the character of the room, which was built in 1850, a gothic cornice has been added. The elegantly simple, carved stone chimneypiece is also a new addition. Seating is arranged in groups for comfortable chatting at parties, and there are lots of pretty things dotted about to intrigue the eye and mind. The conversion and decoration of the schoolhouse (see, too, page 194) were masterminded by interior designer Colin Orchard, who shares the house with William Yeoward, designer and retailer of furniture, fabrics and decorative objects. The large cabinet with elaborate glazing is one of William Yeoward's designs. >

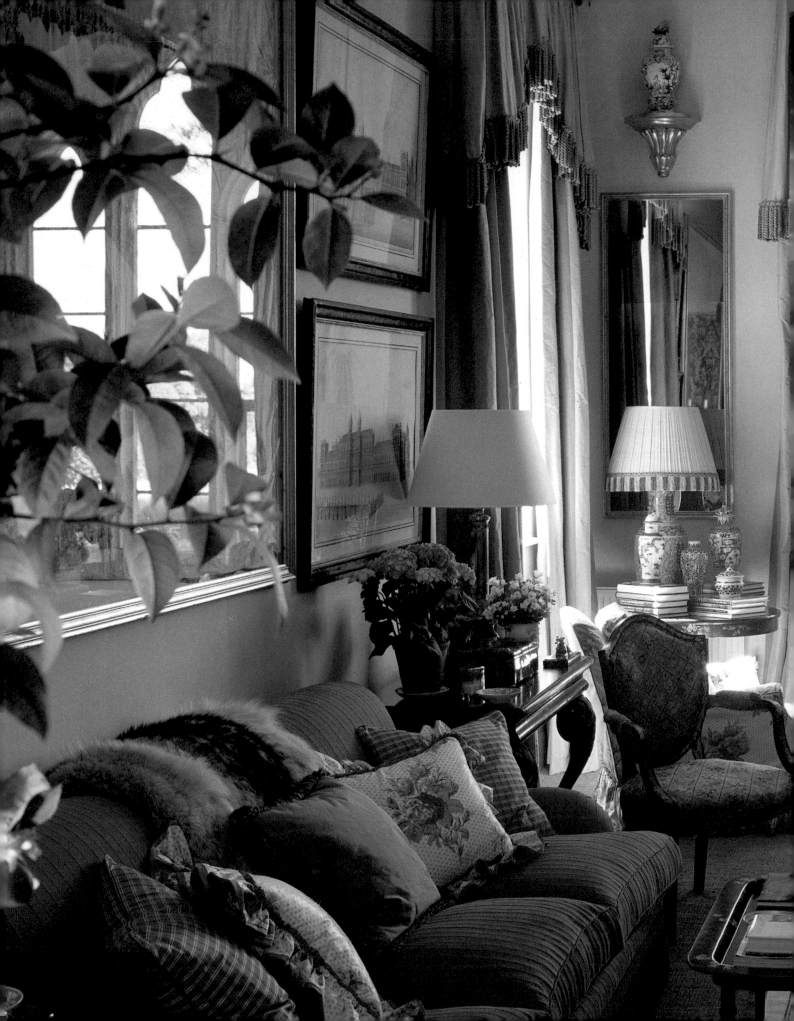

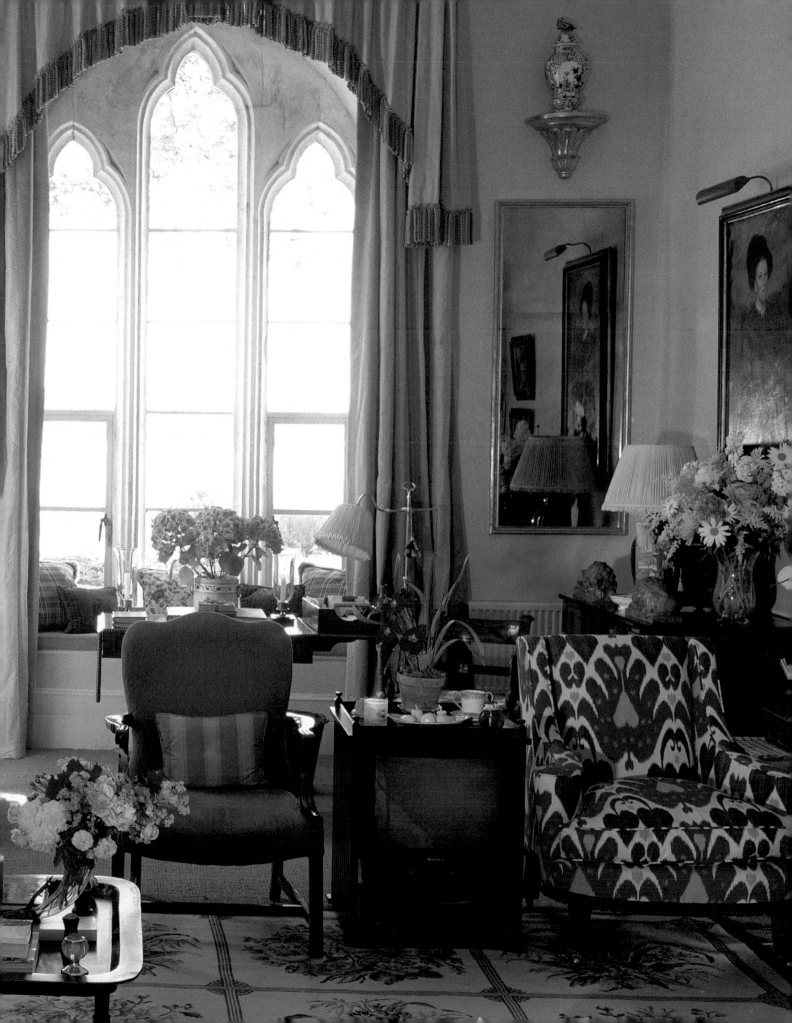

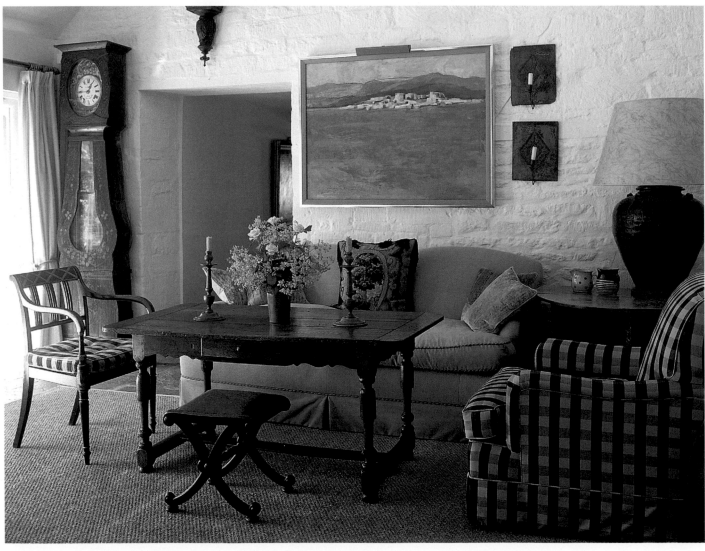

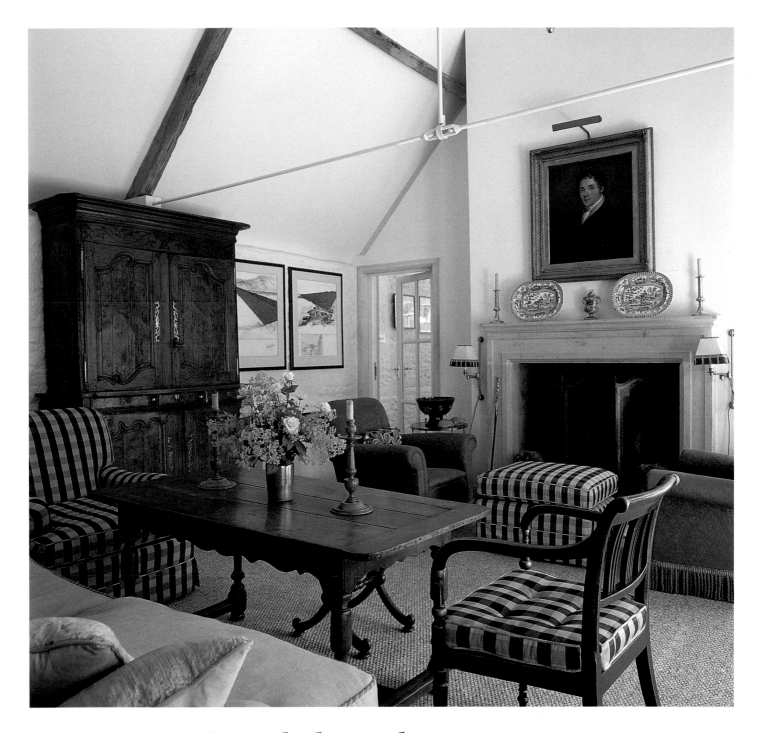

An enlightened conversion

An old stable and adjoining coach-house near Burford in the Cotswolds had already been partially converted into a home when American interior designer and antiques dealer Robert Hering first saw them, and potentially they were exactly the sort of English country retreat he had been looking for. Collaborating with his principal architect, Peter Yiangou, and with Califonian Ugo Sap, he kept within the parameters of the original character of the building while making some sympathetic alterations. In the summer sitting-room, seen

here, he retained the existing, exposed ceiling timbers but replaced the hefty, wooden cross-beams which were too low to be practical and darkened the room. In their place are slim metal ties which are equally effective structurally but less disruptive visually. Colours are restful, and there is a predominance of natural finishes: York stone and sisal for the floor; painted brickwork for the walls; stone for the chimneypiece. The furniture is an eclectic mix of English and Continental styles. (See, too, page 92).

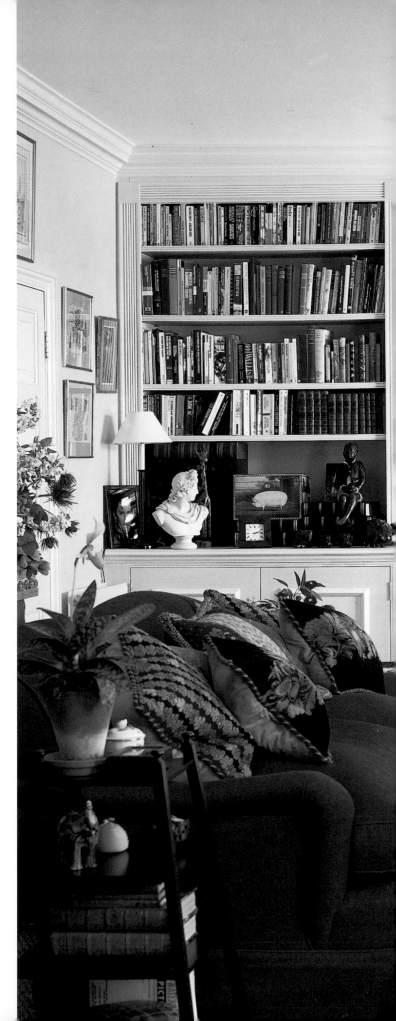

Deceptively rural

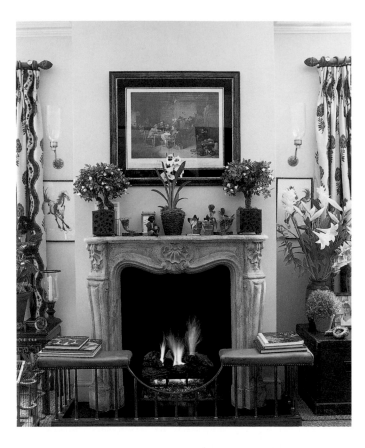

'A cottage in town' is an apt description of the central London home of Charlotte Lane Fox and her husband Bruce Ellis. Its situation is remarkable for being one of three detached, mid-nineteenth-century cottages set in one-and-a-half acres of wooded garden, completely hidden from view yet only a stone's throw from a busy urban thoroughfare. The rural-seeming location is reflected in the style of interior decoration which has a cheerful, updated country-house flavour. This is an adept example of a look which has moved on from the typical version of the English country-house style: it is stronger and more eclectic. Yellow walls are a light, sunny enhancement to the bold patterns and colours of the textiles; and details such as terracotta flowerpots make interesting contrasts with the room's more refined materials.

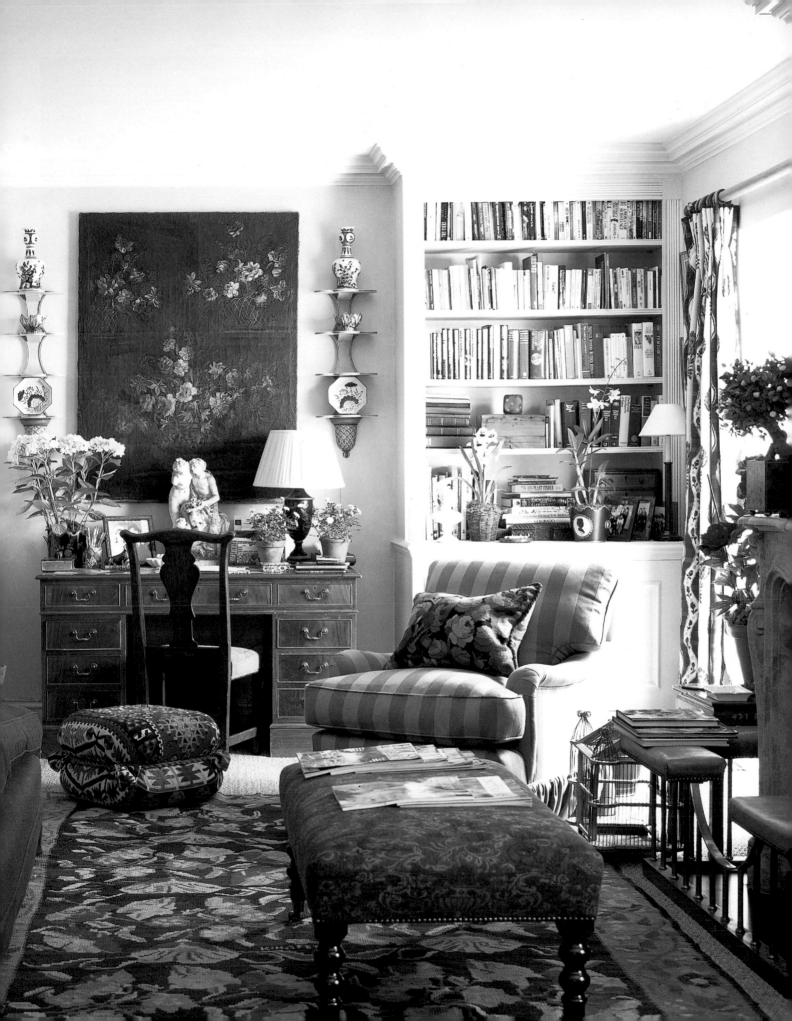

In a flintstone folly

The eighteenth-century version of gothic architecture and furniture design displays a lightheartedness and romanticism which verges, delightfully, on frivolity. Here, a little flintstone folly in Hampshire has been converted from a gothic bath-house, built somewhere between 1750 and 1770, into an exquisite late-twentieth-century weekend retreat without compromising the building's personality.

William Thuillier and Robert Perkins sensitively chose to furnish the folly in a simple manner, in order to avoid any feeling of clutter or opulence which would be out of place in such a setting. Especially appropriate are the eighteenth-century gothic chairs which are ornamental but have the sort of forthrightness and sturdiness that suit a country location. (See, too, page 136.)

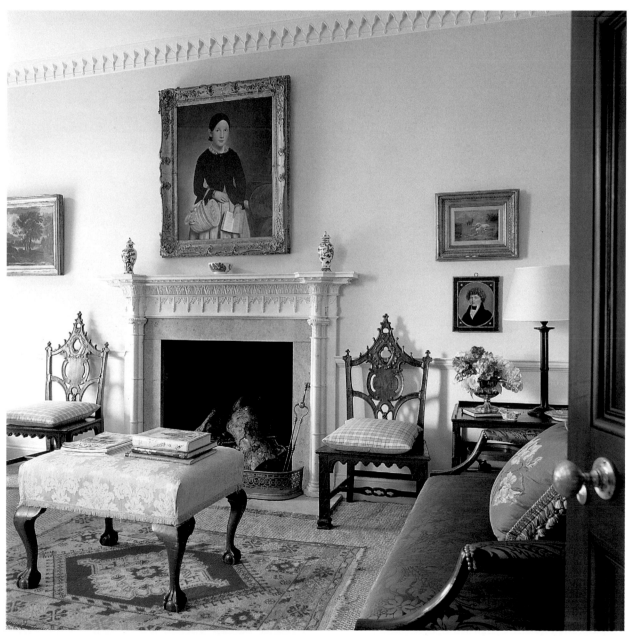

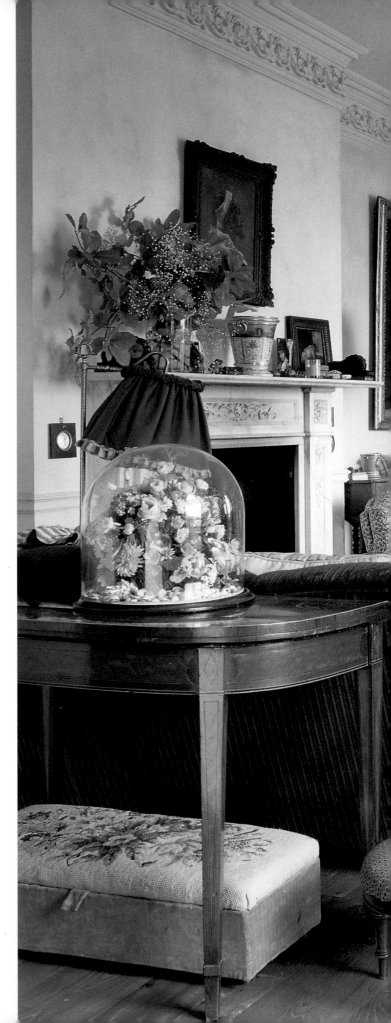

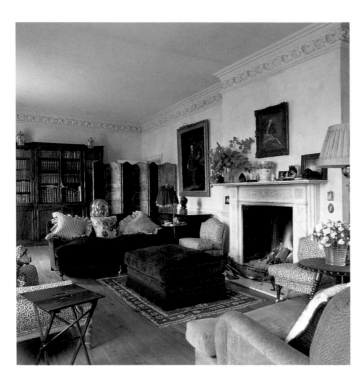

A recent addition

This drawing-room is a new addition to a small cottage on the estate at Uppark, the grand house built by the Earl of Tankerville in the late seventeenth century and now owned by the National Trust. The extended cottage (see, too, page 140) is lived in by Sophie Warre, whose family home was Uppark, and her husband Angus and children. She has decorated it in an elegantly revised country-house manner and included in her scheme a few cherished family possessions rescued from the private rooms at Uppark when it caught fire in 1989. Amongst these are exquisite watercolours painted in the eighteenth-century by one of Sophie Warre's female ancestors and a pair of Victorian brass lamps which belonged to Sophie Warre's grandmother. These and other antique pieces are intermingled with comfortable modern seating covered in unconventional fabrics, such as deep purple velvet. Bare floorboards also introduce a contemporary nuance. At the far end, a wide doorway leads to the dining-room (shown on page 126).

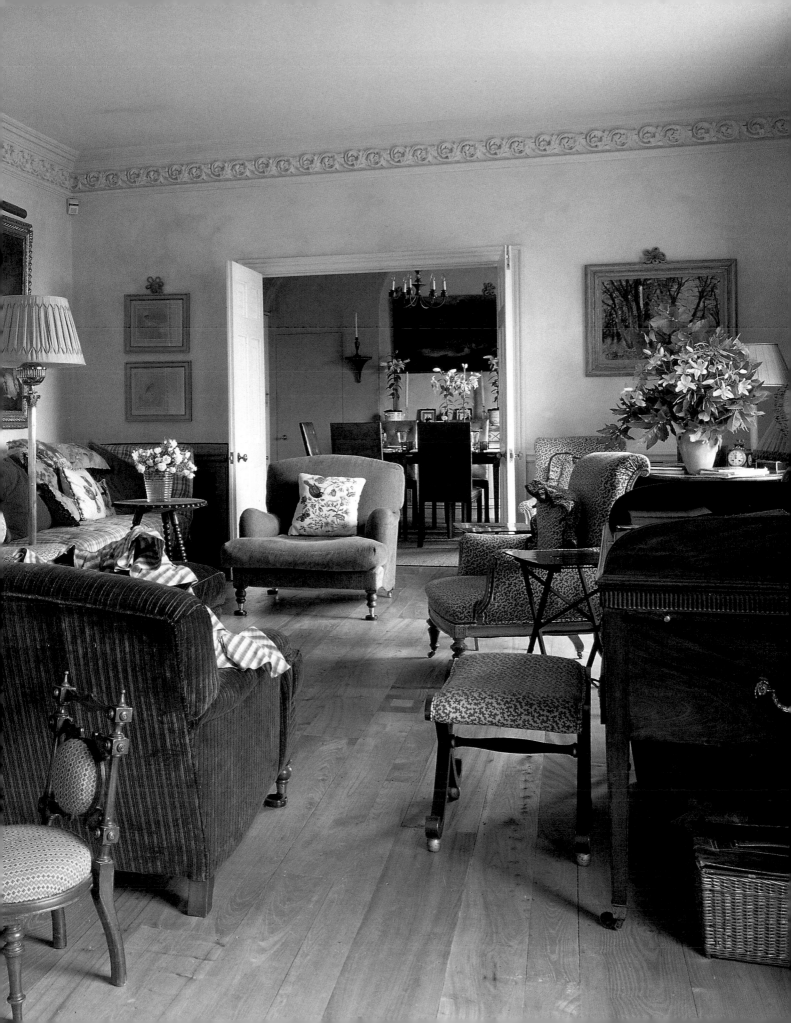

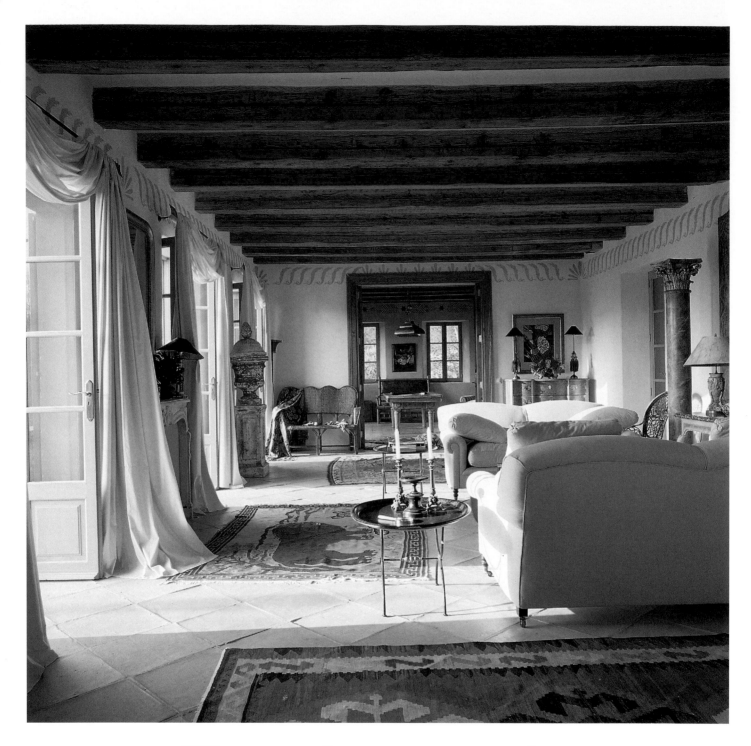

Where nothing is too perfect

Although the architecture is typical of the locality, the furnishings and accessories in Ursula Hubener's Majorcan sitting-room are gleaned from many sources, creating enjoyable elements of surprise. Corinthian columns, used ornamentally rather than structurally, frame a painted panel which hangs above a marble-topped table. In striking contrast with the classical style of the columns and the stone urn at left are the colourful rugs. Two sofas have fitted covers in plain cotton to match the curtains at the French windows. At the far end, a wide doorway leads to a billiards room. 'Nothing is too perfect here,' says the designer – and that is partly why the room is so successful. (See, too, page 108.)

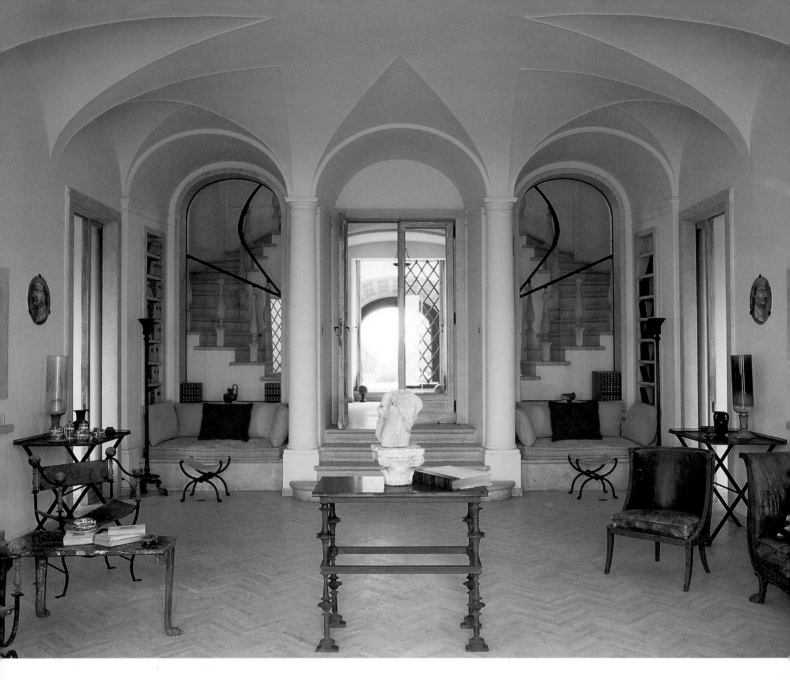

Classical concepts

Few rooms anywhere in the world could rival the geometry and panache of this grand salon in a villa on a lagoon south of Rome. It was built in 1960 by Nathalie Volpi, who had the artistic vision and courage to commission a house in the classical Greek and Palladian spirit on a site which, at the time, was in a remote and unfashionable area, and where the land was shifting sand. Her architect, Tommaso Buzzi, overcame all the technical problems and produced a scheme which matched his client's inspiration. Nathalie Volpi's son, Count Giovanni Volpi, now uses this spectacular house where the interior continues the fantasy of a building dating from an earlier civilization: uplighters are concealed inside bronze torchères; ashtrays are Roman incense burners; electric light-bulbs simulating candles flicker in iron candelabra. There is almost no colour in the room – except for the brilliant splashes of the red felt curtains. >

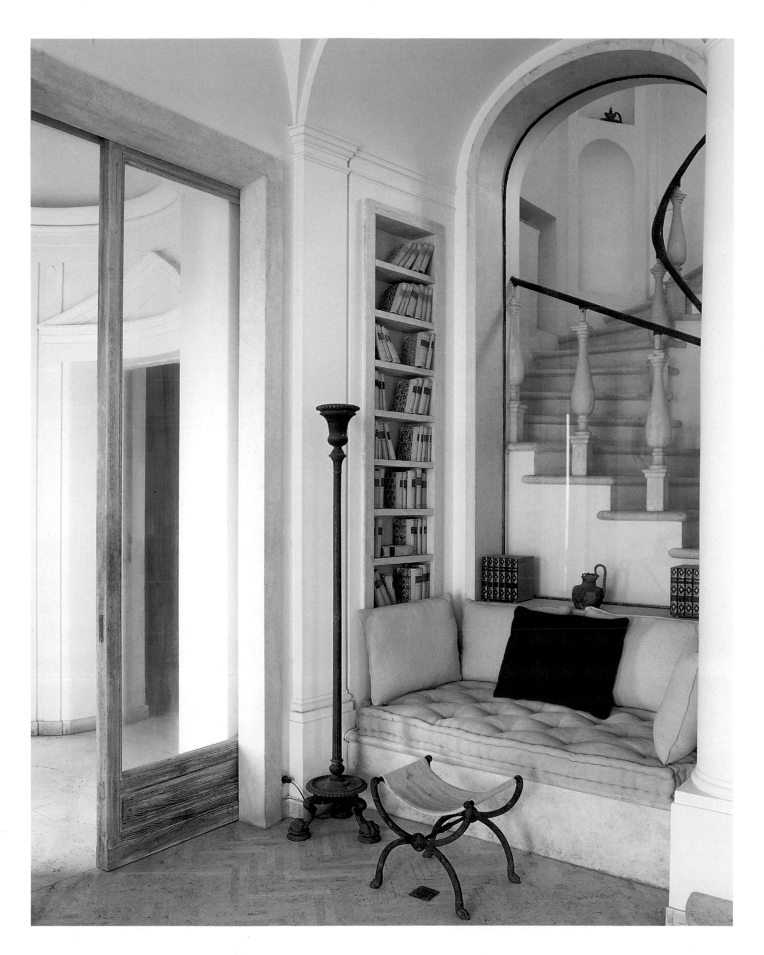

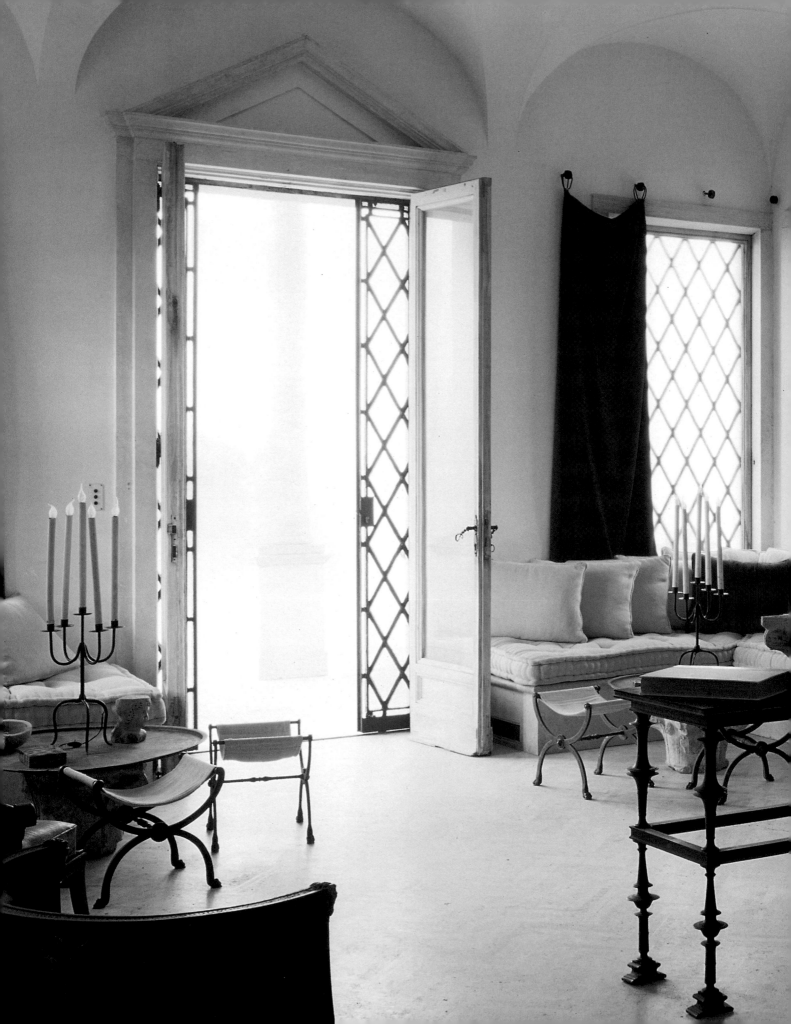

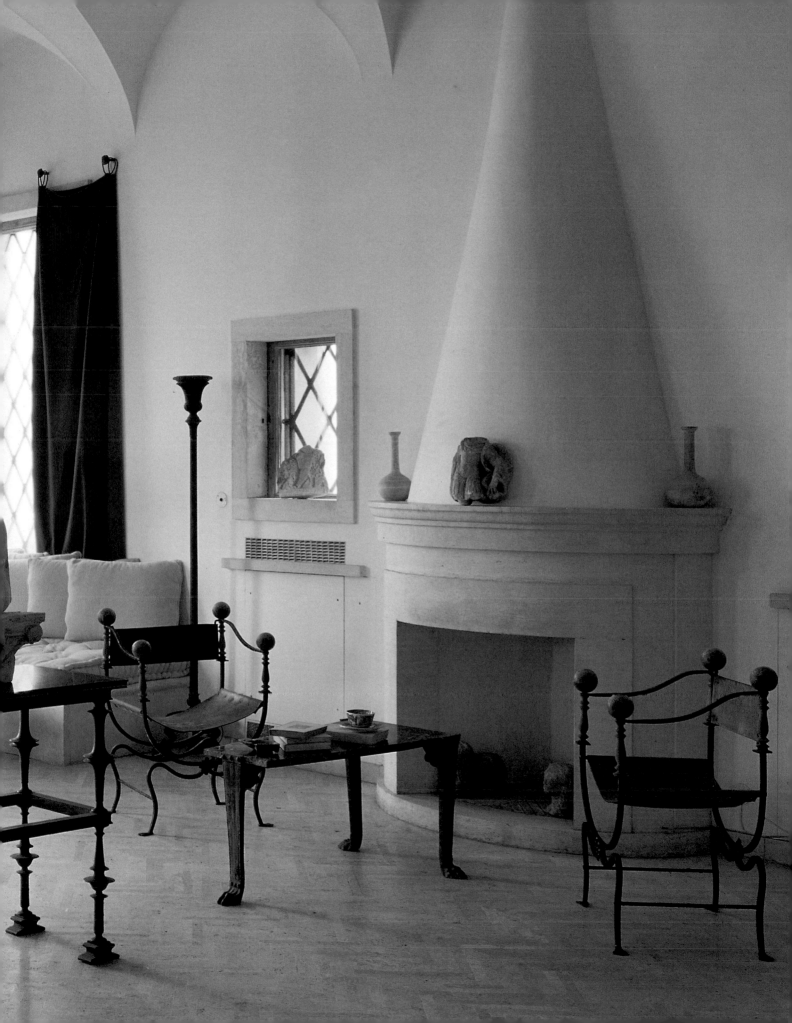

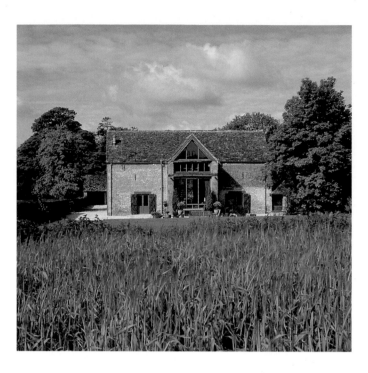

Open and exuberant

Emily Todhunter is the designer of so many fashionable interiors in New York and London that it comes as a surprise to find her spiritual home is the country. Her refuge from the urban life is a stone-built, Cotswold barn which had already been converted when she and her husband Manoli Olympitis found it. The main living-area is very open and, says Emily Todhunter, 'doesn't feel like an English country house at all. It's a lovely mix of ancient and modern, and it's difficult to place.' With its rugged textures, which include stone-flagged floors and exposed areas of stone wall, the interior of the barn has echoes of Provence and Tuscany. Vast windows allow light to flood in, especially in the central atrium area, which is seen on the following pages. Because of the nearness and visibility of the garden, Emily Todhunter has minimized the indoor-outdoor boundaries by using >

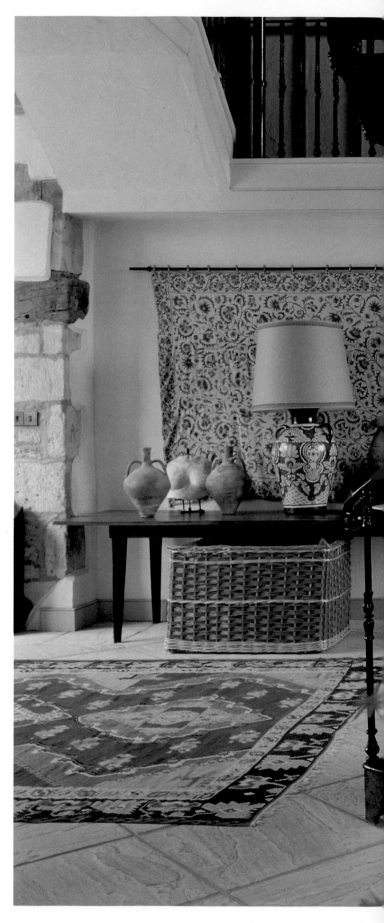

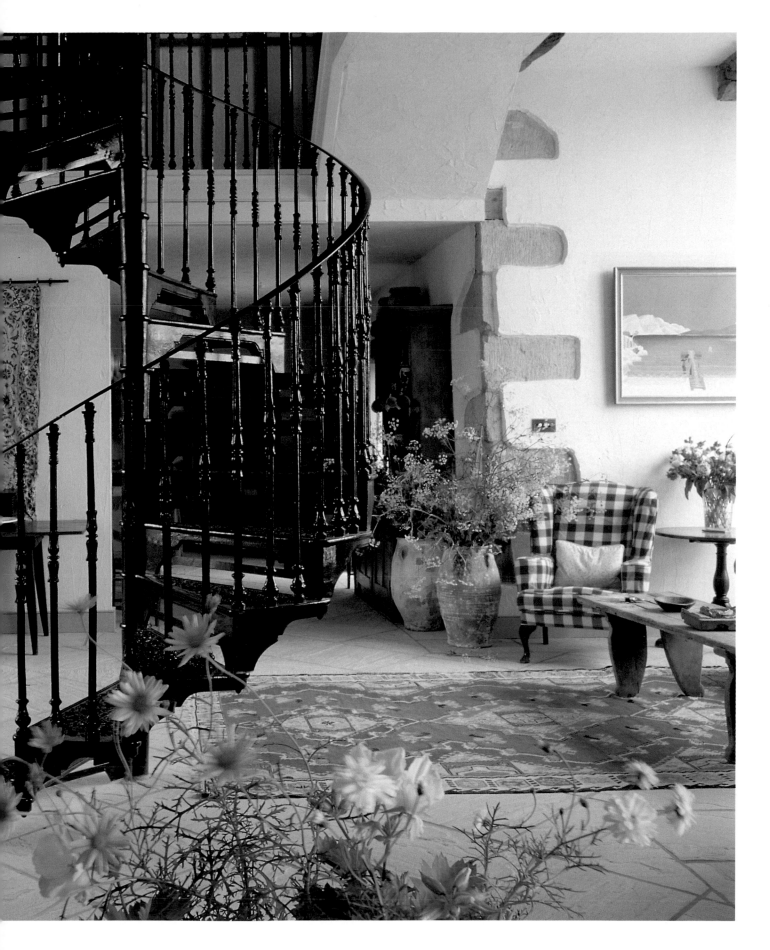

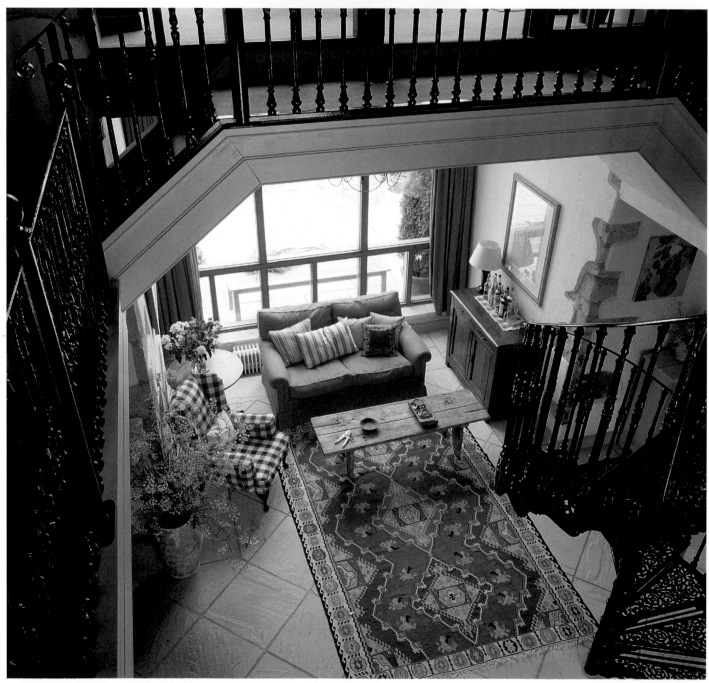

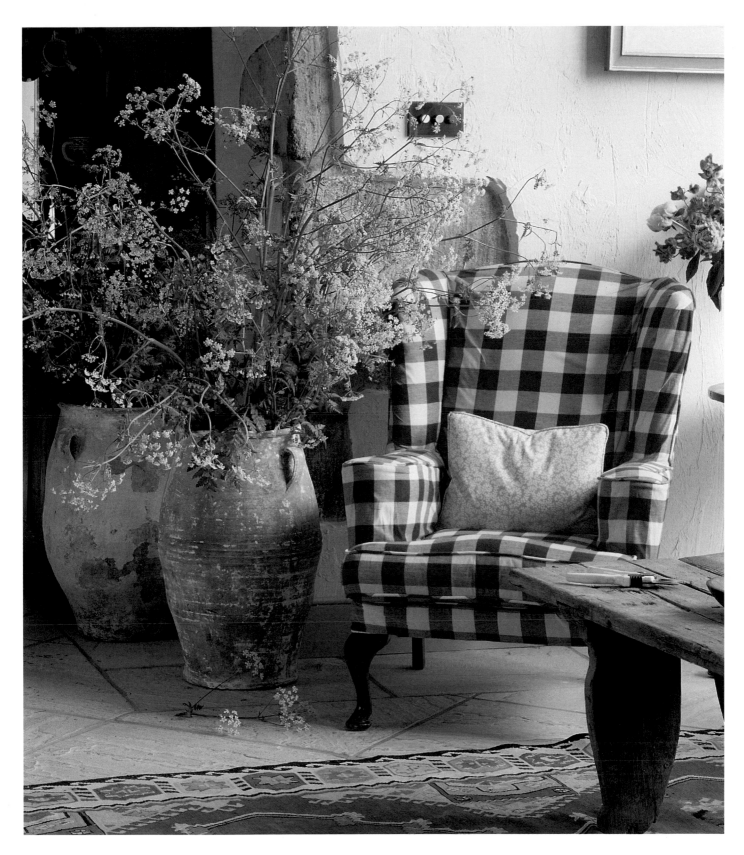

< garden-type furniture and big terracotta pots as part of the interior design. Tall amphorae filled with cow parsley are sculptural and striking. The colours and patterns of the textiles are informal and bold, incorporating lots of reds, big checks and exuberant kilims. Fabric hangings soften the walls, and light filters through the curtains of unlined cinnamon-coloured linen. 'It makes everything look gentler and less new if there is no lining,' advises the designer.

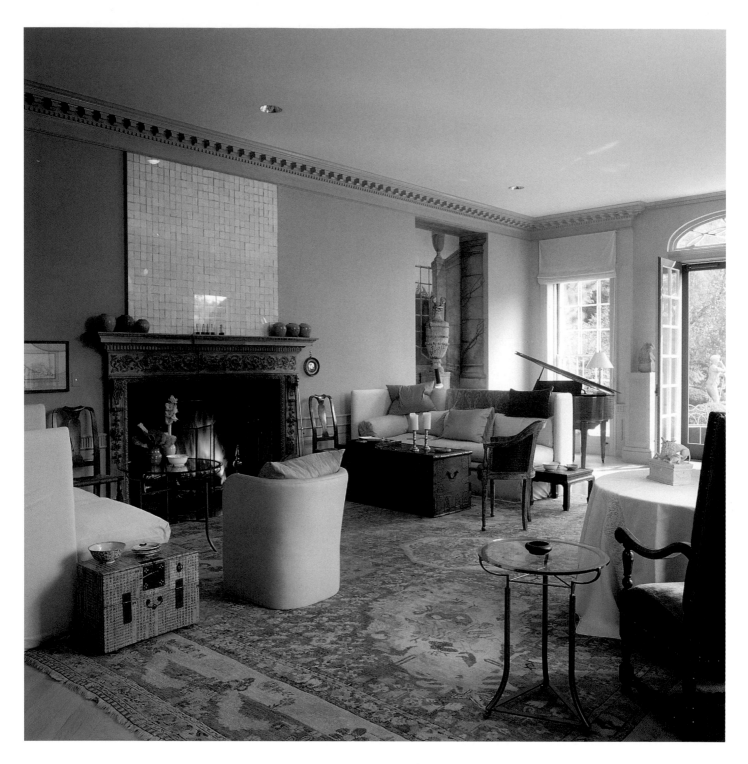

Proving a theory

This room proves the theory that combining old and new elements in interior decoration gives a far more interesting result than sticking rigidly to a single style or period. However, there is one important caveat: successful mixing demands a good eye and an open mind. New York designer John Saladino has just such vision and imagination. He does not eliminate the traditional feel of a period room yet imbues it with a new aesthetic by including modern

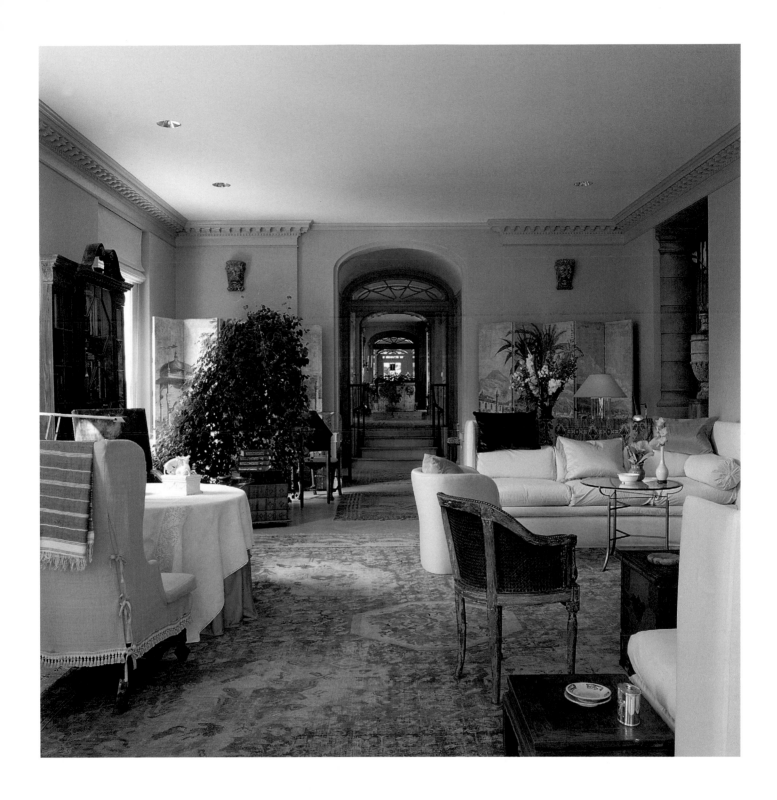

artworks and furniture of his own design. He has a knack for keeping everything in balance. In the drawing-room of his 1920s Palladian-style country home in Connecticut, the high-backed sofas (slip-covered in pale blue cotton) and glass tables were designed by him. In contrast, there are Queen Anne chairs and a pair of antique English pine cabinets. In front of one of the sofas is an old North African wedding chest, used here as an occasional table. Next to a >

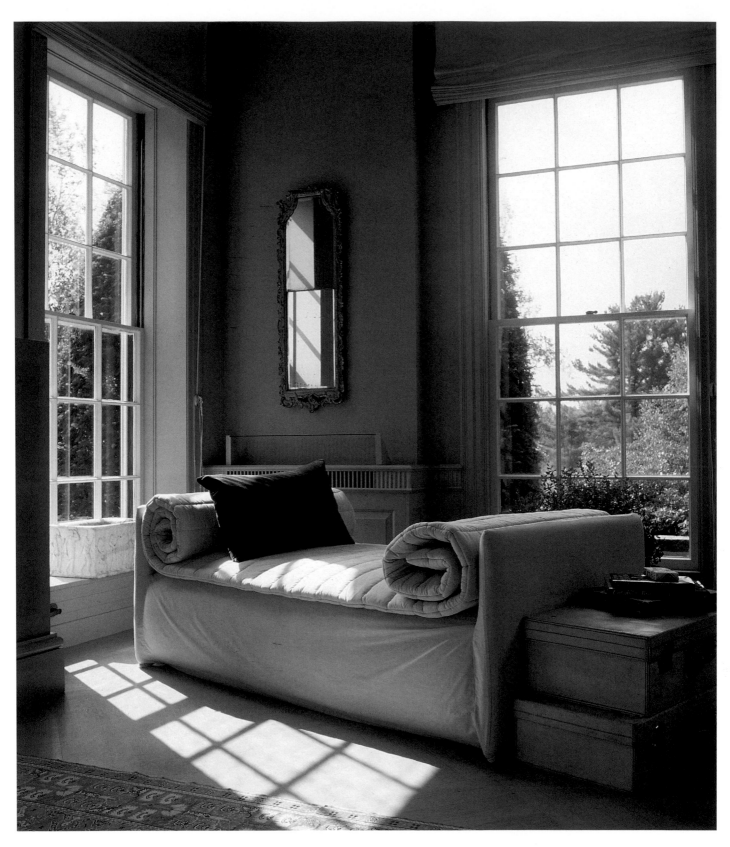

< daybed in another part of the room (shown above) bleached pigskin suitcases also act as an occasional table. The room is entered via an arched doorway from the hall (opposite, below) where a magnificent, architectural well-head contains luxuriant plants. The view from the hall to the drawing-room extends through to the garden and gravelled terraces where there are sheltered seating-areas. (Other views of the house are on pages 106 and 196.)

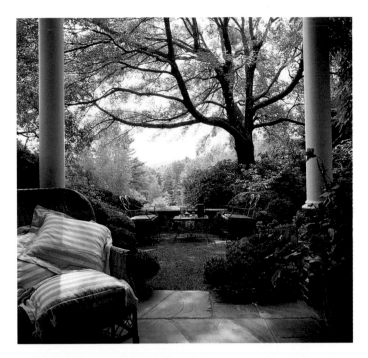

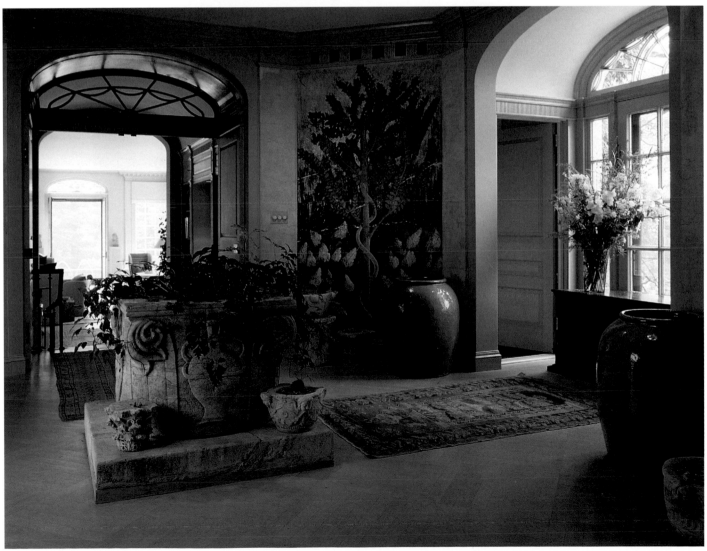

Refreshing colours

Part of the room seen here and on the following pages was originally a separate library. The dividing walls were removed to create a majestically proportioned space with an 8-metre (26-feet) ceiling height and a vast, round-headed window. In spite of the scale of the interior, the decoration and furnishing are refreshingly relaxed. A background colour scheme of palest blue-grey and ivory complements the abundant natural light and leafy views through the double-storey glazing. Against the delicate palette, accents of bright red spring out from the patterned fabrics, trefoil ottoman and pleated lampshades. The effect is uplifting and inviting

all year round, and in winter the comfortably furnished area in front of the fireplace is the gravitational point for sitting and reading. The library area, opposite the fireplace, has a tall bookcase and free-standing steps to reach the uppermost shelves. The pictures have an eighteenth– and early-nineteenth-century character – though they are not all of that period. Some are real – the engravings of topographical studies of Egypt commissioned by Napoleon, for instance – but others are not. The two grand-looking oil paintings to either side of the great, arched window were copied from an auction catalogue. Interior designer: Charlotte Moss. >

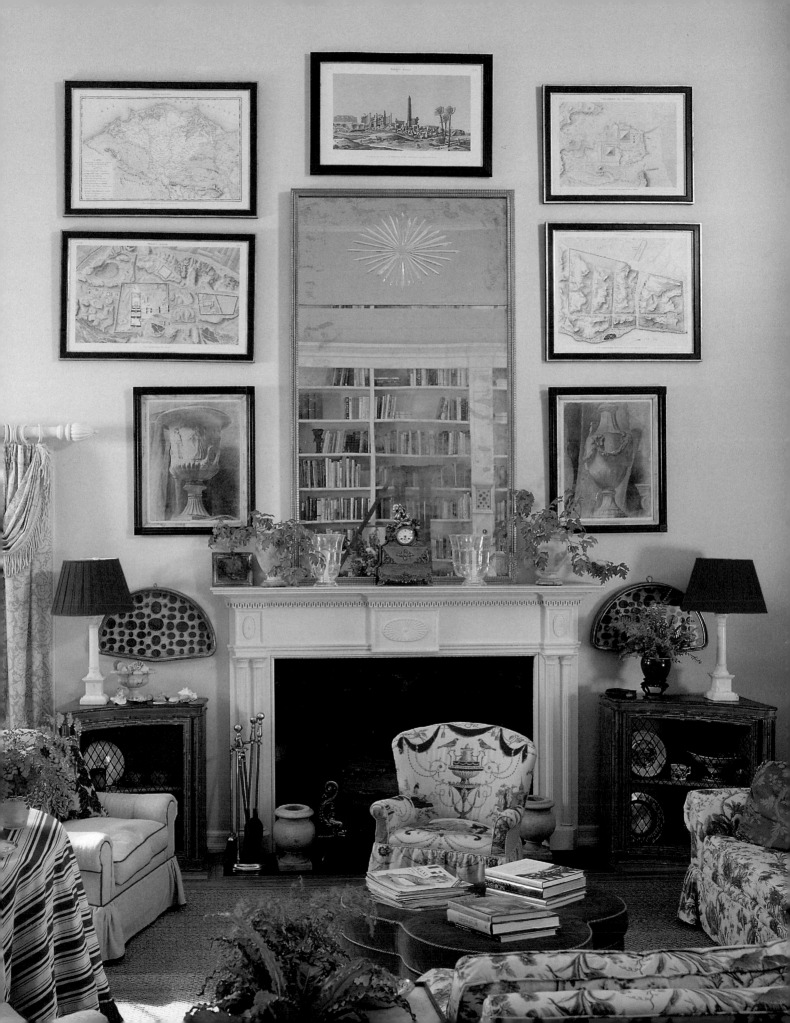

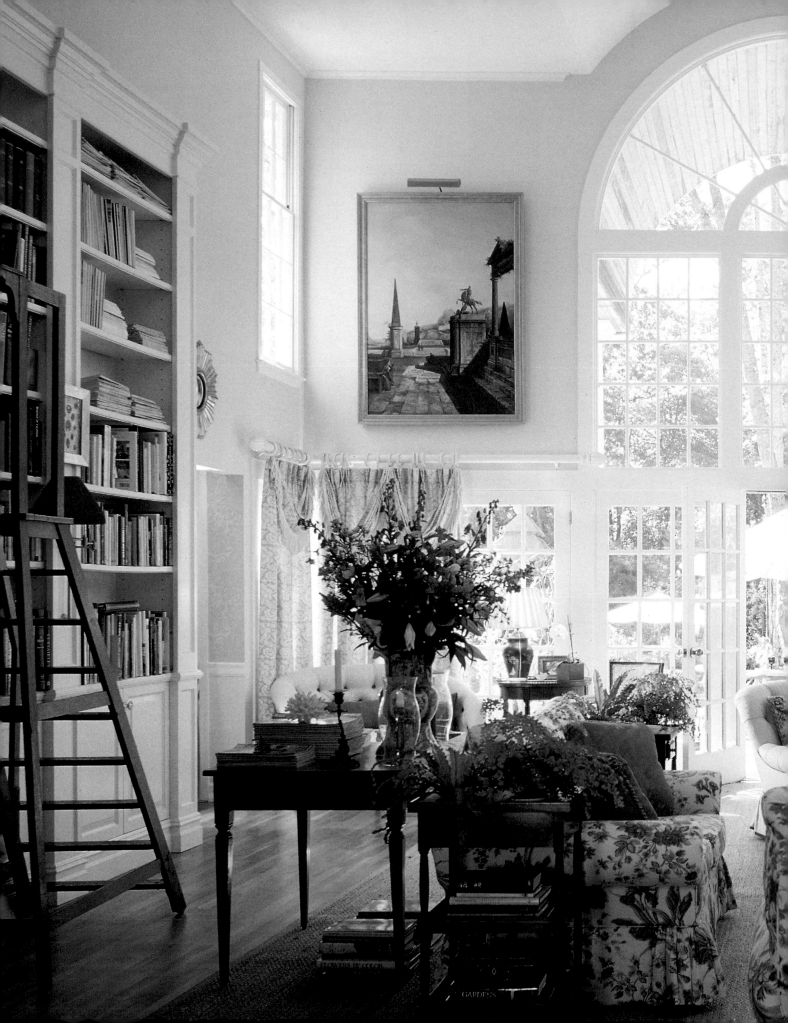

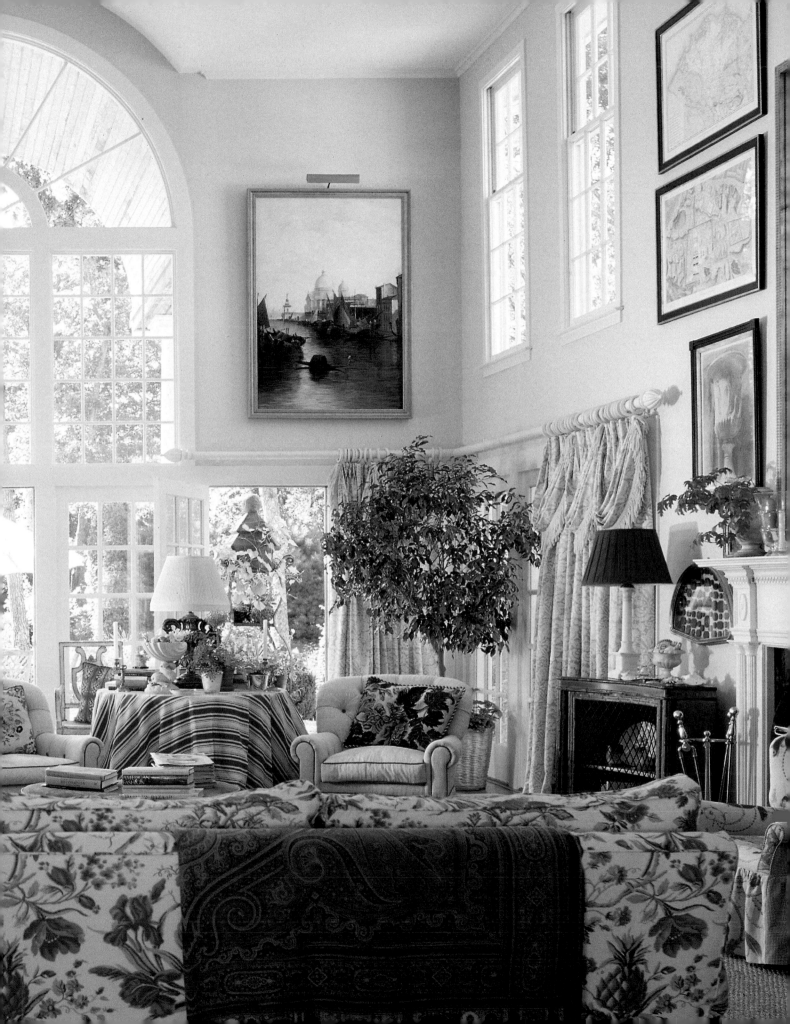

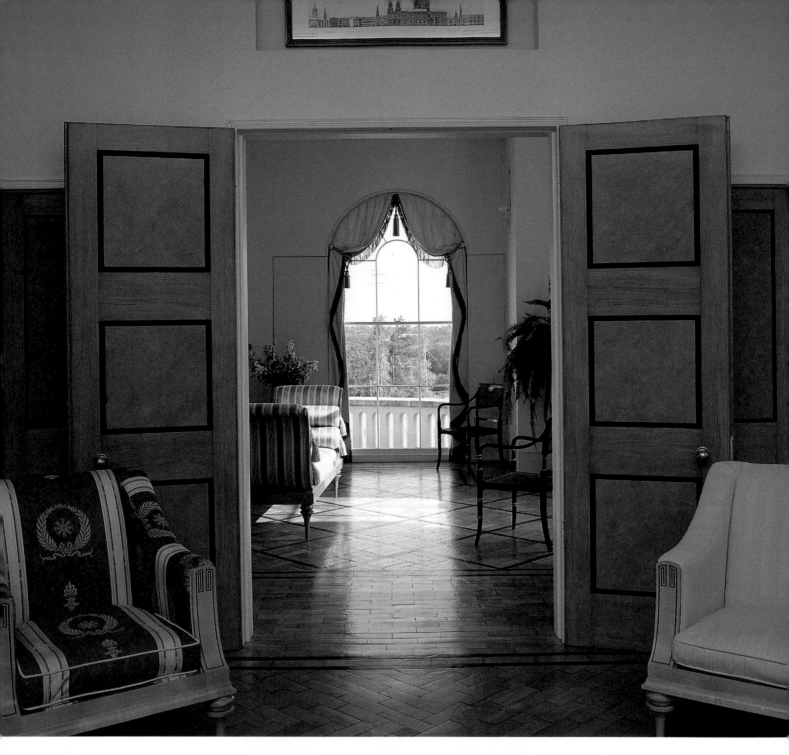

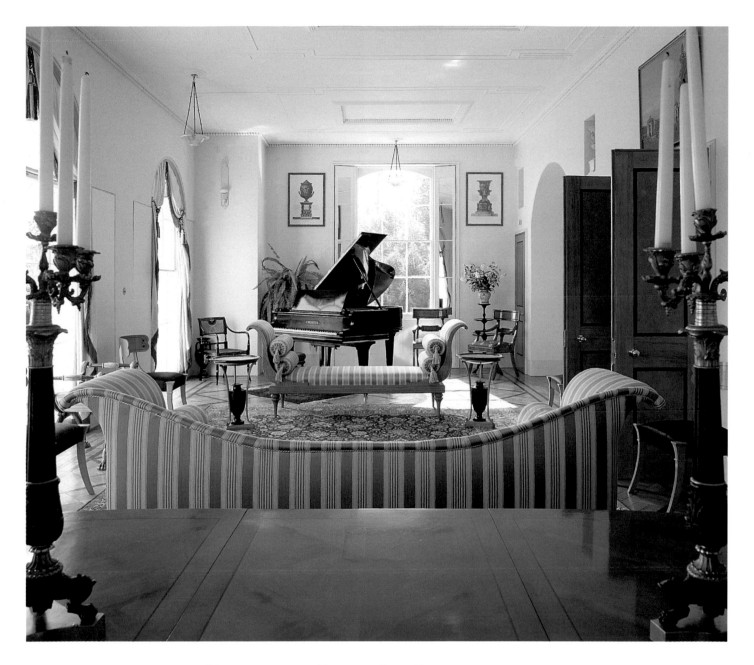

Designed with distinction

Very few architect-designed houses have been built in Britain during the past fifty years – and of those that have, very few have much distinction. One architect who has shown that it is possible to design a brand-new house which is out of the ordinary yet follows in the great English tradition of country-house building is John Simpson. The house he designed for his parents, John and Lydia Simpson, is set in Sussex farmland and is characterized by a pared-down form of classicism. 'The idea was not to build a grand country house, but something more like a traditional gentleman's residence,' says the architect. From a practical viewpoint, the main consideration in the design brief was ease of maintenance. Aesthetically, the objective was 'to

invest the house with grace and loftiness, and to give the impression that it is larger than it is'. John Simpson has achieved the illusion of space by creating a series of vistas within the interior. Typically, there is a long view (seen opposite) extending from the sitting-room through a double doorway to the drawing-room and then on through an arched window to a terrace. Meticulous attention to detail is evident throughout: note, for instance, the ceiling mouldings which are derived from designs by the early-nineteenth-century architect Sir John Soane. At night, mirrored shutters are opened out from concealed boxes flush with the walls. Much of the furniture, including the pale-wood daybed, was designed by John Simpson. (See, too, page 222.)

Tropical white on an island

For a house in the tropics, no colour scheme can out-do white. In this room on the Caribbean island of St Lucia, even the pine telegraph poles bearing the dramatic span of the roof have been limed to give a whitened effect. Apart from its obviously cool, pristine appearance, white is an excellent harmoniser, bringing together 'hard' surfaces such as masonry steps, and 'soft' surfaces such as sofas and chairs. It also looks as appropriate for plain cotton upholstery as for painted, carved furniture. Perched >

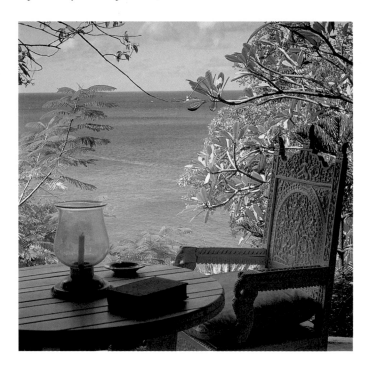

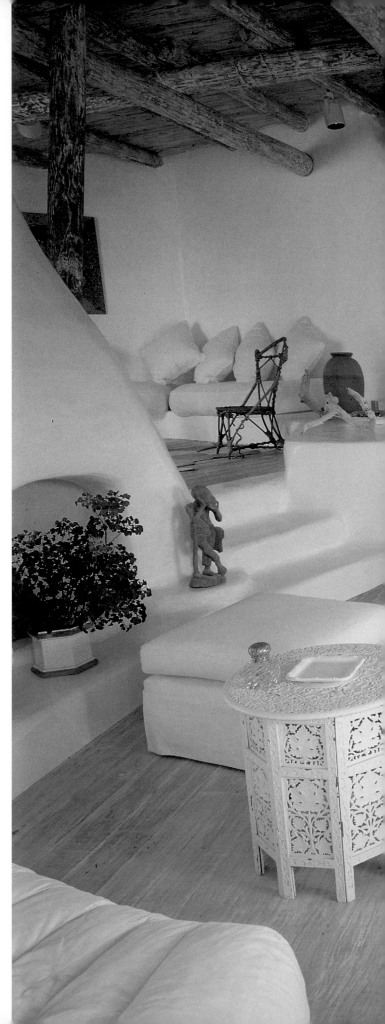

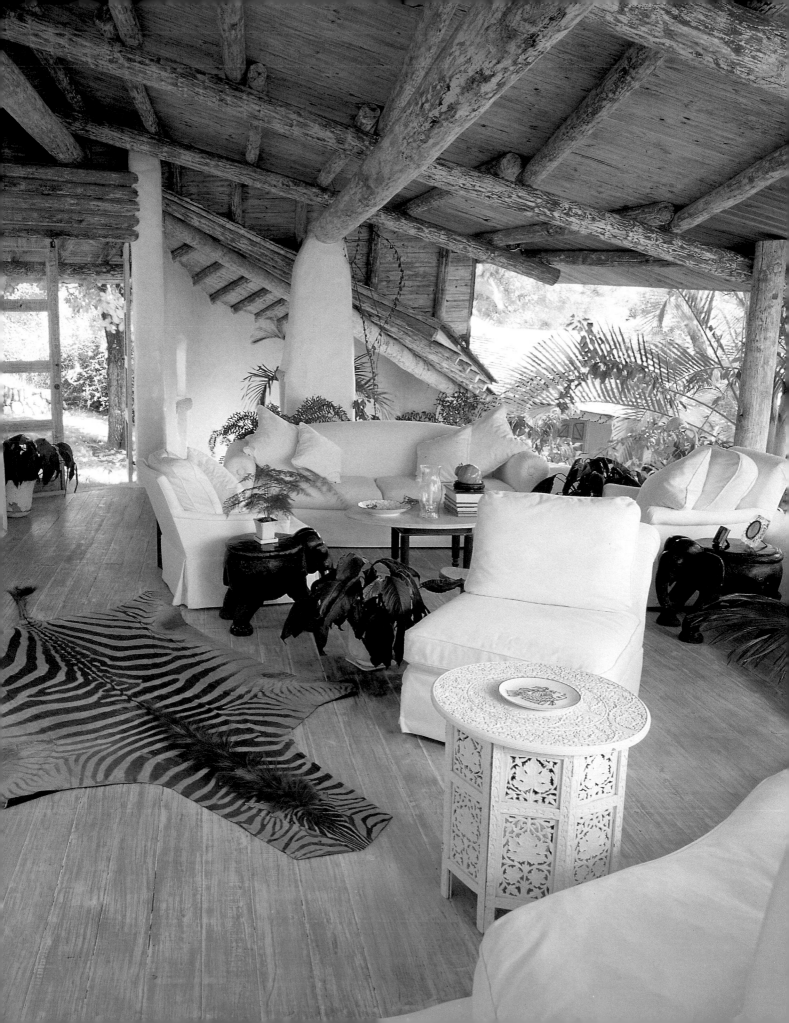

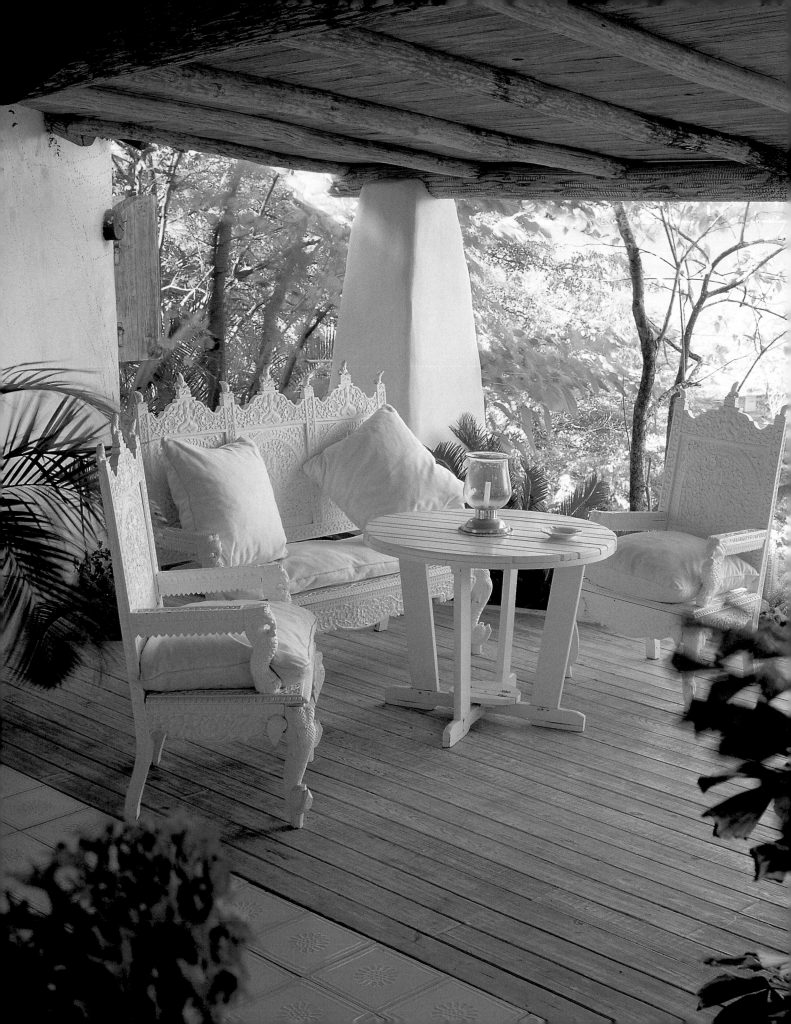

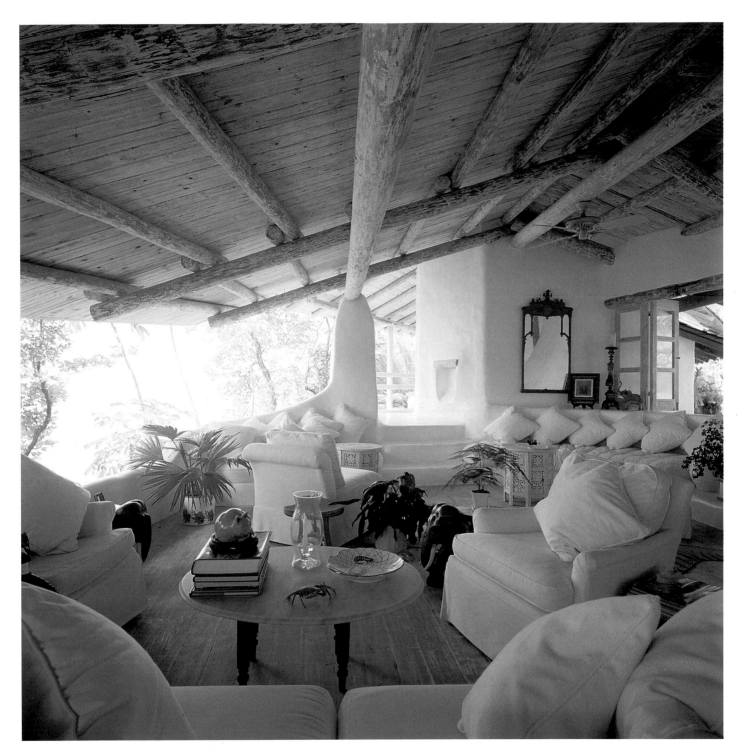

< vertiginously on a wooded cliff, the house closely follows the contours of the land and is edged with terraces which open uninterruptedly off the main rooms. The living-area is set out on two levels and has a series of seating groups, some furnished with free-standing chairs, others with cushioned banquettes. The raised section of the room overlooks the garden and hills; the lower section faces the sea. Taking full advantage of the magnificent views the design was the result of a three-way collaboration between Marc Johnson, Ian Morrison and Judy Johnson (see, too, page 146.)

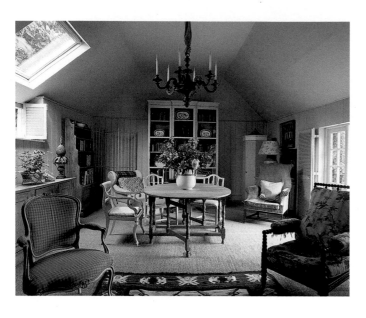

A sitting-room in a studio

Charles Beresford-Clark's house in Sussex was built in 1910 in a style which was not especially charming but, with gentle tweaking, has taken on the more pleasing air of a modest 1840s English rectory. Adjacent to the main house (see page 100) a free-standing, artist's studio had been built, also in the early years of this century, and this was one of the great attractions for Charles Beresford-Clark: 'I liked the cottagey feel of the main house, but I still felt a need for at least one good-sized room.' The studio is now the large sitting-room shown here. In it are grouped several family pieces, including a set of country chairs painted by Charles Beresford-Clark's grandmother in the fashion of the Thirties. The walls are lined with tongue-and-groove boarding which has been painted umber-white. A tall bookcase broaches the top of the boarding and provides an important vertical feature within the high space.

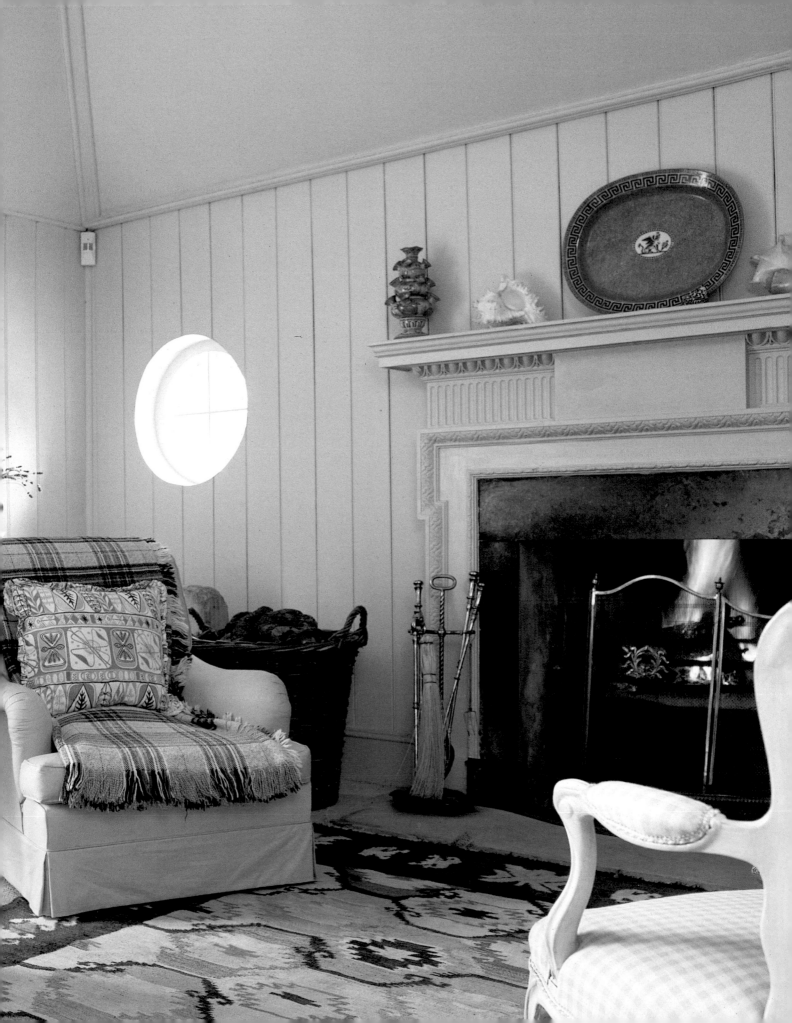

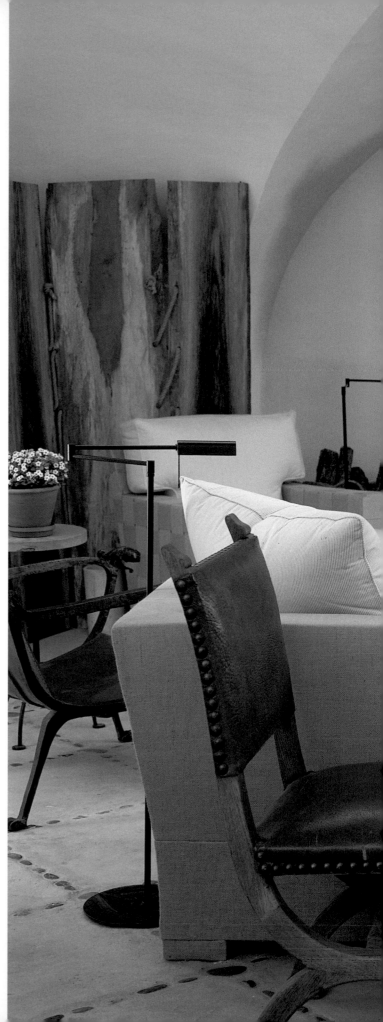

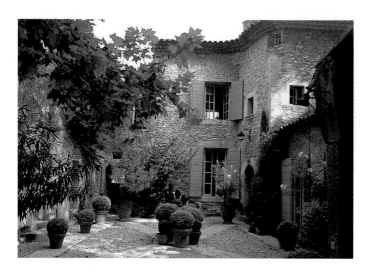

A natural progression

French designer François Catroux has an international renown for devising sophisticated and original interiors. His work has encompassed a variety of looks, progressing from the bright colours of the late Sixties to the cooler, more tailored manner of the Seventies, and then on to a chic neoclassicism in the Eighties. Recently, his style has tended towards more informality, and this particularly suits the interior of his own holiday home in a fourteenth-century farmhouse in Provence. In the stone vaulted living-room seen here, he has created a harmony with the natural textures of stone, wood, iron and leather. He has also played up the almost medieval character of the room's structure by laying an unusual floor of polished concrete, inset with >

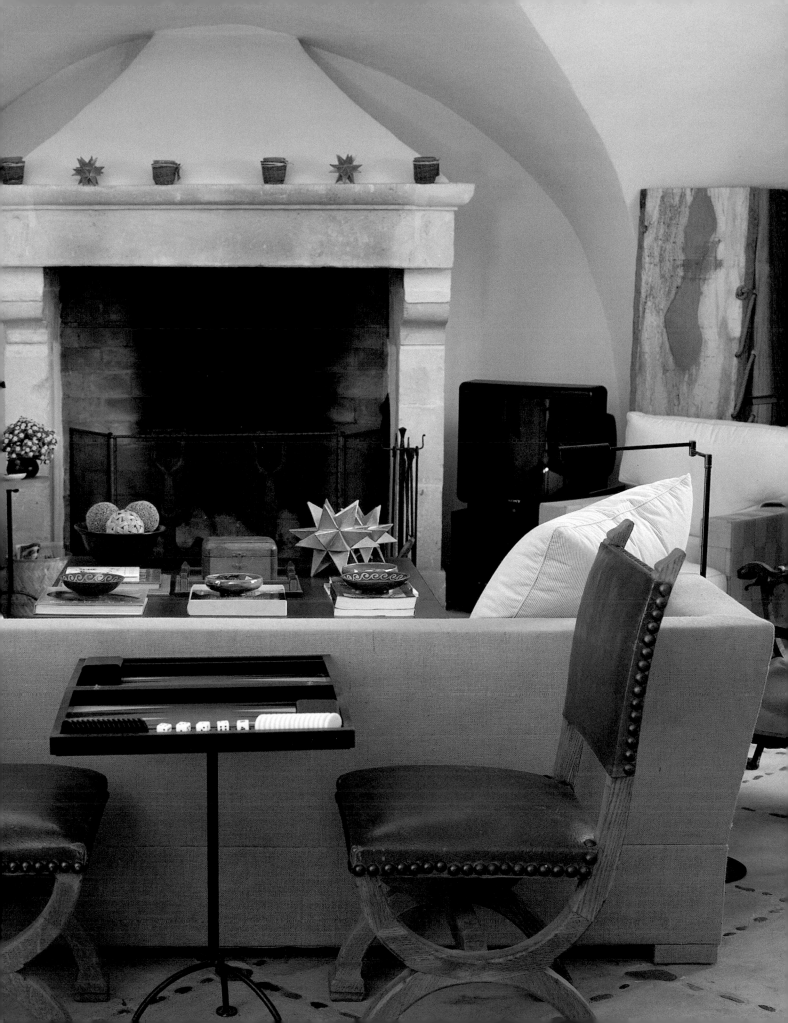

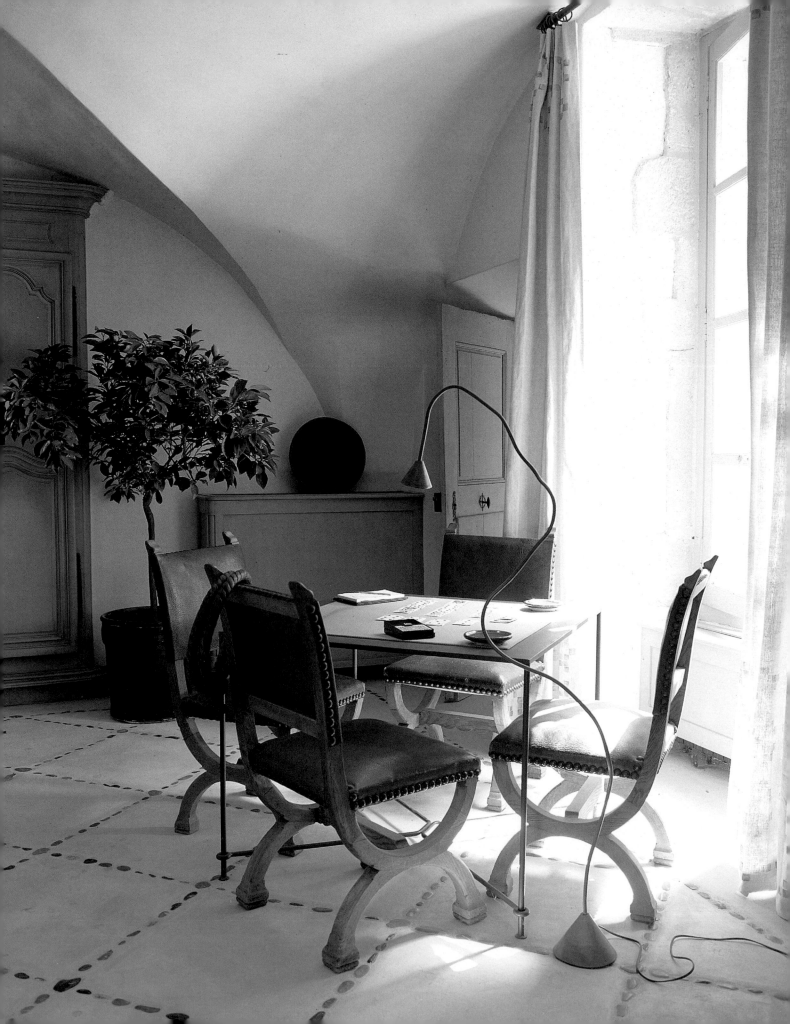

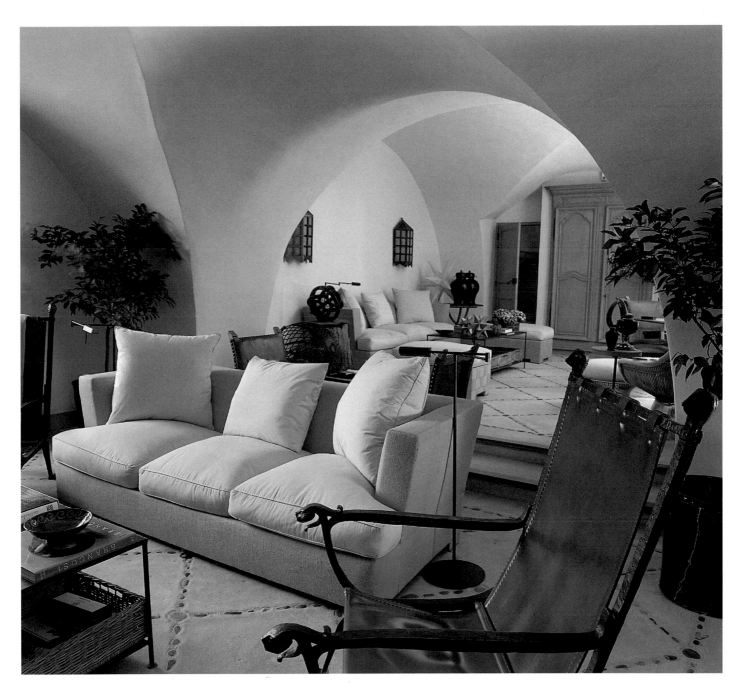

< local pebbles. But if François Catroux enjoys creating interesting rooms, he does not lose sight of the fact that they must be practical and comfortable for today. Here, he unapologetically includes a large television, positioned so that it can be enjoyed – along with the warmth from the fire in winter – from the sofa. To either side of the chimneypiece is a handsome screen with each panel made from a single plank of wood. From the television area, shallow steps lead up to another sitting-area, shown above and opposite, with a games table in front of the window. (See, too, page 202.)

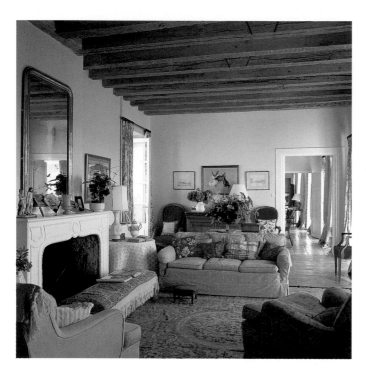

A love of fabrics

Compared with their English counterparts, drawing-rooms in France often look stiff and constrained, mainly because the seating tends to be upright and placed very precisely. The French room seen here has none of that strait-laced bias. It is totally relaxed and radiates comfort at every point. The explanations for its inviting character are found in the facts that its owners, Lord and Lady Ashburton, are English, and Sally Ashburton has freely indulged her passion for old textiles. There is a medley of patterns, but they achieve an accord because they have been chosen by someone with a coherent eye and a real understanding of fabrics.

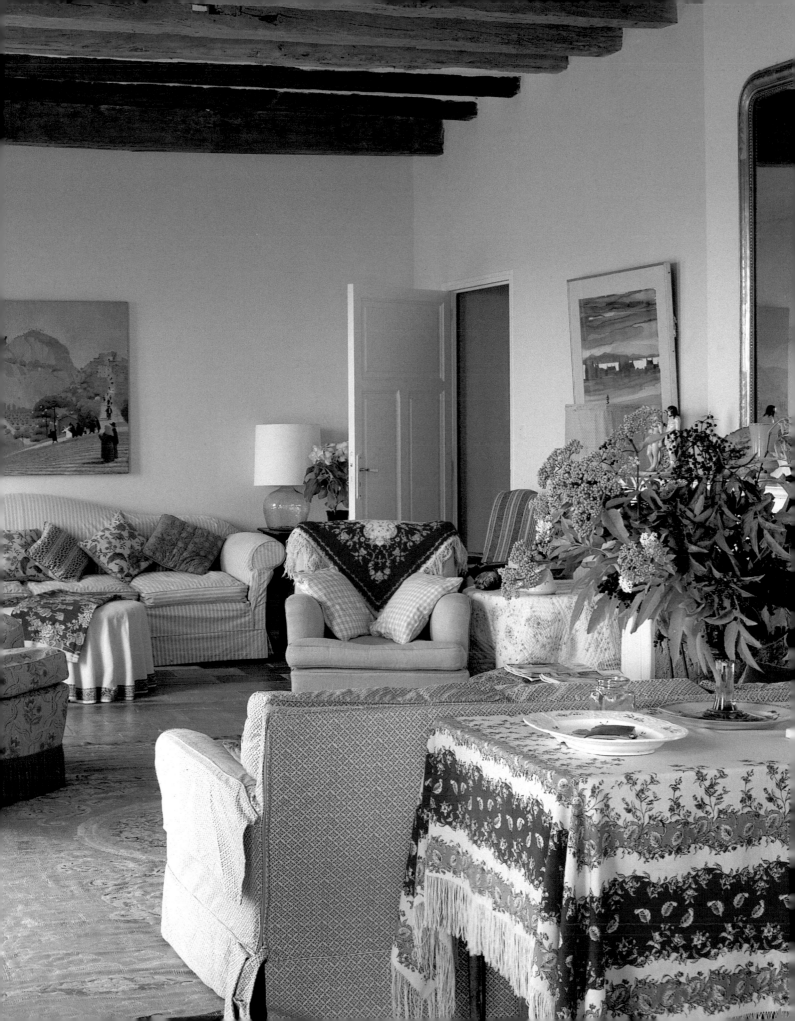

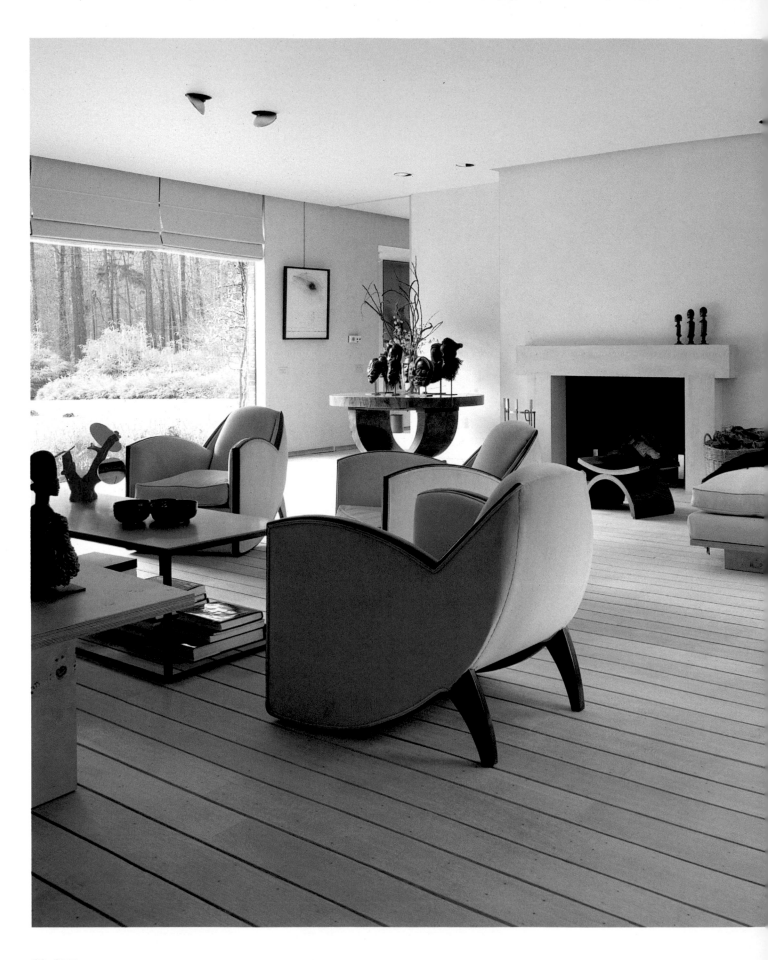

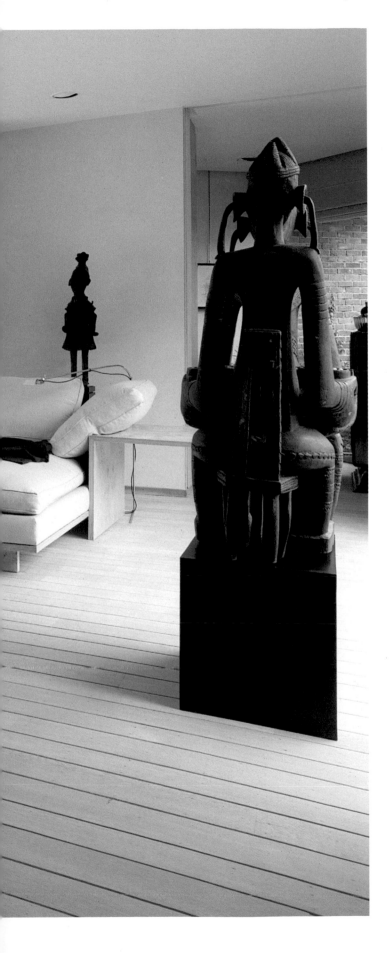

From the Thirties to the Nineties

'Our previous homes were modern, but here we decided to see what the 1930s could offer the 1990s.' That was the decision made by Stany Janssen and Jan Verschuere when they moved into a modern house in Belgium designed by Marc Corbiau. They were confident that Art Deco furniture would suit the house and, equally relevantly, that it would blend well with their collection of African art. Claire Bataille and Paul Ibens were commissioned to help with the design of the interior, which has the advantage of large, south-facing windows giving extensive garden views and lots of >

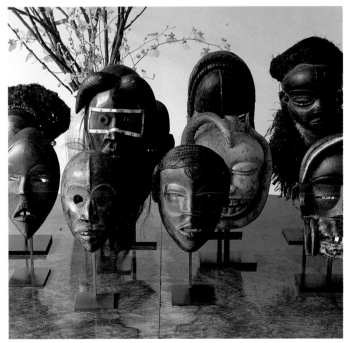

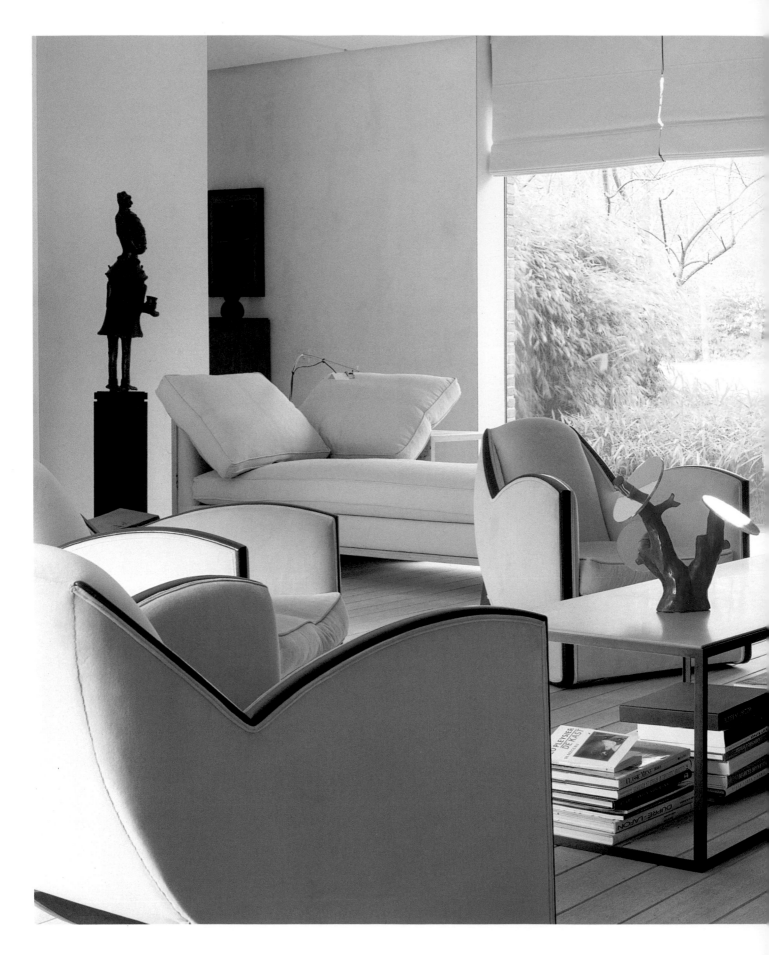

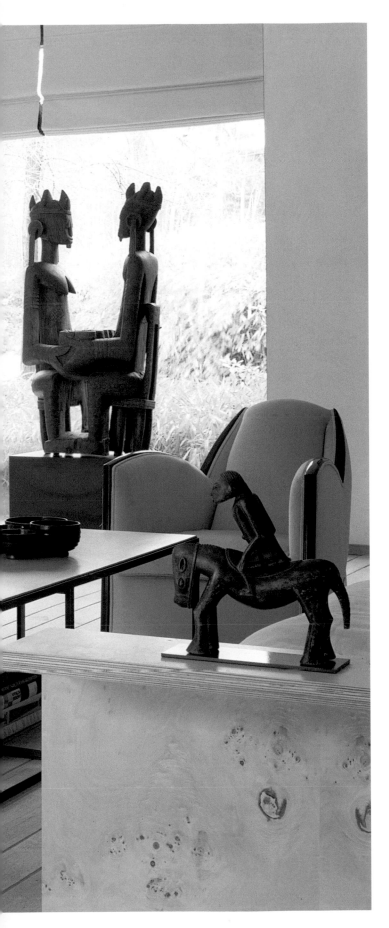

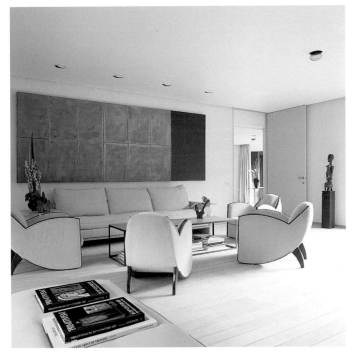

< natural light. The theme in the main living-room took off to a flying start when the interior designers found a fine quartet of Art Deco chairs. These are augmented by a Thirties walnut table which displays a group of African masks. The birchwood daybed was designed by Claire Bataille and Paul Ibens. Strategically placed in front of the panoramic window, the African 'mirror' sculpture appears to be set in a landscape. In a totally contrasting style – but echoing the room's neutral colour scheme – is Michael Mouffe's 'Monochrome' painting above the sofa.

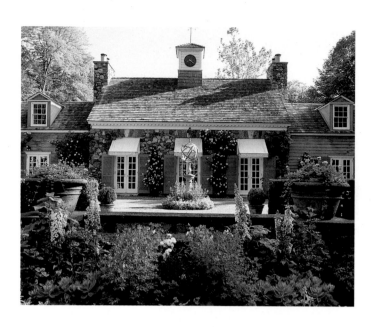

A simple plan for a single space

Ten years ago when architect-cum-interior-designer David Easton built his home in New York State, he worked to a very simple plan. Having observed at parties that, whatever the alternatives, people invariably congregate in one room, he felt that a single, multi-purpose living-area was a better solution than two or three smaller rooms, each with a designated use. A sizable space with generous windows, his sitting-room, which is also used as a dining-room and reading-room, is filled with natural light enhanced by pale walls and a ceiling that is open to the rafters. A fireplace at each end gives a focus to the room's different functions: sitting and reading take place at the one end, and working and dining at the other. Mexican floor tiles and limed oak beams create a rural framework for the furniture and decorative objects which reflect years of collecting. The way in which the objects are arranged is a nice blend of the haphazard and the carefully ordered. Especially attractive are the recesses for the Delftware pots above the doors.

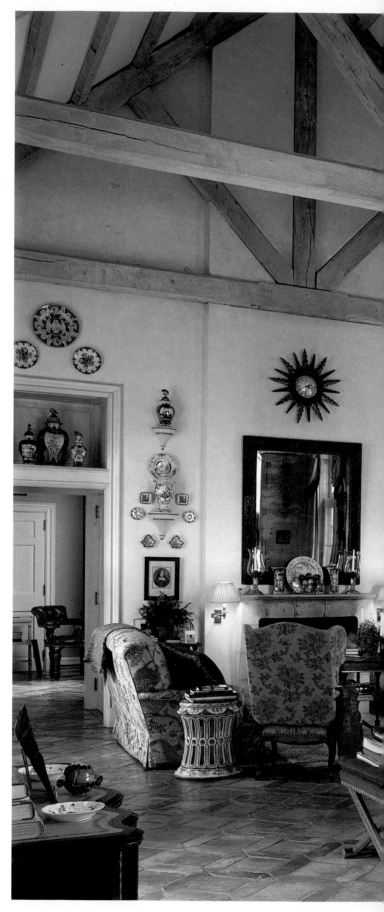

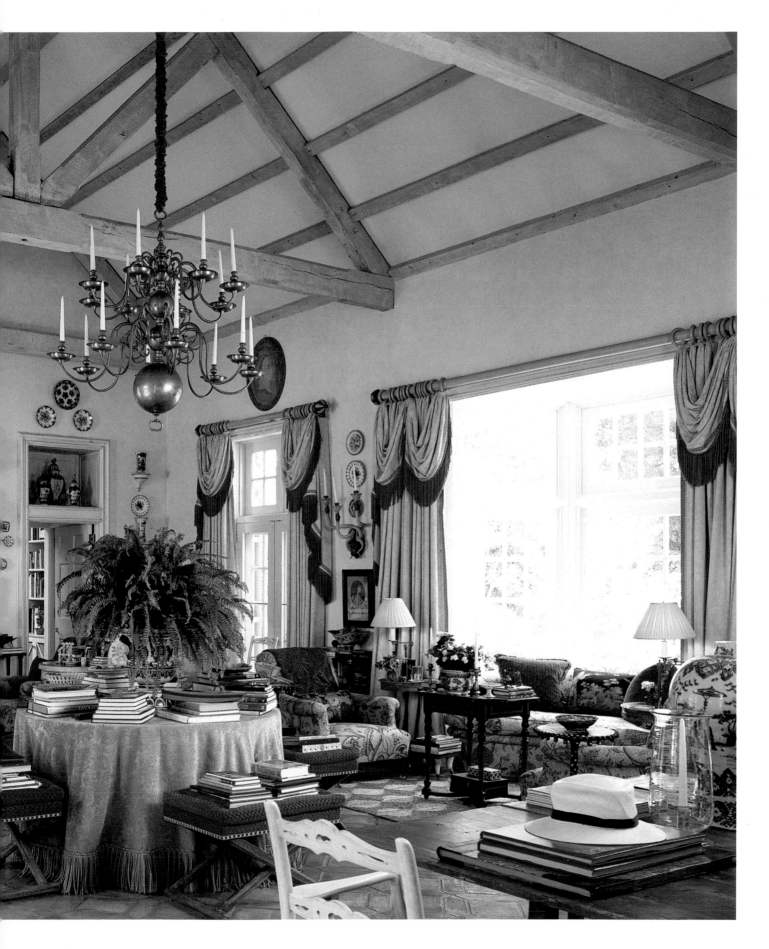

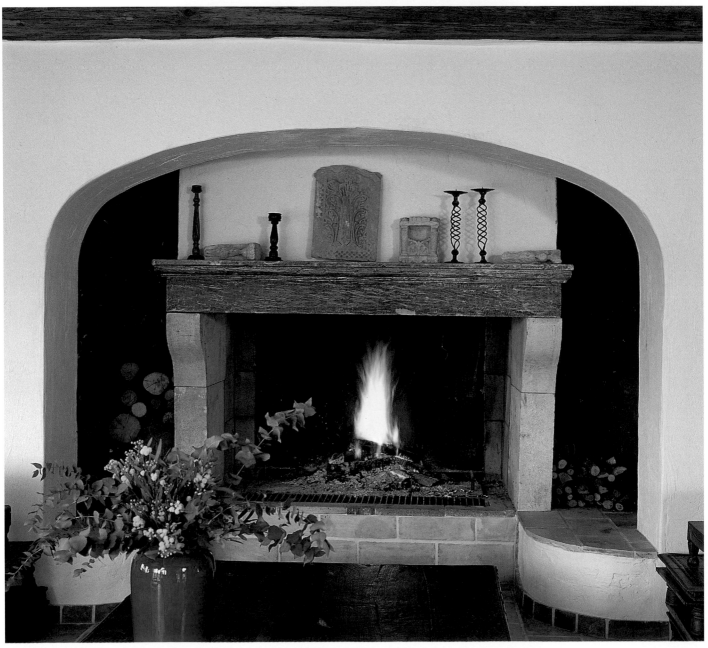

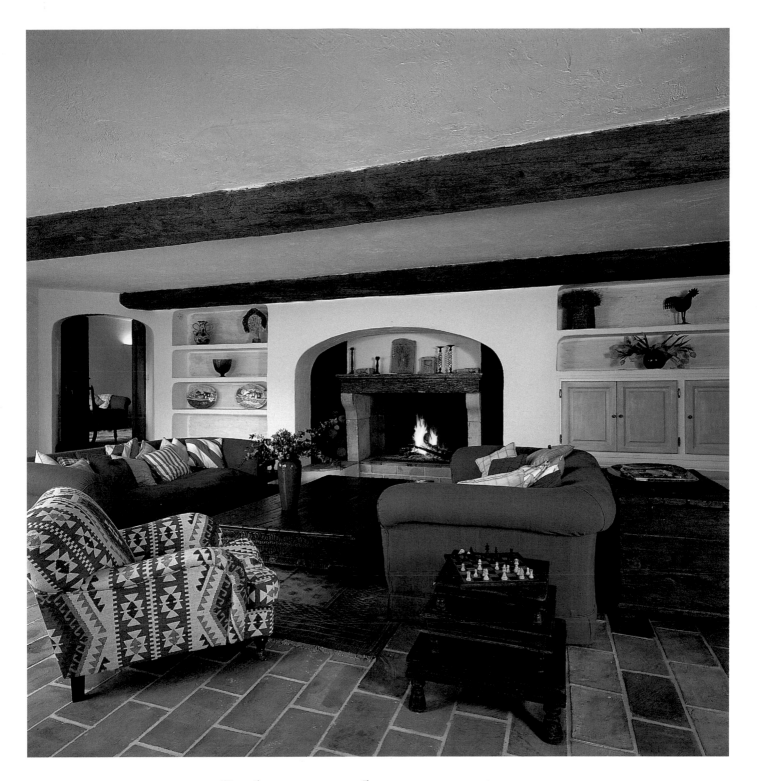

Substantial proportions

The character of this sitting-room in Provence is robust: the construction is solid and, though new, it has the same ruggedness and earthiness as the traditional buildings of the neighbourhood. The room has as a central feature an eighteenth-century fire surround recessed within an arch. Two Chesterfield sofas are placed at right-angles to the fire and scattered with boldly patterned cushions. Timber tables and a chest correspond with the substantial nature of the architecture, and the pattern of the kilim upholstery on the armchair brings together all the colours in the room. The house was designed by Robert Dallas for Barry and Victoria Myers. (See, too, page 142.)

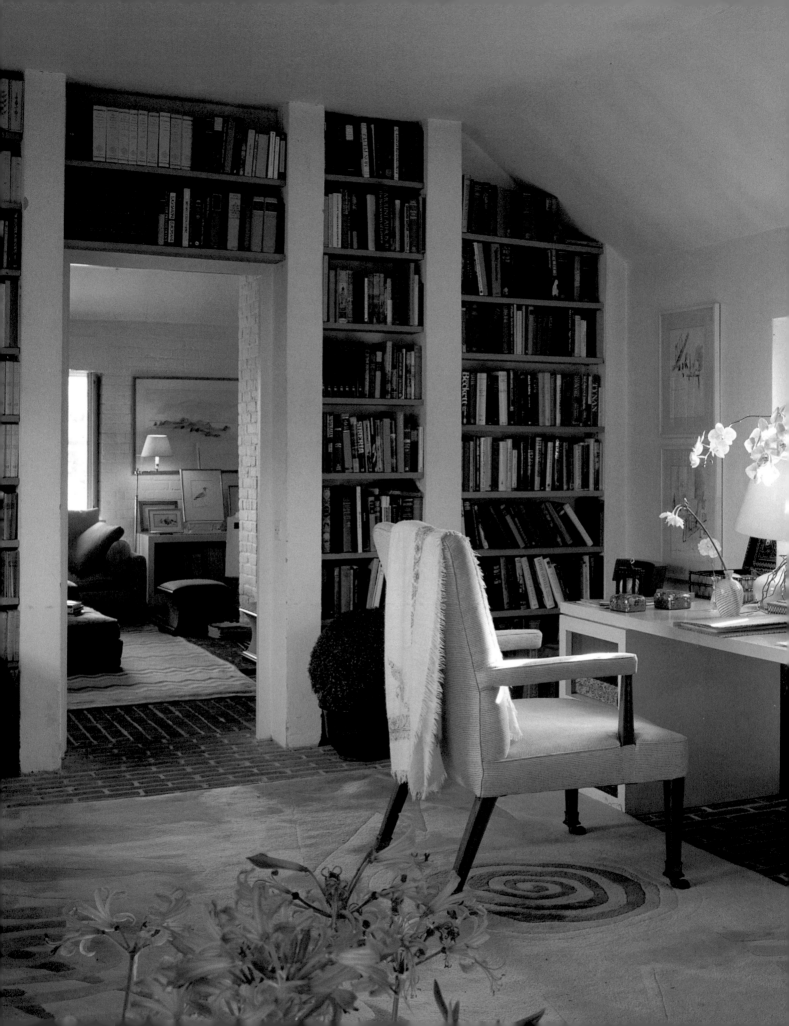

LIBRARIES AND STUDIES

Changes in work patterns and new communications technology have enabled many people to earn their living while based at home. The function of an office in this context is clearly defined, but even people who commute to work every day often choose to have a small study or library to which they can retreat in the evenings and at weekends, either to catch up on domestic paperwork or to read in a peaceful atmosphere. If space is insufficient for a separate book-room, a rational option is to combine a library with an under-used dining-room – as in the French interior overleaf. This room exemplifies a country look which exploits contrast effectively: the cultivated appearance of the books is a foil for the rusticity of the antler chandelier. The rooms on pages 98-99 are much more modern and airy, taking advantage of the natural light from the large windows.

This study-cum-library is in a one-time cowshed – hence the basic but interestingly-shaped architecture. John Stefanidis's conversion of the building pays deference to the original farm character by using chalky-white paint on the walls and bare bricks on the floor. In this type of setting, many decorators would have played safe with typically 'country' furniture but, skilfully, John Stefanidis has taken a more original route by introducing classic, contemporary pieces.

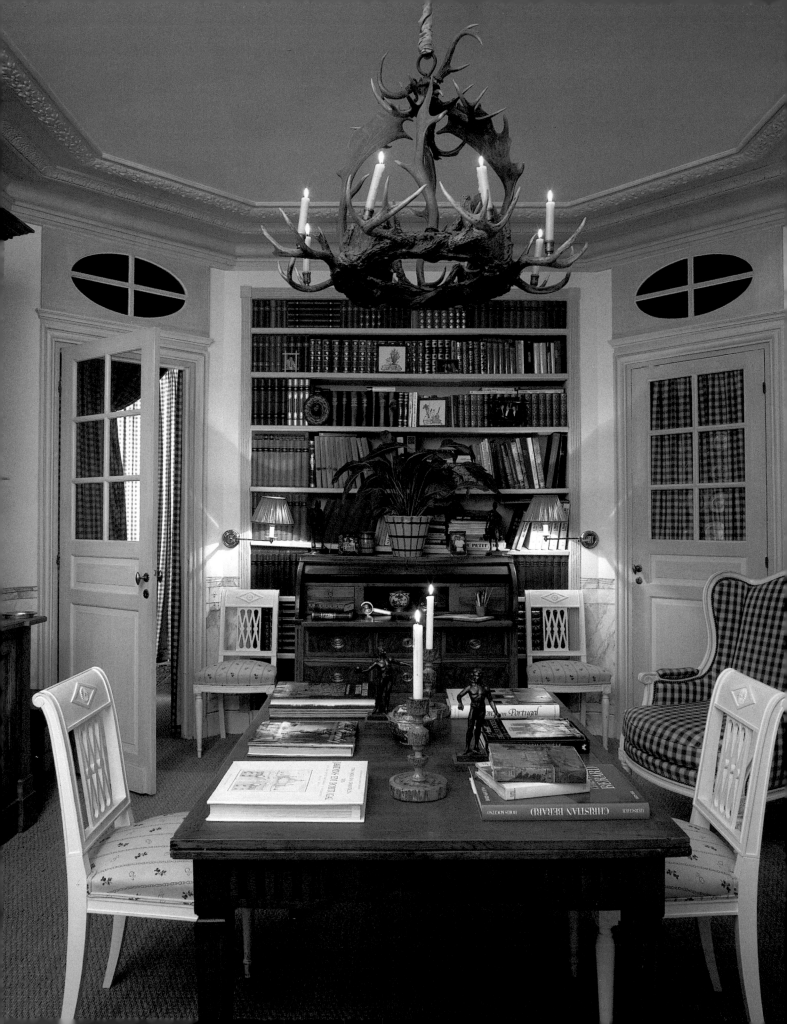

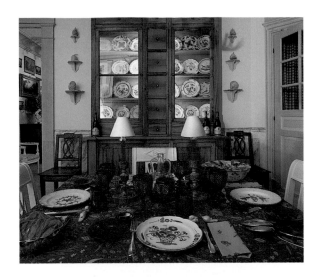

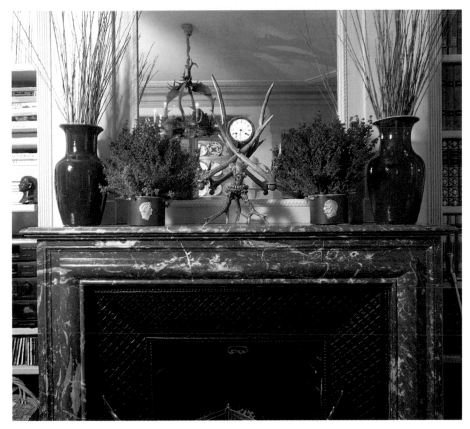

Double purpose

Combining a library and dining-room is an economical use of space. In this dual-purpose interior, Maurice Savinel and Roland le Bévillon have indulged two of their favourite decorative devices: symmetry and *le style provençal*. Both devices appear in the treatment of the doors. Firstly, only one door (the one seen at left) is real; the other is fake, inserted across the corner of the room in order to achieve a symmetrical plan. (Both *œil de bœuf* windows above the doors are fake.) Secondly, the half-glazing of the doors, backed by gathered gingham, is charmingly suggestive of an interior in Provence. In fact, the room is in Paris, but the *timbre* is cleverly orchestrated to be far removed from the city. The old, pharmacist's cabinet, antler chandelier and painted chairs add to the smart but warmly rural theme.

Top-floor design

Rooms at the top of houses often have an interesting
architectural character which can be turned to advantage.
For decorator Robert Hering, the old hayloft of a converted
coach-house (see page 40) provided useful space for an extra
office to take the overflow from the main studio. He played
up the symmetry of the sloping walls by furnishing the room
with equal regularity. It is a very straightforward
arrangement; there is practically no colour and, apart from
the blind, no pattern, yet the room packs a lot of visual
punch in a constrained space. Sturdy-looking furniture in
warm-toned woods is set against exposed stone walls which
have been painted in a soft white.

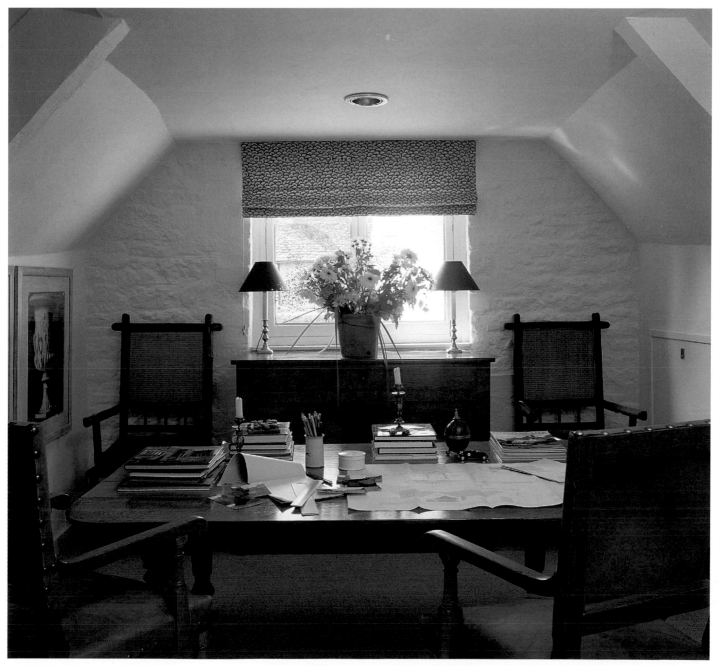

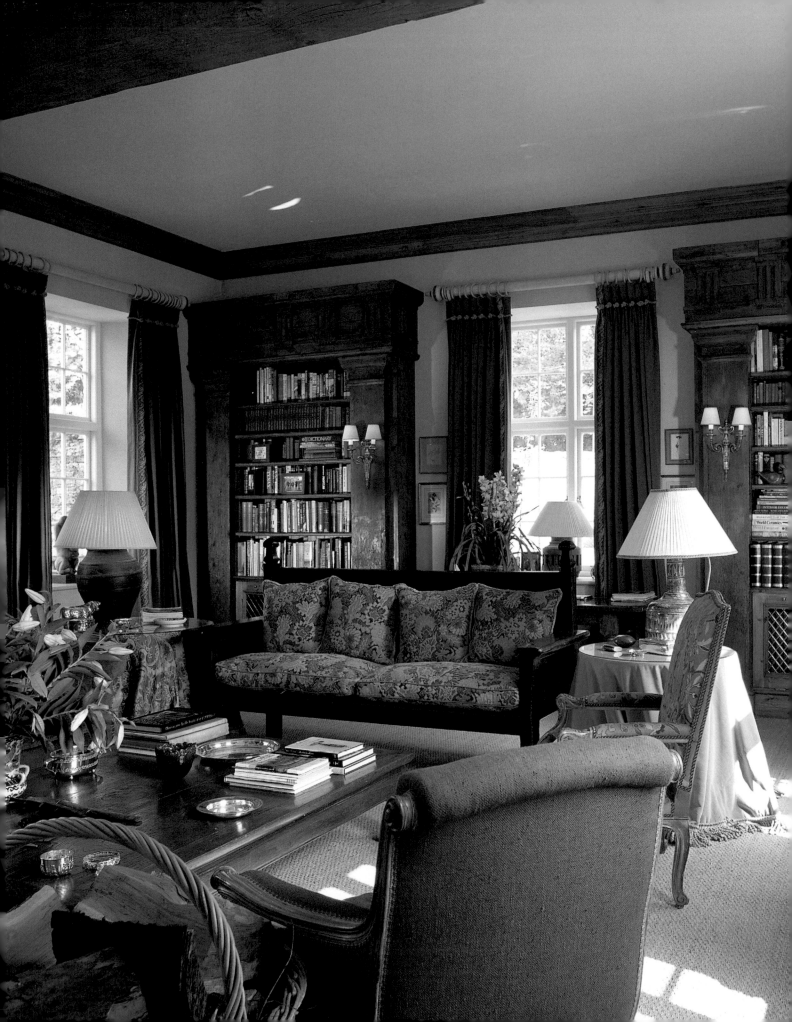

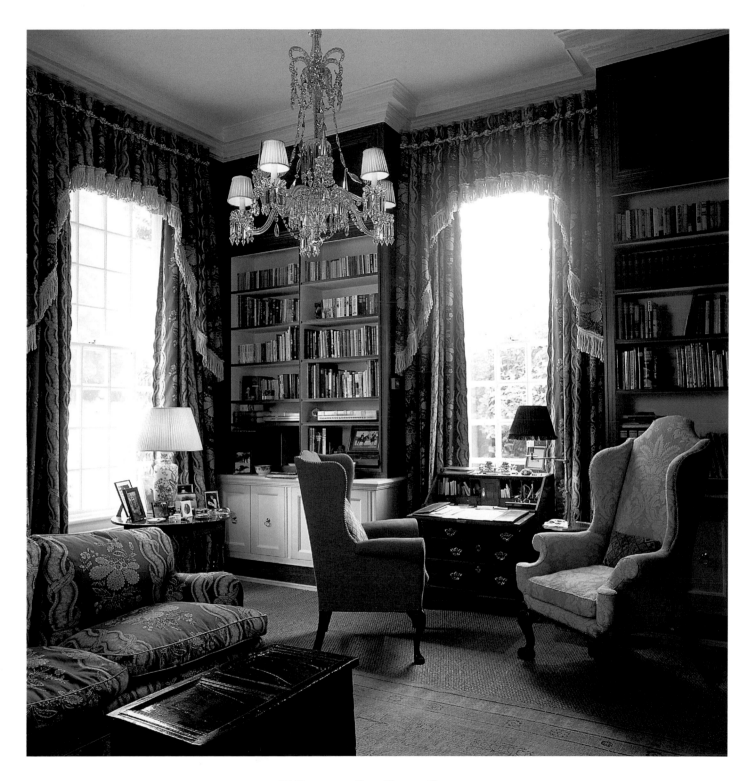

Visual rhythm

The alternation of bookcases and windows in these two rooms gives an attractive visual rhythm of solid and void. Originally a farrier's workshop, the drawing-room of Hugh and Anne Millais's home (left) in a converted stable block in Oxfordshire has a pair of imposingly proportioned bookcases. These were once part of a Georgian shop and, coincidentally, are of the same date as the stable. The study designed by Bob Perkins for a house in Leicestershire (above) was given a masculine edge with a dark green paint finish to balance the patterned fabric. The room is cosy and intimate but the pale colour used inside the shelving and on the cupboards beneath keeps the scheme fresh.

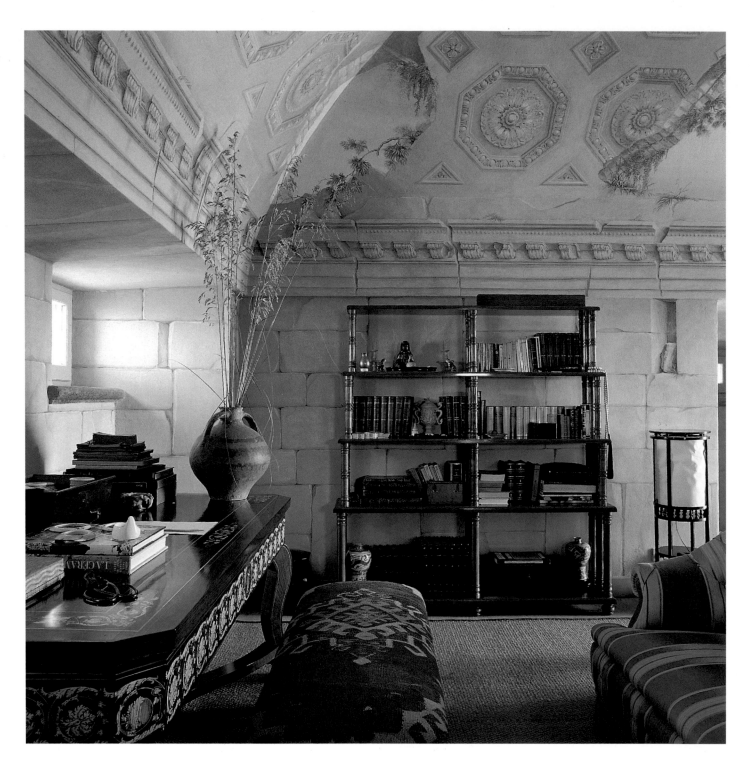

Painted illusion

These two studies have several things in common. They are both in unusual buildings – the one above is in a restored sixteenth-century watch-tower in Italy; the one opposite is in a converted pigsty in a walled garden in Wiltshire – and they both have skilful *trompe l'œil* paintwork. The Italian study, decorated under the direction of Renzo Mongiardino and Elsa Peretti, is painted, ironically, to look cracked and

crumbling, the ruined ceiling with a gaping 'hole' being a particularly brilliant exposition of the art of deception. In the Wiltshire room, the 'marble' panelling was made by local carpenter William Critchfield to a design inspired by Renzo Mongiardino and then painted by Nemone Burgess. The transformed interior now makes a peaceful, country office for its art-dealer owner.

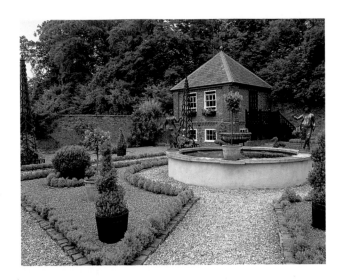

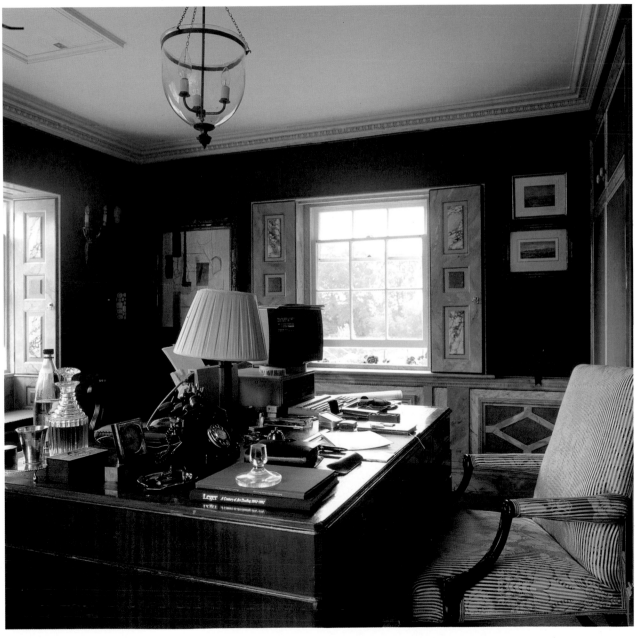

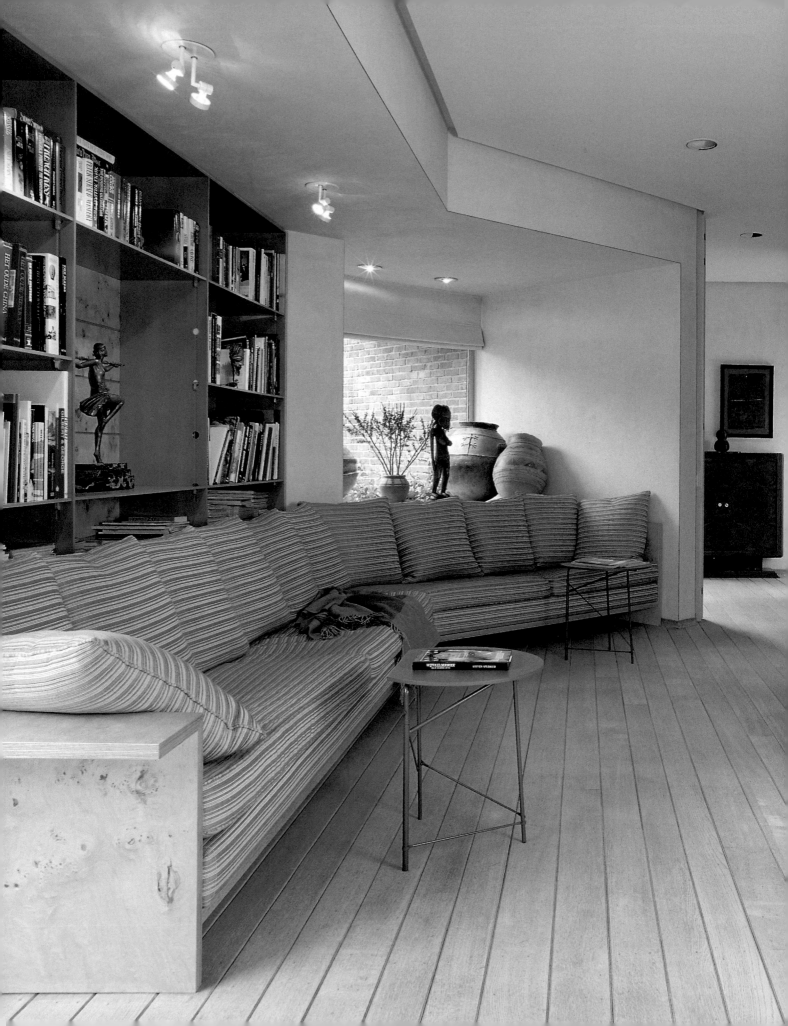

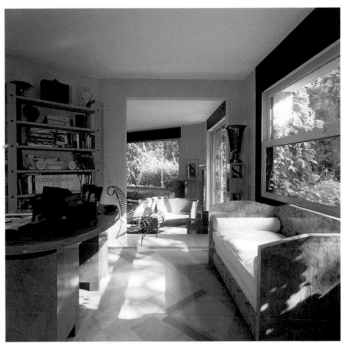

Wood and metal

In Stany Janssen's and Jan Verschuere's house, designed by architect Marc Corbiau, the library (left) is linked to the living-room (see page 80) by a doorless, ceiling-high opening. The interior-design scheme by Claire Bataille and Paul Ibens concentrates on two materials which figure prominently throughout the rest of the house: wood and aluminium. Facing the minimalist fireplace are a specially made banquette framed in birchwood and a grid of metal bookshelves. The library-cum-study shown above also opens directly off a living-room and has pale-wood furniture. In this case, the location is more urban but the green outlook gives the room an open, country feel which is taken up by the light tones of the Thirties, olive-wood sofa and desk. The bookcases were designed to correspond with the Thirties furniture and the modern setting. The interior designer was Monique Duveau. Both rooms demonstrate a contemporary mood which is nevertheless rural.

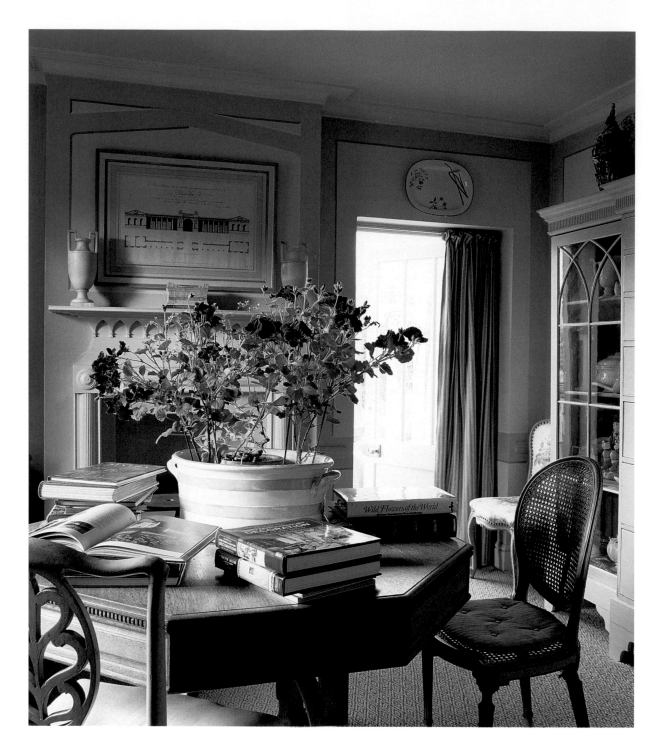

Discreet flourishes

Charles Beresford-Clark's style of decoration is elegant and understated, but within that mode he adds discreetly theatrical flourishes – just enough to give a room vitality without jarring. In order to increase the light and space in his comparatively small house in Sussex, he opened a shallow gothic archway between the study and adjoining hall which, previously, was very narrow and dark. The study has been painted to imitate panelling, and a gothic-glazed

cabinet displays creamware and other eighteenth- and early-nineteenth-century ceramics. The most visually extravagant feature of the room is the superb gothic chimneypiece on which is ranged a restrained group of objects in alabaster, a perfect tonal complement to the room's elegantly monochromatic colour scheme. Through the arch, the palette is similar, but the stair wall is subtly enlivened with painted flowers. (See, too, page 72.)

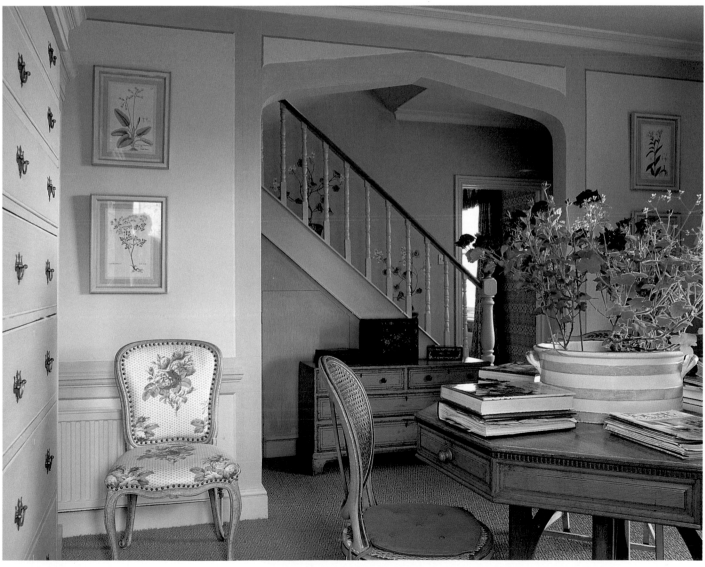

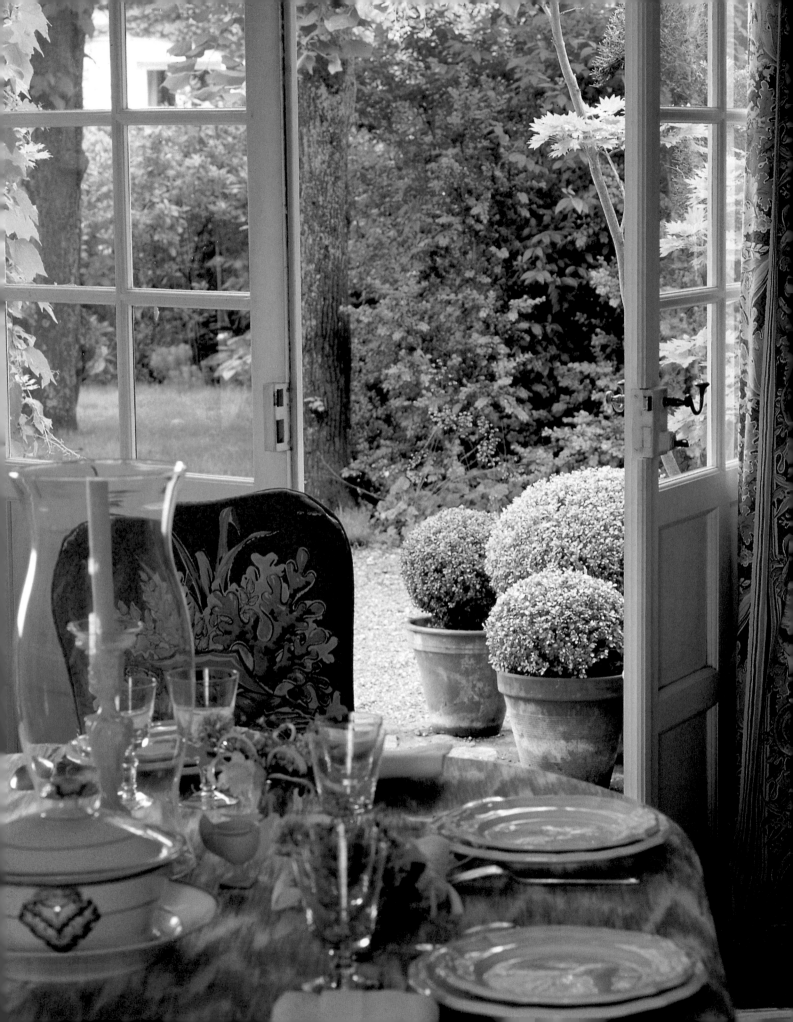

DINING-ROOMS

Dining-rooms in towns are usually at their best in the evenings when the curtains are drawn and the world outside is excluded. In country situations, dining-rooms tend to be more 'daytime': light and uplifting, they exude a sense of gaiety which suits weekend lunches rather than intimate dinners. Even when there is a flamboyant scheme of interior decoration, the country dining-room benefits from being given an informal slant – perhaps by a paint effect on the walls or by terracotta tiles on the floor. The Majorcan room on page 108 is a theatrically composed example of this. The walls in the room in Jenny Hall's house in France (page 114) also have a rugged finish, and here it is the perfect complement to the monumental, stone chimneypiece. Both rooms have interesting juxtapositions: in the first instance, an eighteenth-century French triptych is hung against walls washed in pale terracotta; in the second, modern furniture and art are boldly placed in an old location.

Blue-patterned fabrics are cool and summery in this dining-room which opens directly onto the garden. The plants nearest the house have been clipped to form architecturally-shaped, outdoor 'ornaments' – a green link between the building and the lush garden beyond. The room was decorated by Yves Taralon, whose house is also shown on pages 28 and 188.

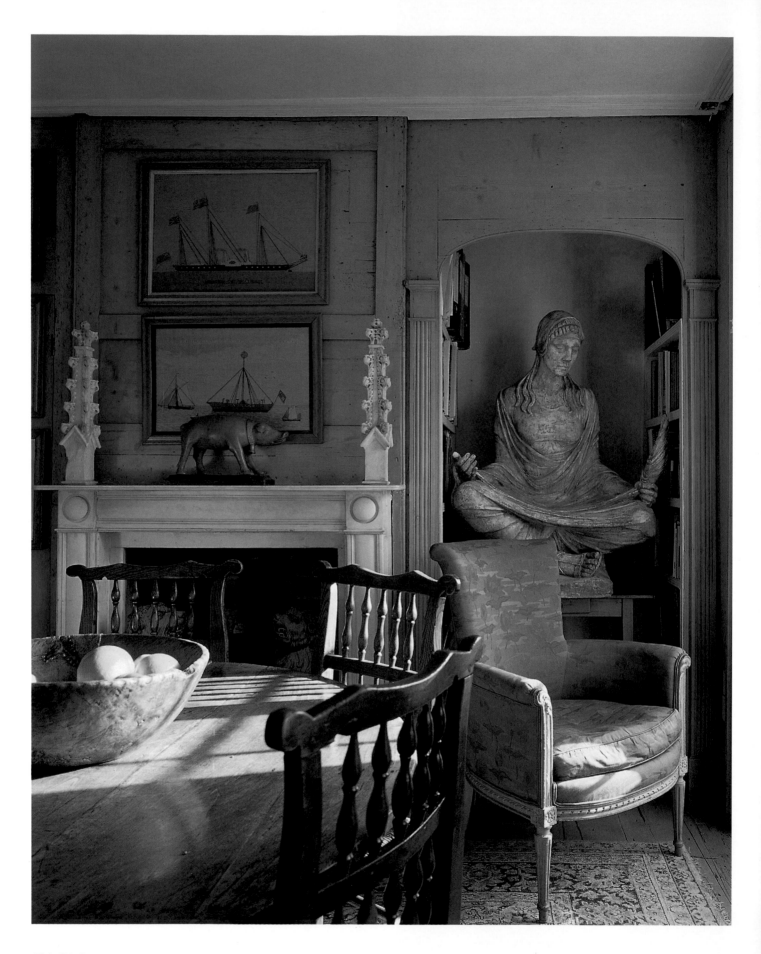

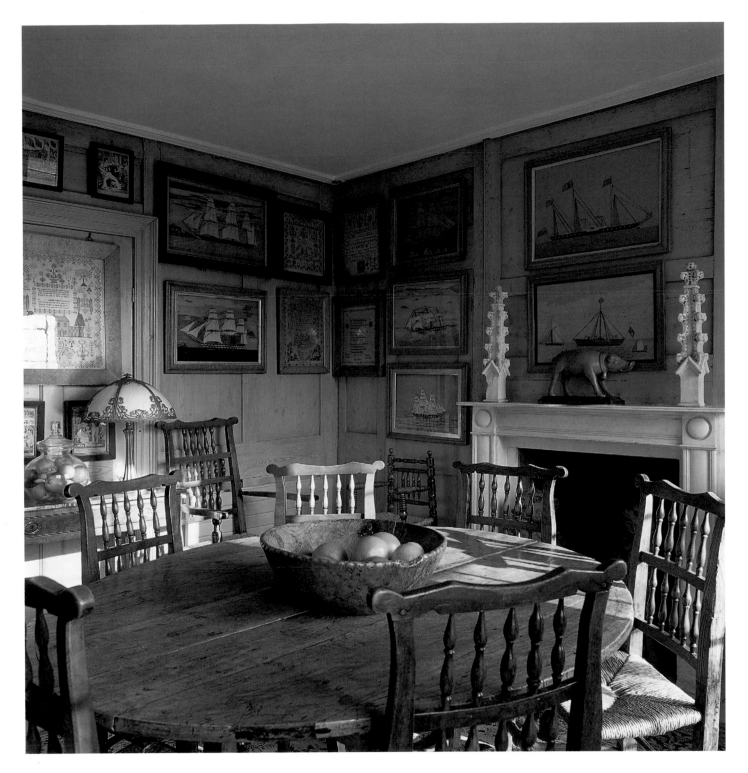

Natural companions

A 1690s terrace house near the Thames at Richmond is the setting for a pine-panelled dining-room furnished with the professional eye of an antiques dealer and the warm heart of a collector. Mollie Evans's love and curiosity for beautiful old things transcend specific eras and styles: somehow, everything she chooses lives happily side by side. Here, an early-nineteenth-century, oval, French dining-table is surrounded by a set of Lancashire rush-seated, spindle-back, elm chairs. Naïve marine pictures, charming samplers, a pair of marble follies, a nineteenth-century Spanish carved-wood pig and, to the right of the chimneypiece, a serene statue, all seem the most natural of companions.

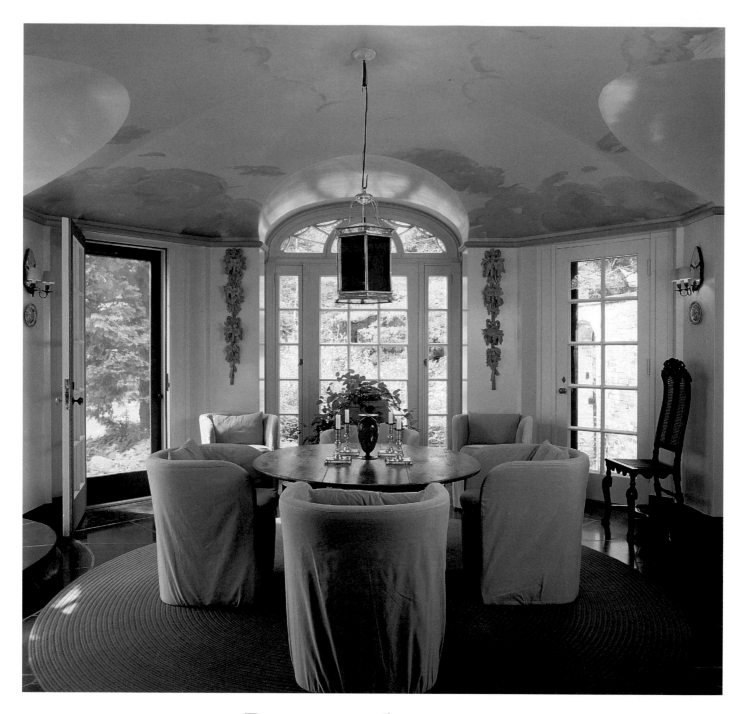

Rooms to linger in

These two dining-rooms are in the country house of New York designer John Saladino. Set in the foothills of Connecticut's Berkshire mountains, the Palladian-style mansion is surrounded by 2.5 hectares (6 acres) of formal garden and 8 hectares (20 acres) of woodland. Inside, the house is furnished with sophistication but has a lightness of touch which bridges the elegant architecture and rural setting. The octagonal breakfast room (above) has a slate floor and glazed doors leading to the garden, making it a cool room for dining in summer. The silver lantern with blue glass panels was made in India during the British raj. The main dining-room (opposite) is much bigger in scale and has a two-metre (6½-feet) diameter circular table, a two-metre (6½-feet) high mirror, exaggeratedly tall candles and a huge canvas by Cy Twombly. The latter, and the rolled-steel sideboard beneath, are what John Saladino refers to as 'the room's twentieth-century moment'. The dining-room and breakfast room have similar, curved-backed chairs which are soft and comfortable 'so guests can linger for hours'. (The sitting-room in the same house is shown on page 58 and bedroom on page 196.)

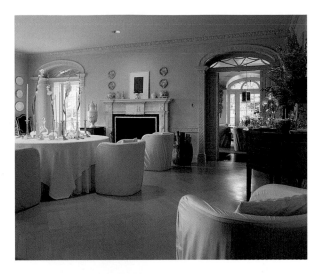

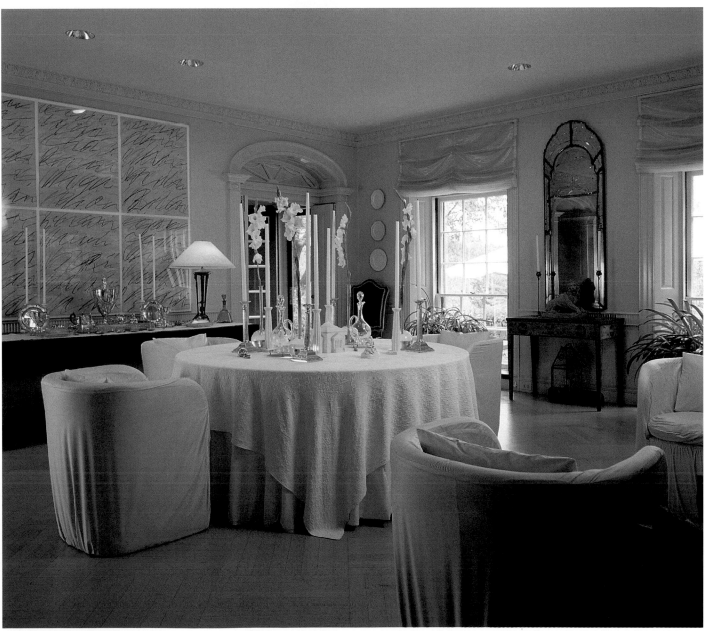

Carefully composed

The feeling in Ursula Hubener's dining-room on Majorca is one of 'set-piece' design, with objects grouped in carefully regulated compositions. On the table, a pair of storm-lanterns flanks a tall bowl of delectable-looking fruits. More fruits are displayed in a verdigris-painted basket on a side-table, which is the centrepiece of a symmetrical ensemble comprising trailing plants on gothic pedestals, gilded candelabra and flambeau wall sconces. The walls of the room are washed in a pale shade of terracotta, echoing the sun-bleached colours of the surrounding countryside, while the turquoise-green frames of the doors and windows reflect the colours of the paintings and furniture (see, too, page 48.)

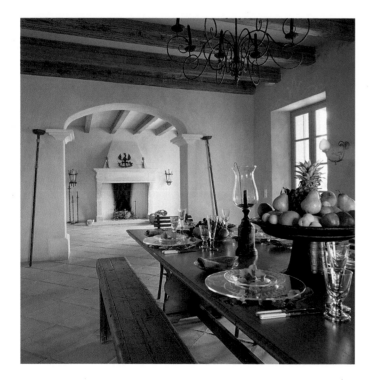

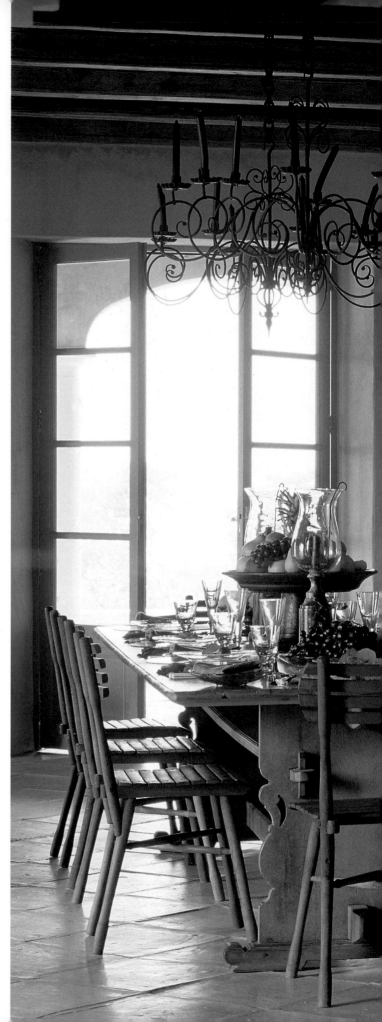

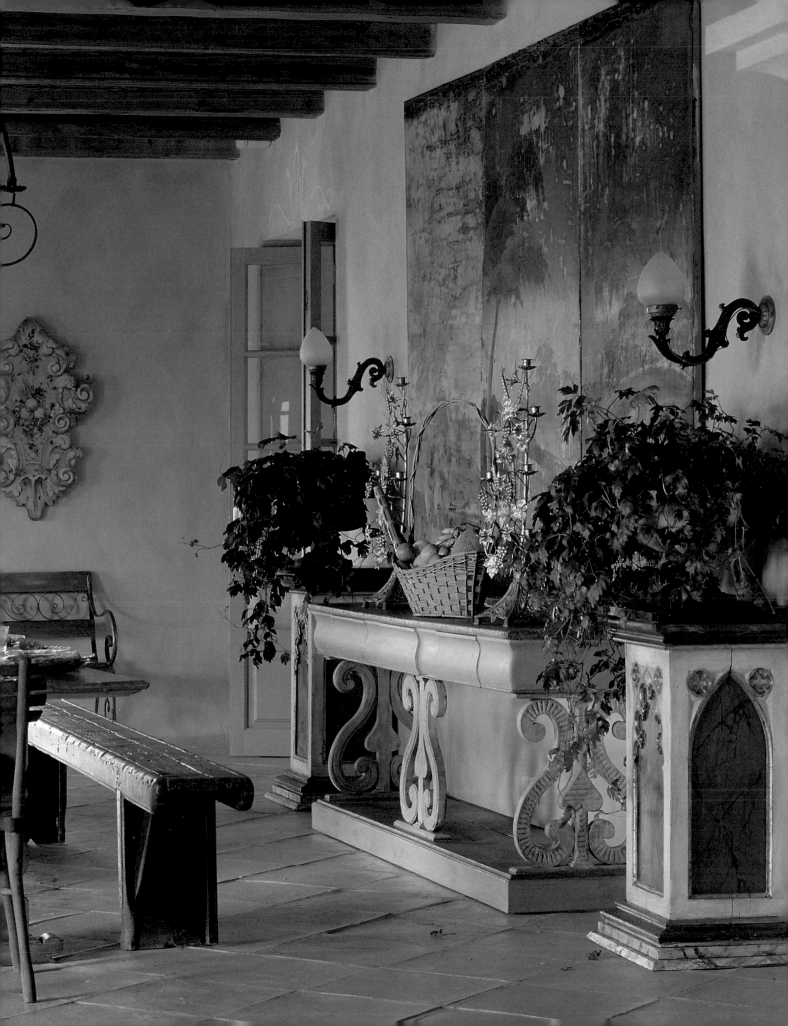

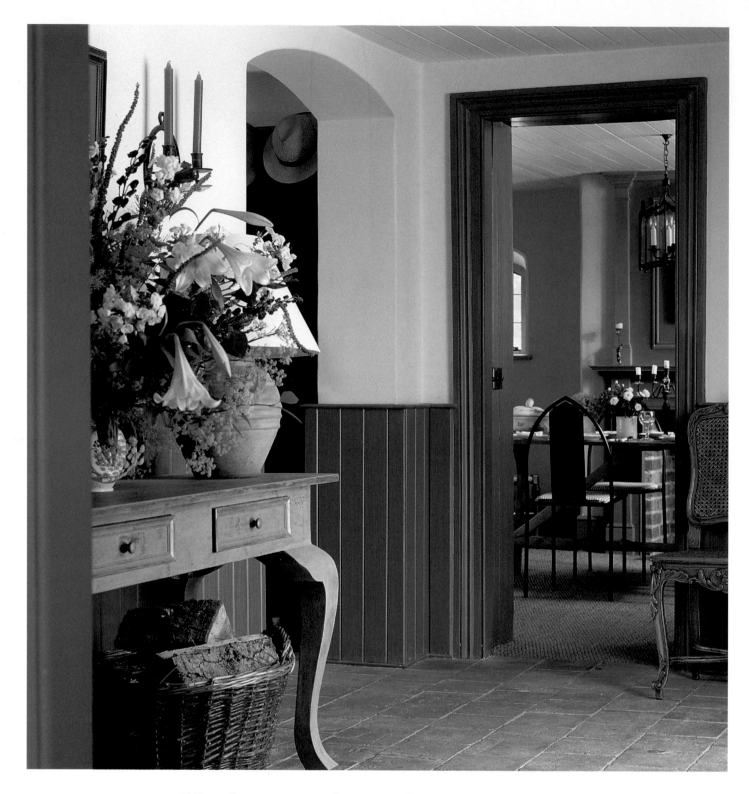

Understanding the character

Doing up an old cottage is like walking a tightrope. It is all too easy to fall into the trap of using finishes and furniture which are too grand for the modest character of the building or to go for a depressingly contrived folksiness. Architect Giles Vincent walked that tightrope with great skill when he remodelled a 1790s cottage in Sussex (also shown on pages 132 and 204). What was previously the kitchen is now the hall (above), which gives access to the dining-room. The new door architraves and boarded dado are painted in a dark, muted shade of green. The woodwork in the dining-

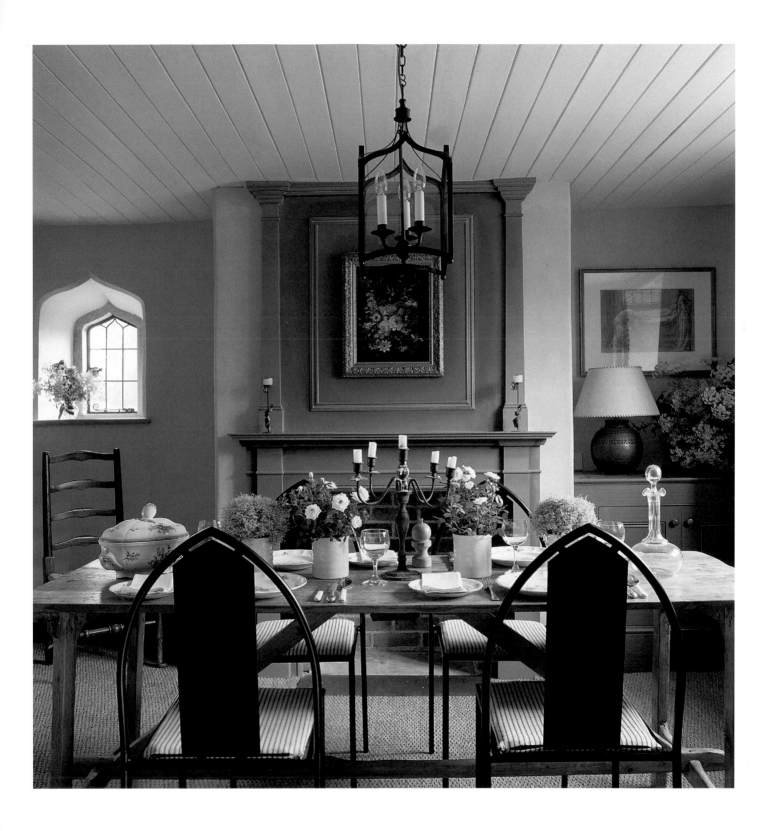

room is painted a slightly different shade of green, with a bronze tinge, and it, too, contrasts with paler walls. The ceilings in both areas are timber-boarded and painted. The chimneypiece and overmantel were designed to create a central architectural feature and a backdrop for a Dutch still life. The gothic theme of the room, established by the new ogee-arched window, is followed through with the lantern and metal chairs which partner a fruitwood table. Although the chairs are modern, they have a simplicity which is in keeping with the tenor of the cottage.

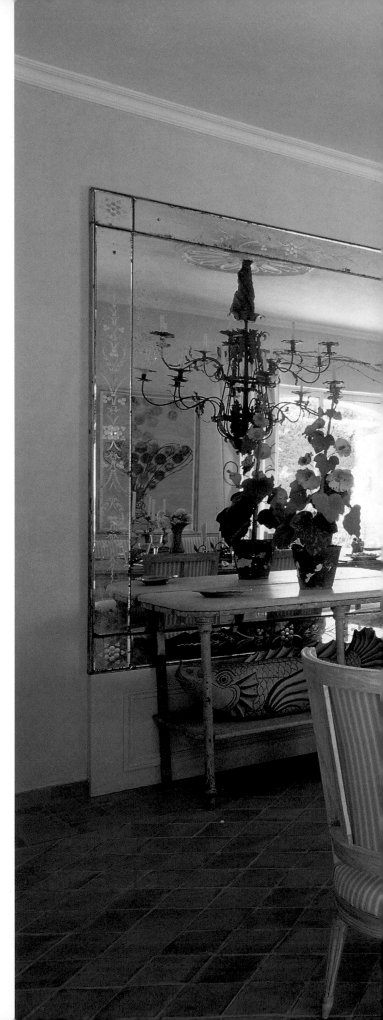

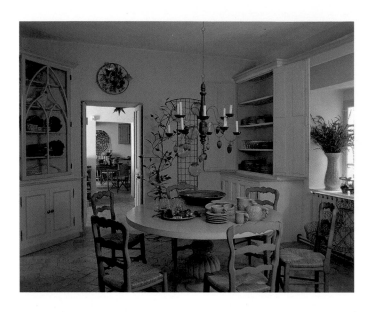

A room of contrasts

With restrained French country overtones and a chic mix of old and new, this dining-room (right) in Provence encapsulates the decoration mood of the moment. It is a room of contrasts: classical Louis XVI painted furniture stands on terracotta flooring; a huge Thirties Venetian mirror reflects nineteenth-century tôle hollyhocks; plain walls counterbalance the sinuous chandelier. A metal chandelier is also a feature of a smaller, more informal dining-room (above) in the same house, where typically French country chairs surround a table with a splendidly voluptuous pedestal. The owner and designer of the house (seen, too, on pages 32 and 180) is artist Catharine Warren, one of whose paintings hangs in the main dining-room.

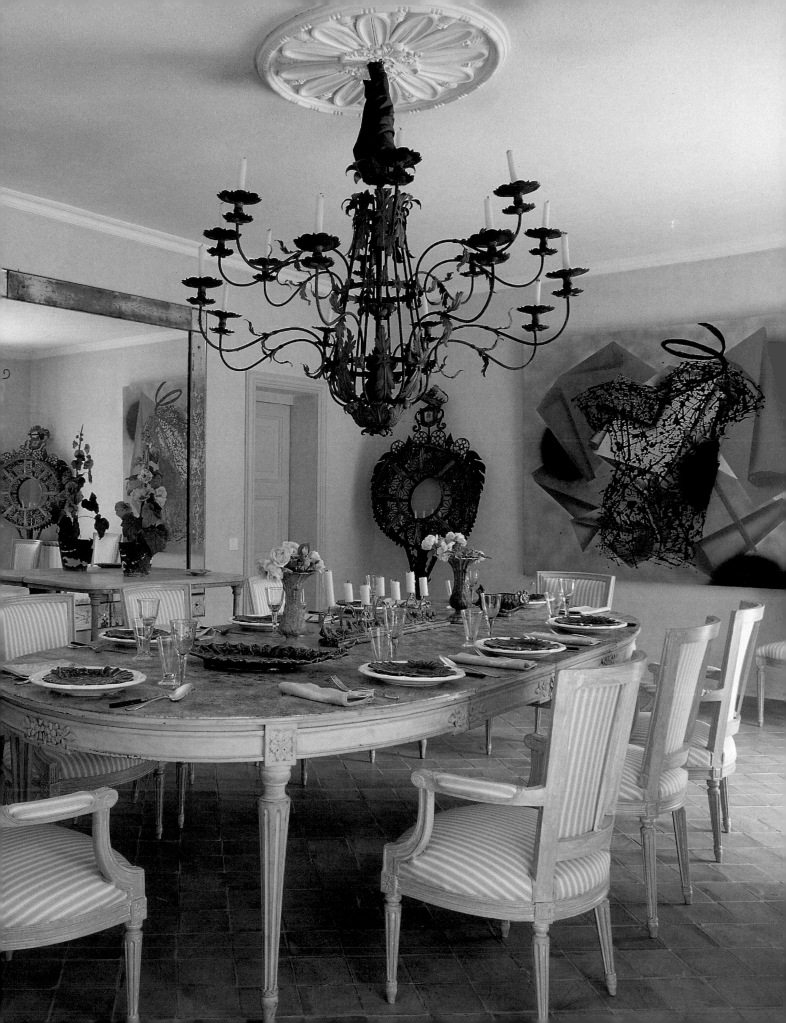

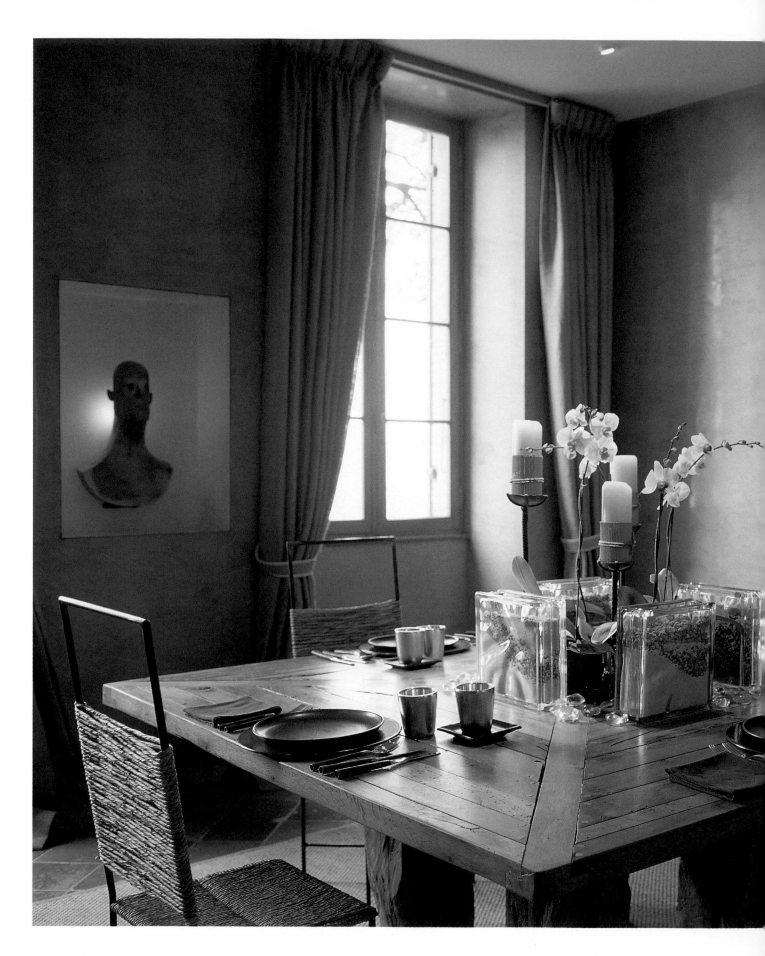

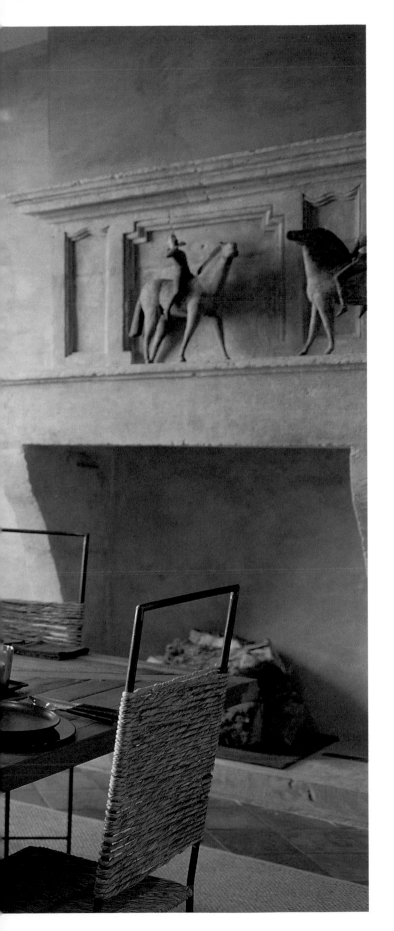

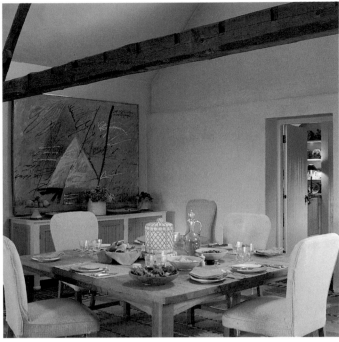

An intriguing combination

The old stone chimneypiece in the room illustrated at left has the intriguing quality of combining craftsmanship and primitiveness. Installed in Jenny Hall's house near Toulouse in south-west France (see, too, page 192), it was bought from a local architectural salvage company and has a monumental presence. The impressive size is exactly what makes it seem so right – a scaled-down chimneypiece would have looked mean and inappropriate in such a setting. On the chimneypiece is a pair of specially commissioned sculptures by Anna Noel. Jenny Hall, who is a considerable patron of artists, designers and craftsmen, also commissioned the table, which was made by Jeffrey James. With its rough-hewn legs and hefty top, this too has a tough character which suits the setting. The other dining-room shown here is in John Stefanidis's house in the English countryside. Like Jenny Hall, John Stefanidis has taken a line that is simple, rural and contemporary, but he has softened the scheme by using upholstered chairs and a cotton dhurrie which was made to his own design. The solid, elegantly plain furniture was also designed by John Stefanidis.

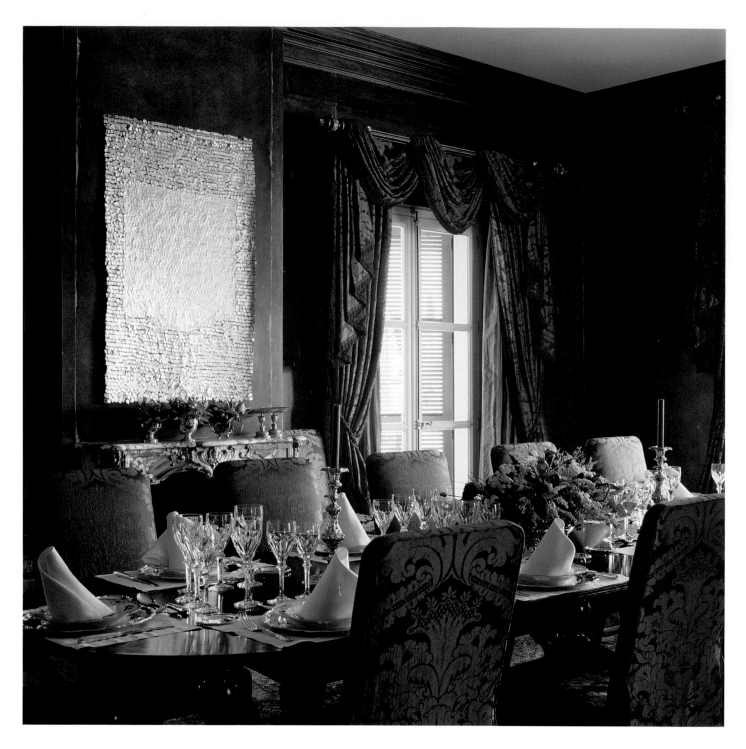

A luxurious drama

This dining-room is in a house which, at first sight, seems to have a long history but in fact was built only a few years ago. Situated outside Madrid, it was designed by Spanish architect Pablo Carvajal, and the interior was devised by Monika Apponyi of MM Design in London. The clients' brief stipulated that the ambience should be luxurious but not glitzy. Recalling the mood of an ancient palace in Venice, the dramatic red-and-gold colour scheme has an antique air

derived mainly from the wall finish by Michael Daly. The most spectacular elements are the paired, eighteenth-century, Italian, console tables and Venetian mirrors placed to either side of the mahogany, double doors. Their eleaborate character and the richness of the silk curtains and chair-covers are in marked contrast with the vernacular materials used for the floor. (The breakfast room in the same house is shown on page 124.)

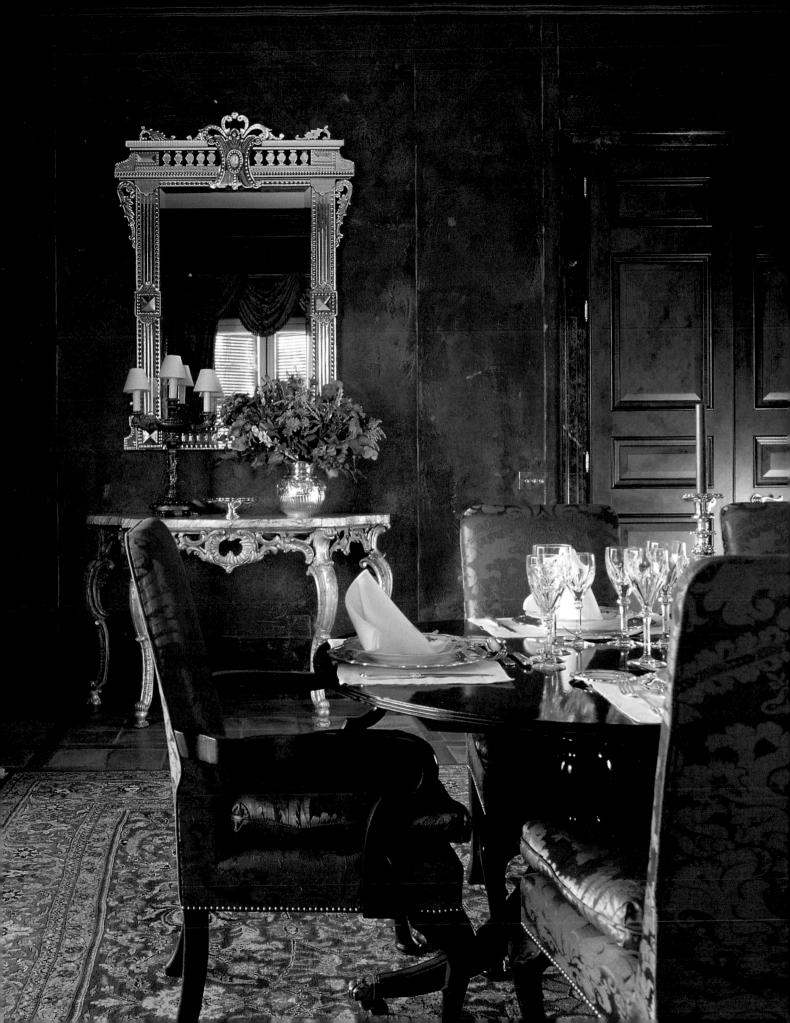

Casting shadows

'If a room is intrinsically dark, then accept the fact and use
well designed lighting to play up the shadowy effect,'
suggests interior designer Marion Lichtig. Because this room
is in a town basement, it has comparatively restricted
natural light and a low ceiling height – two factors which
make it comparable with many interiors in country cottages.
Not only does the decoration of this interior strike a rural
note but it shows that there is no need to be timid about
using bold scale and contrast in such rooms. 'When the
builders uncovered the bricks beneath the plaster, I realized
that the juxtaposition of the rough wall and formal furniture
could work really well, especially with simple linen curtains
and a few over-sized objects.' The chimneypiece was
installed as a deliberate counterpoint to the room's
proportions. The colours throughout are natural and
parchment-like, a theme echoed in the rows of books.

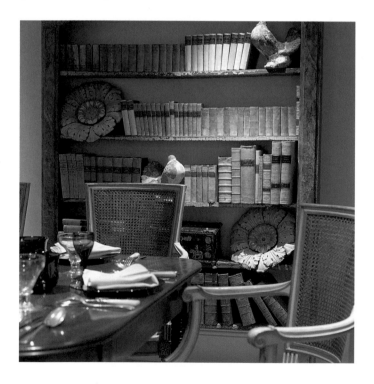

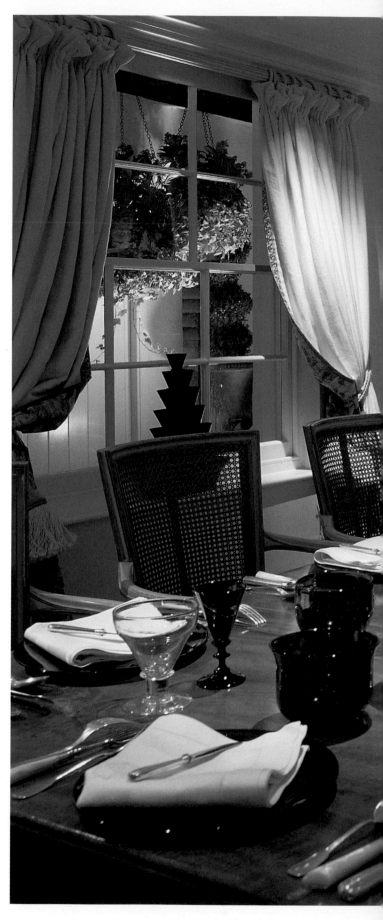

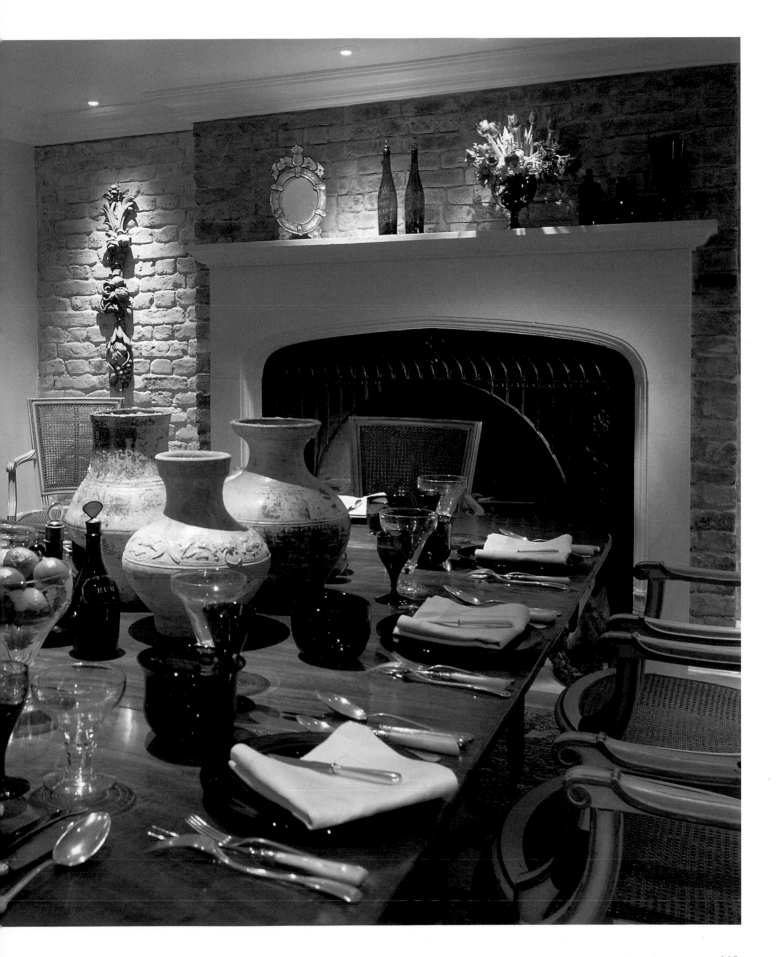

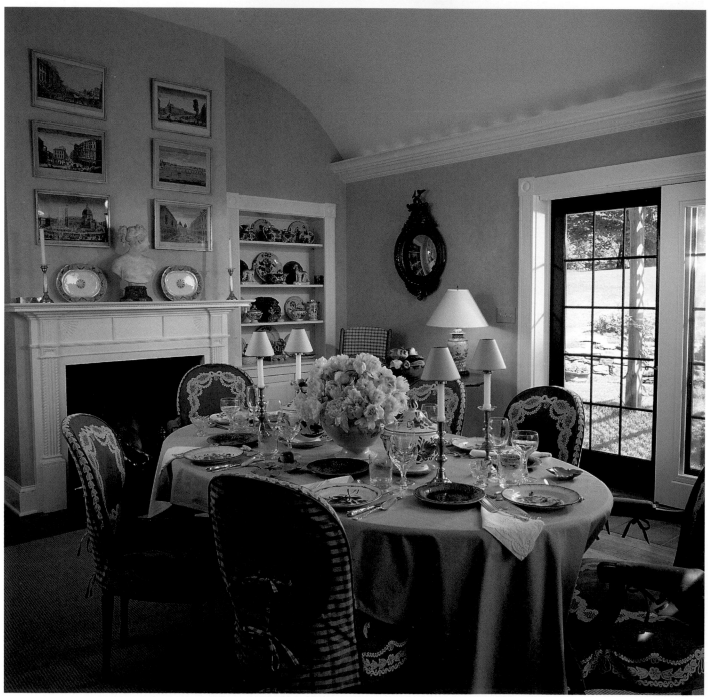

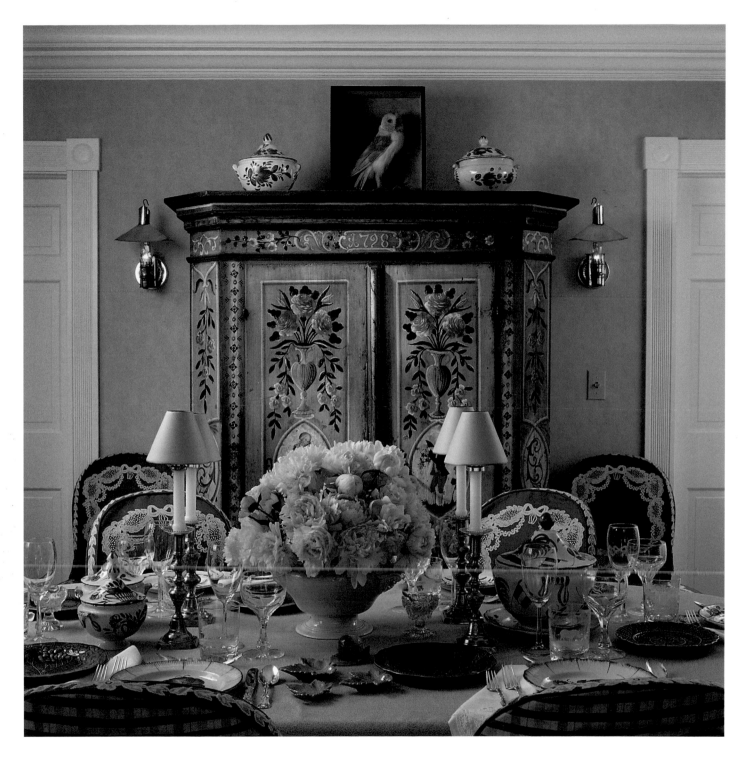

Pretty from every angle

There are two focal points in Albert and Murray Douglas's dining-room in their house in upstate New York: the beautifully painted Austrian cupboard, dated 1798, and the fireplace with a group of architectural engravings above it. Coral-pink is the perfect background for the cupboard and prints, and it has the useful characteristic of looking warm at night yet fresh during the day, when the room is used for summer lunches. There are no curtains at the windows, but blue-and-white fabric has been used highly effectively on the chairs. Murray Douglas, who is a leading light in the fabric company Brunschwig & Fils, had the tie-backed slip-covers made up in two different patterns to give extra interest and ensure that the chairs look pretty from every angle. The oval dining-table reflects the curve of the ceiling.

Mellow colours and textures

Designed by Nancy Braithwaite, these rooms capture the unpresuming nature of traditional country style whilst having a smart, present-day vitality. As a serious and knowledgeable collector of Southern States vernacular furniture (see, too, pages 20 and 34), Nancy Braithwaite has sufficient understanding of the genre to be able to design new pieces which harmonize with her exceptional antiques. In her dining-room (this page and opposite, below), the rectangular heart-of-pine dining-table and the iron chandelier were designed by her, and both look perfectly in

keeping with the tall, nineteenth-century 'hunt board' which displays a collection of Edgefield pottery, also nineteenth-century, from Southern Carolina. Wing chairs bring an air of comfort to the room, and the natural colour of their slip-covers complements the rich woods and deep brown of the sponged walls. The breakfast room (opposite, above) is lighter in style, with a finely-profiled chandelier and wicker chairs. The walls are lined with eighteenth-century wooden planks, against which hang early-nineteenth-century fire-bags, originally used to protect valuables.

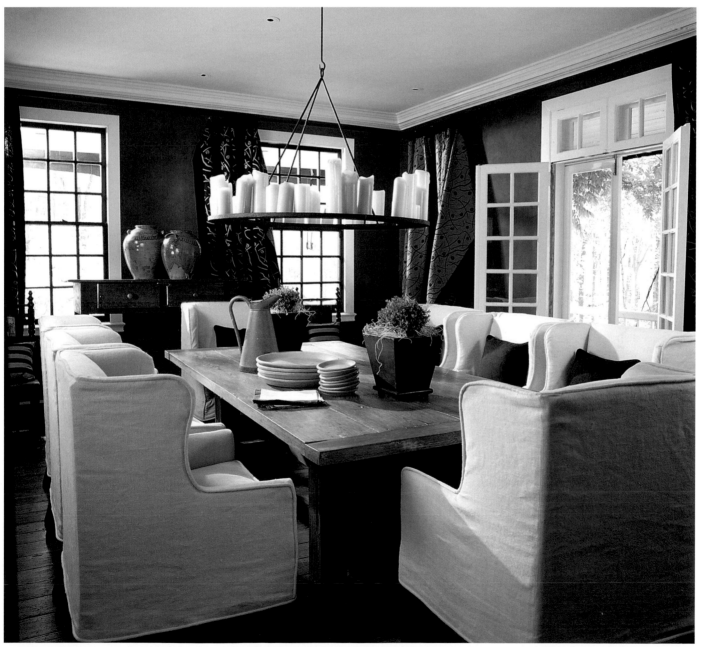

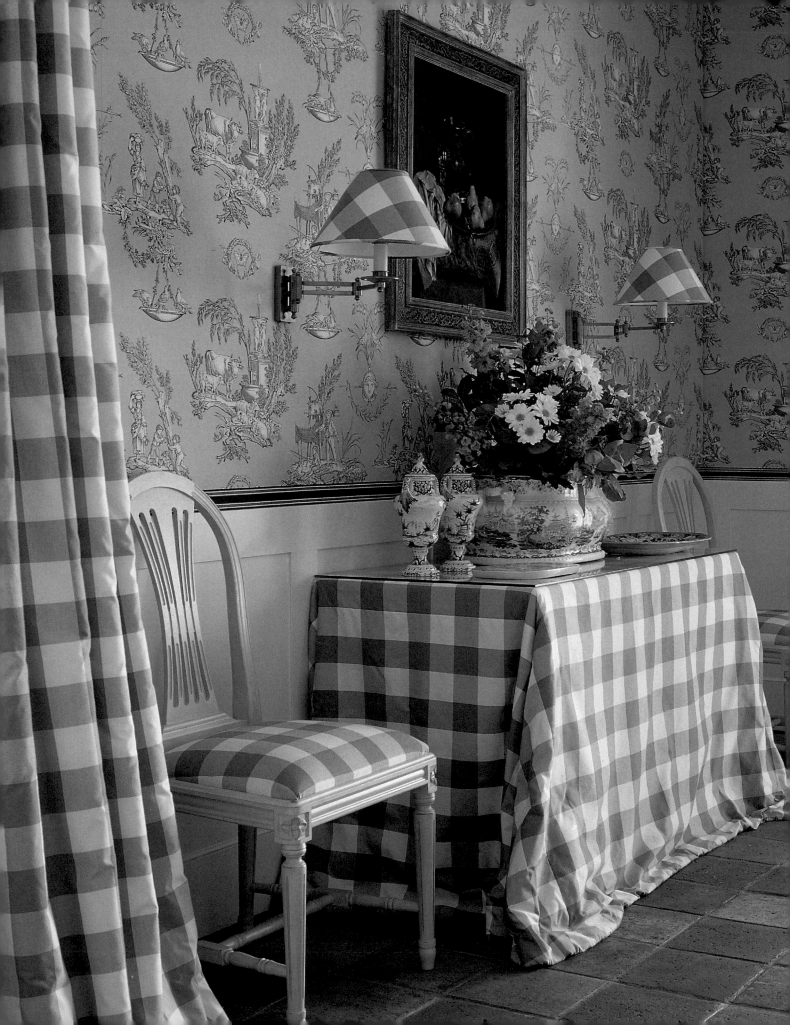

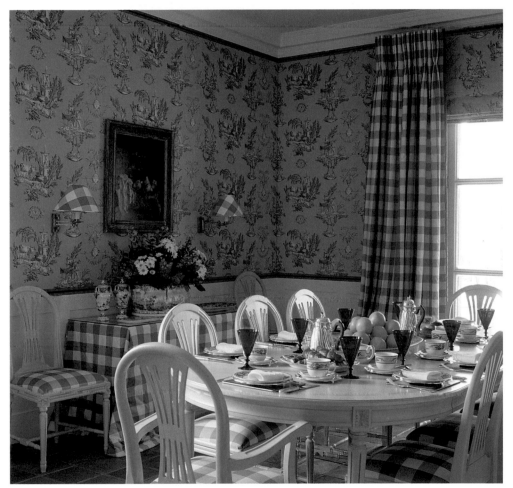

Colourful and idealized

Designed by Monica Apponyi of MM Design, a charming breakfast room is based on a brightly coloured yellow-and-blue *toile de Jouy* depicting idealized scenes of rustic life in the eighteenth century. Using a fabric such as this to line walls is especially effective as it allows the narrative of the design to be seen flat and thus fully appreciated. The *toile* is carried across the cupboard doors so there is minimum interruption to the room's overall scheme. A large-scale blue-and-white check is the perfect foil for the *toile* and works as tellingly for the curtains as for the tablecloth, seat-covers and lampshades. (The main dining-room in the same house is shown on page 116.)

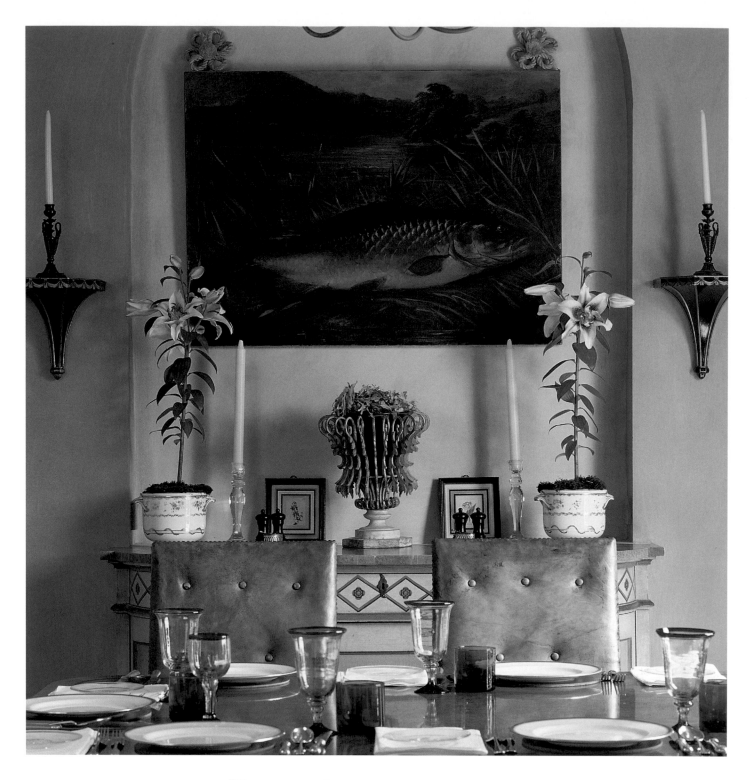

Byzantine resonances

The ceiling in the portico at Uppark, the magnificent mansion on the South Downs, was Sophie Warre's inspiration for the decoration of the dining-room in her house on the Uppark estate. The vaulted ceiling has been painted deep blue with a little dull gold showing through, emitting splendidly Byzantine resonances, while the walls are a rich yellow. Both paint finishes were carried out by Laura Jeffreys. The distressed-leather dining-chairs and the table

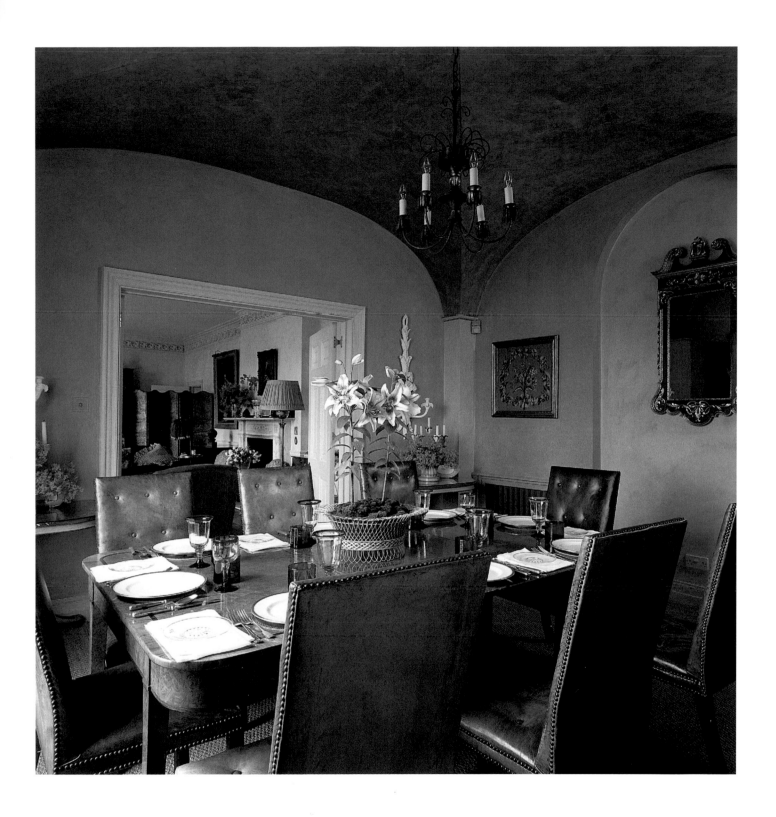

(a fine copy of a Regency breakfast table in Suffolk elm, rosewood and ebony) were made by Lou Quenton of The Suffolk Artisan. In one of the shallow recesses, a painting of a huge fish hangs above a nineteenth-century jardinière on a painted sideboard. To either side, vertical emphasis is created by a pair of painted-and-gilded wall-brackets supporting a single candlestick. The dining-room opens directly off the drawing-room, which is shown on pages 46 and 140.

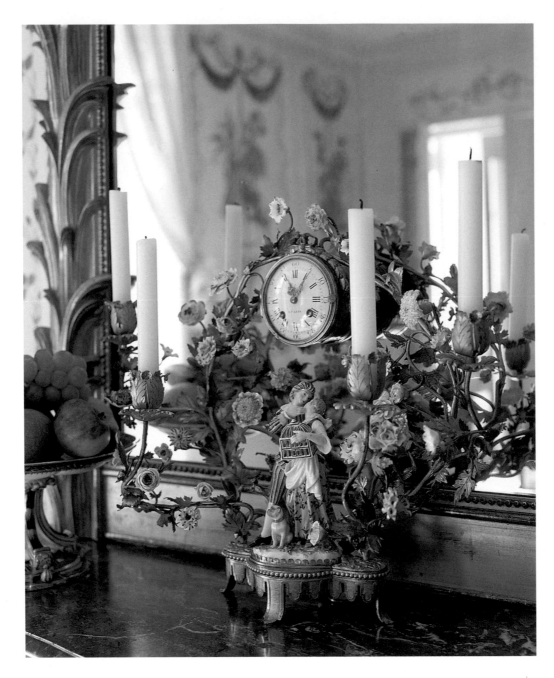

Rural trophies

Cartouches of rural life were painted on linen by Marcus May, then fixed to the walls of the dining-room of a house near the Loire decorated by Katya Grenfell. The trophies of horticultural implements are framed by swags and drops, their graceful lines echoed by the metal chandelier. The latter is a pretty and unexpected alternative to a glass chandelier in a room which has traditional furniture. On the marble mantelpiece beneath the rococo mirror is an unusual eighteenth-century clock with a female figure clasping a birdcage and surrounded by foliage. The candles on the table have pierced shades which are practical and decorative since they shed light without glare at eye-level.

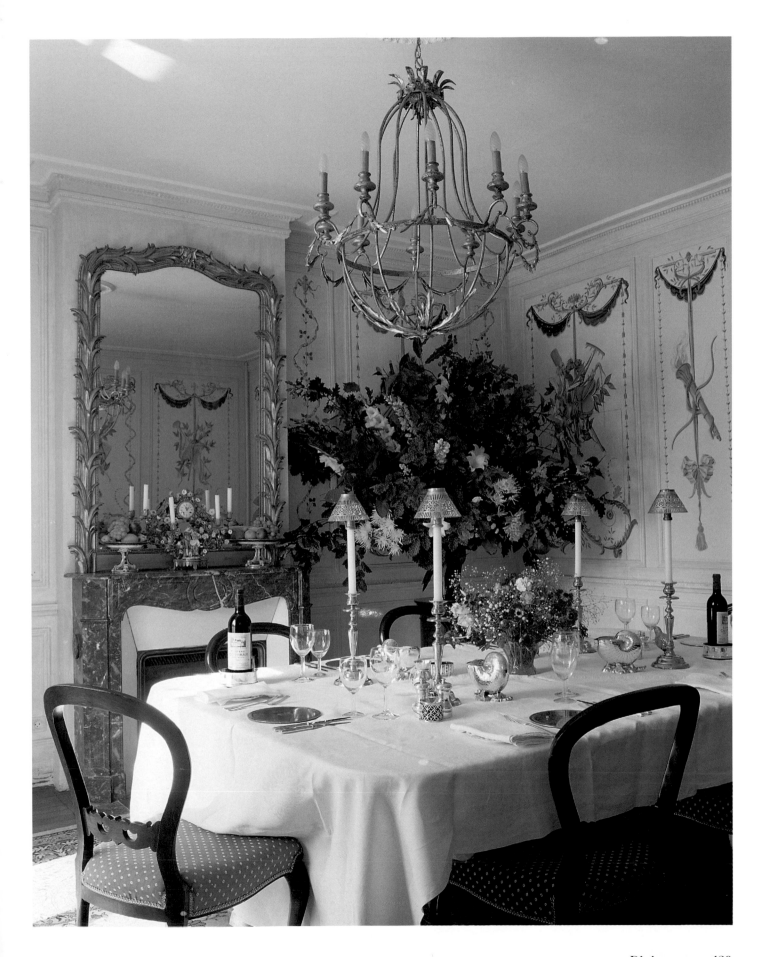

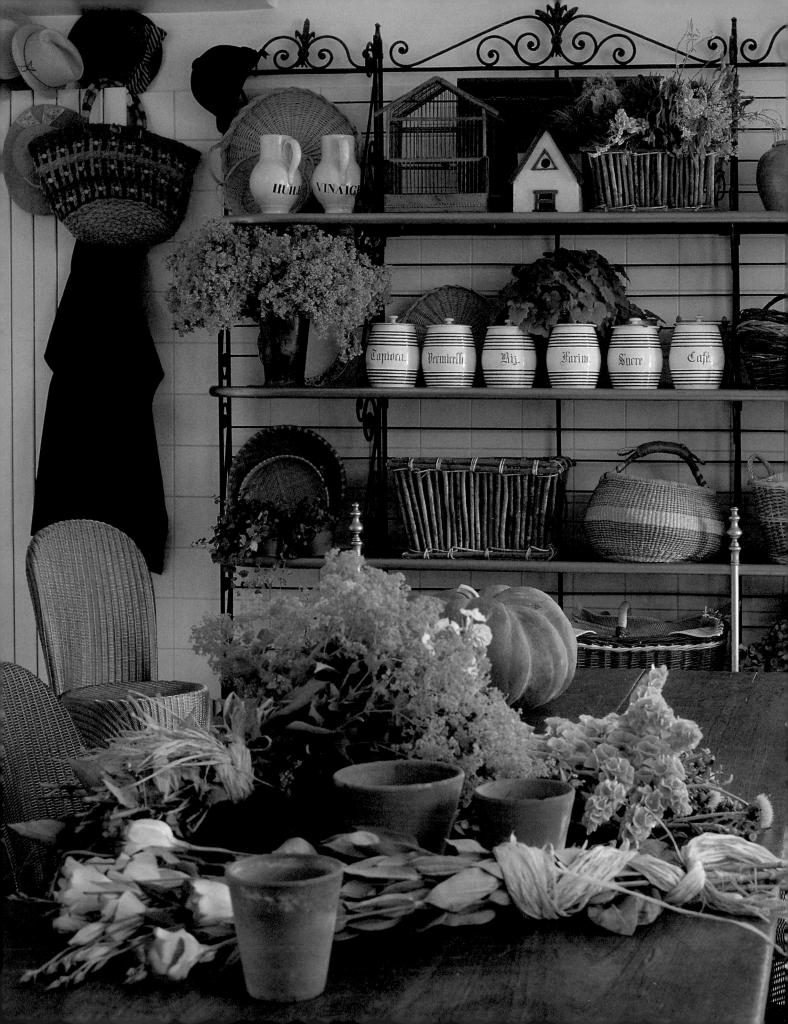

KITCHENS

An uncompromisingly streamlined kitchen looks neat but is unfriendly when compared to a country-style kitchen. The latter is fillled with deliciously warm associations: comforting, home-cooked food; jars of preserves made from fruits grown in the garden; baskets of freshly picked vegetables. The reality may be that nothing in the country kitchen is home-grown but the fantasy created by the rural style of interior decoration is persuasive. The kitchens illustrated in the following pages all have country themes and emblems, but they vary in the way the owners have adapted the look. The kitchen in the one-time school-house shown on page 148 is typically English in that it has an Aga and a dresser filled with china, but the wall finish – a large-scale, red-and-white check – is exuberantly different and rather gallic. The room illustrated on page 142 takes its artistic theme from the locality – an area of Provence associated with numerous celebrated painters. Colour is an important ingredient in this kitchen – as it is in the one designed by Johnny Grey (page 138). The latter is a particularly interesting scheme because it is inventive and modern but has the warmth of a traditional room. With its mellow-toned wood and handcrafted character, it is a design which, space permitting, would work equally well in a town or country situation.

Antique, bakers' shelves displaying a miscellany of homely objects make an imaginative, kitchen still life. Arranged with casual artistry, baskets intermingled with flowers, jars and a birdcage establish a country garden theme. (Other views of this seaside house in Belgium are on page 16.)

Reflecting the past

This new kitchen added to an old cottage in Sussex was designed by Giles Vincent to look as though it had been there for years, both externally and internally. The casement windows have oak frames and handmade leaded lights, secured by catches incorporating the client's initials, and the cupboards are painted pale duck-egg-blue, copied from an eighteenth-century dairy in Somerset. A Belfast sink adds to the authentic ambience – as does the painted chimneypiece based on an Arts and Crafts original of about 1905. (Other rooms in the cottage are on pages 110 and 204.)

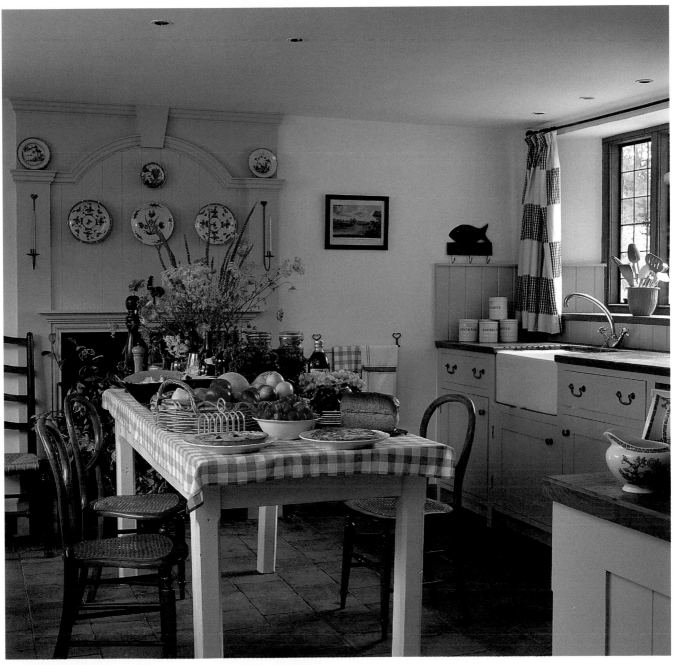

Practical and sociable for cooking and eating

An enthusiastic cook, Hugh Millais prefers a large kitchen-cum-dining-area to two separate rooms. When he and his wife Anne converted an old run-down stable-block in Oxfordshire, they turned part of the former coach-house into an open-plan interior which integrates the practical aspects of cooking with the social needs of dining. Beyond the two refectory tables – one table is slightly more formal and has upholstered chairs – is an Aga with a seventeenth-century fireback. Open shelves carry cookware and some splendid Spanish crockery. An oak floor is hard-wearing and warmer underfoot than tiles.

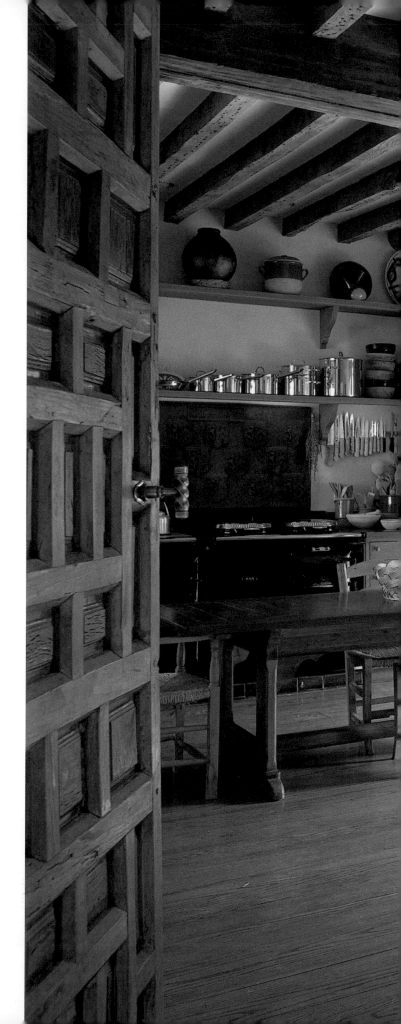

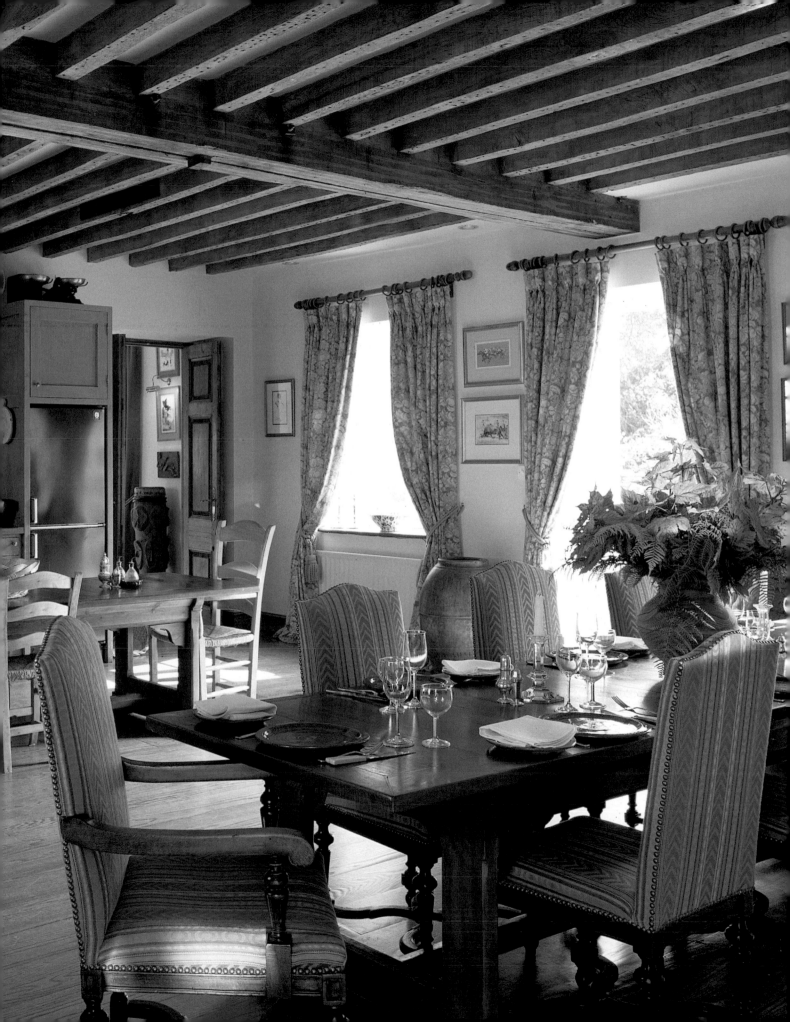

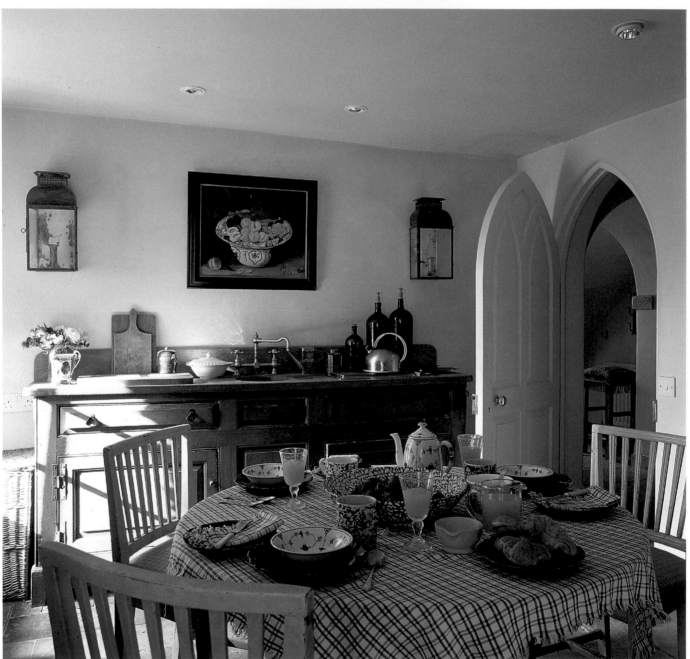

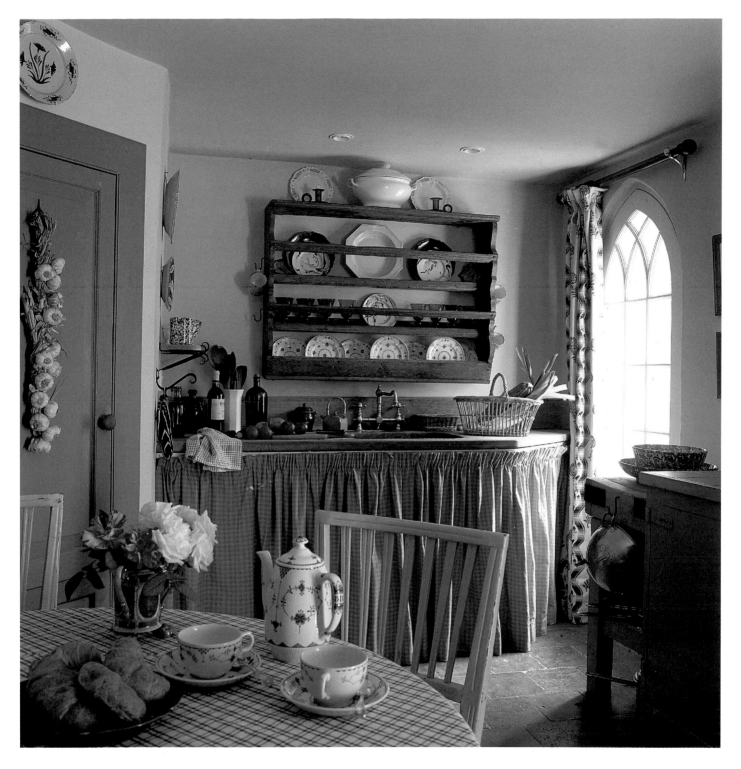

In a special setting

A kitchen must be practical but when it is in a building of special architectural interest it also needs to take account of the context. In this case, the building is an eighteenth-century gothic folly in Hampshire (see, too, page 44). A modern, built-in kitchen would have looked totally out of place, so when William Thuillier and Robert Perkins restored the folly some ten years ago, they decided on an unfitted kitchen and a mature-looking colour scheme of cream and blue-grey. To add to the effect, the painted woodwork was aged, and most of the 'mod cons' were concealed behind a curtain beneath the sink. A useful second sink has been set into an old French provincial cupboard.

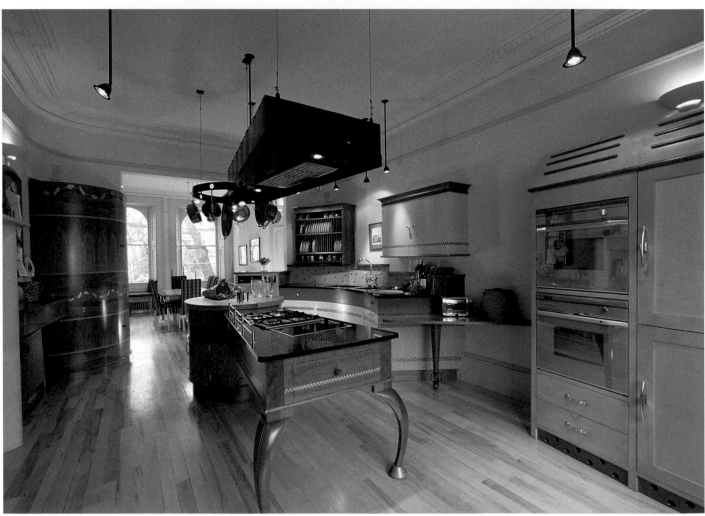

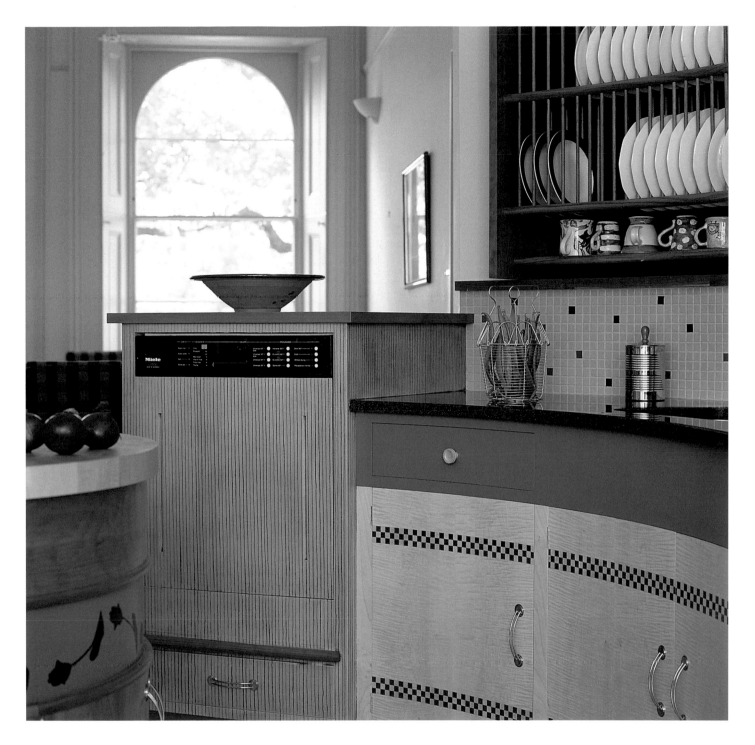

Pioneering layout

Designed by Johnny Grey, who pioneered the idea of the modern 'unfitted' kitchen, this room is in a house in Kensington but the wood finishes and the imaginative use of colour and crafts would translate well to a country situation and offer an alternative to the more predictable old-world look. The clients' brief stipulated 'a room that could double as a family area and still be smart enough for a dinner-party'. Since the original room was very long and could have ended up looking like a corridor, the positioning and form of the various work areas were crucial. The section with a central island is based on a keyhole space, allowing the cook to prepare meals while the family and guests can pass without hindrance. The dishwasher is raised above the level of the work surface in order to mask the kitchen sink from the dining-table. The units are made predominantly of cherry wood, with friezes painted by Lucy Turner.

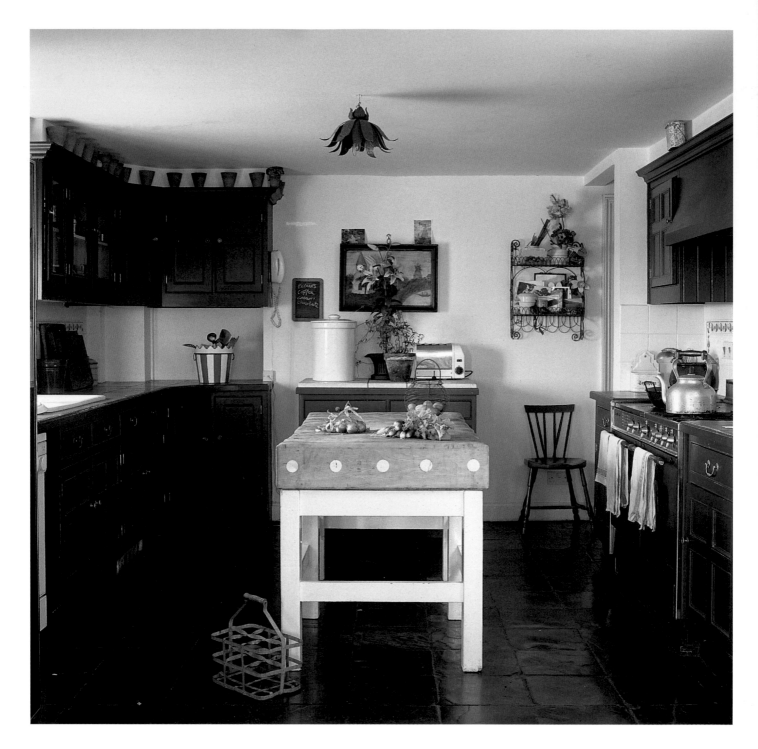

Horticultural allusions

This kitchen is in a house which has grown from a small, gardener's cottage to a five-bedroomed house for a family. In the functional part of the room, the floor is laid with slate, an old butcher's block provides a solid work surface, and a row of small terracotta flowerpots along the top of the cupboards alludes to the cottage's horticultural past. In the conservatory area of the kitchen, a gothic window throws light onto a table used for cutting flower, and baskets hover above a fine dresser made specially for the room by Lou Quenton. (More views of the house are on page 46 and 126.)

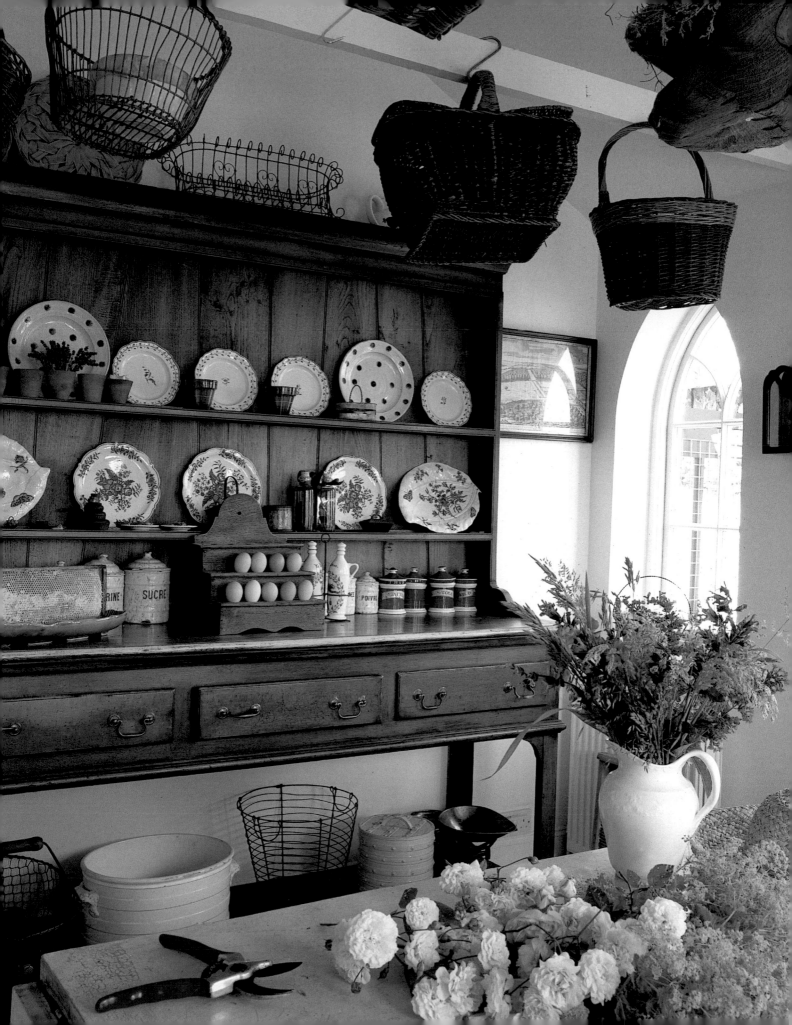

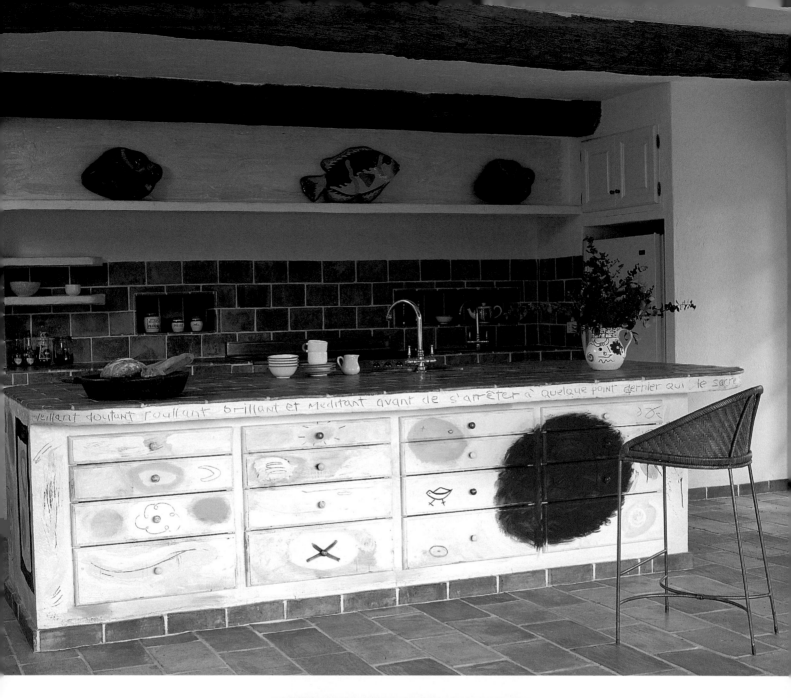

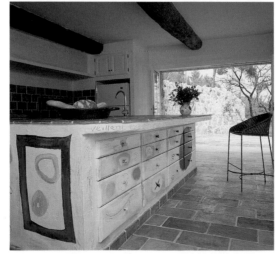

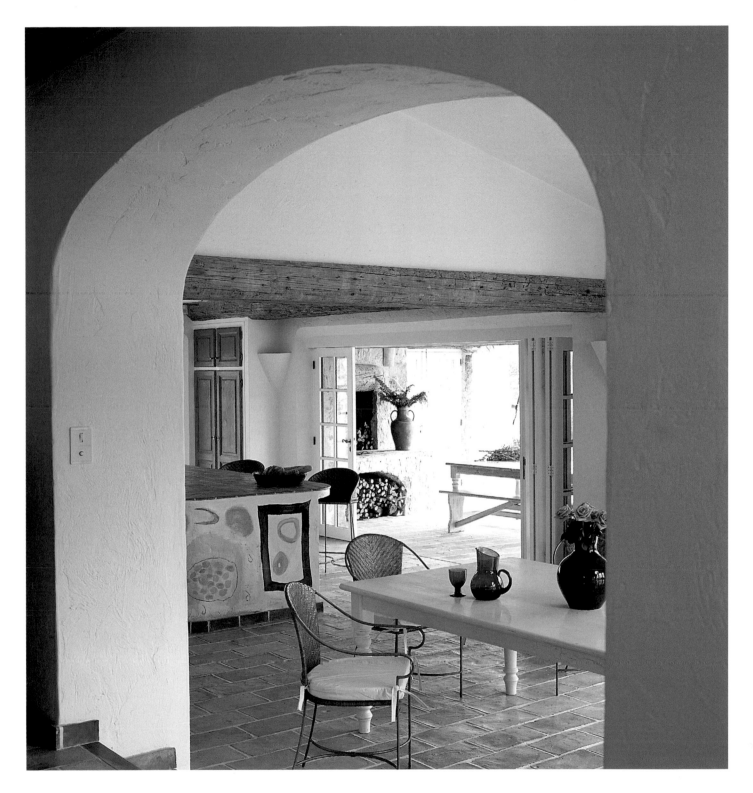

Local colour

A substantial, island unit, 3 metres (10 feet) long and over a metre (3½ feet) wide, acts as a breakfast bar separating the kitchen and dining-area in this house in the South of France. It is also a storage space, incorporating cupboards and drawers beneath the tiled top. But functionalism is not the island's only characteristic – the unit is a work of art by Felix Delmer evoking memories of artists who lived in the locality and were inspired by the landscape, colours and light. Here are echoes of Matisse, Picasso, Chagal, Miró and Léger, lending joyful character to practicality. (See, too, page 86.)

Granite and steel

The current look in kitchens for country cottages is mainly nostalgic, with free-standing dressers and natural-wood units. But, as this room eloquently shows, a more forward-looking design can be extremely successful. In a picturesque, seventeenth-century house in the West Country (see, too, page 184), the long, low, white-beamed room has been painted a warm shade of plaster-pink, and one entire wall has been given over to an unbroken run of granite-and-steel fittings. Opposite the Aga in the chimney recess is a large built-in, glass-fronted fridge – a sleekly modern contrast to the big, oak table by Ed Nicholson and the traditional French garden chairs. Leading off the kitchen is a china-room-cum-wine-cellar, shown above, where the stone walls have been painted bright red to set off the blue-and-white tableware.

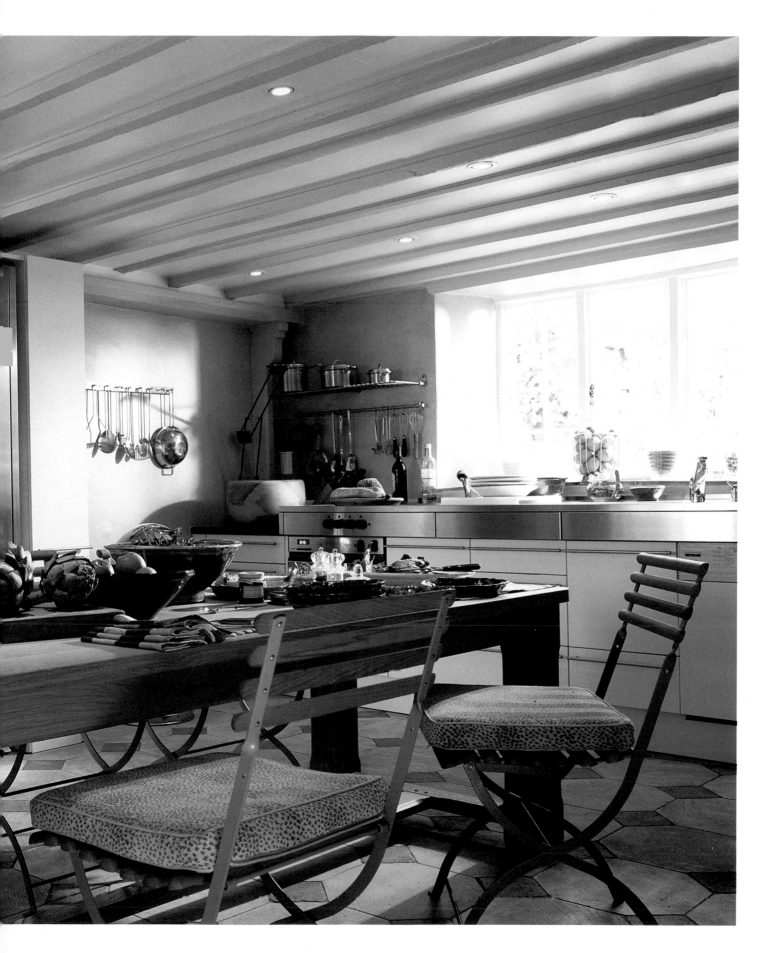

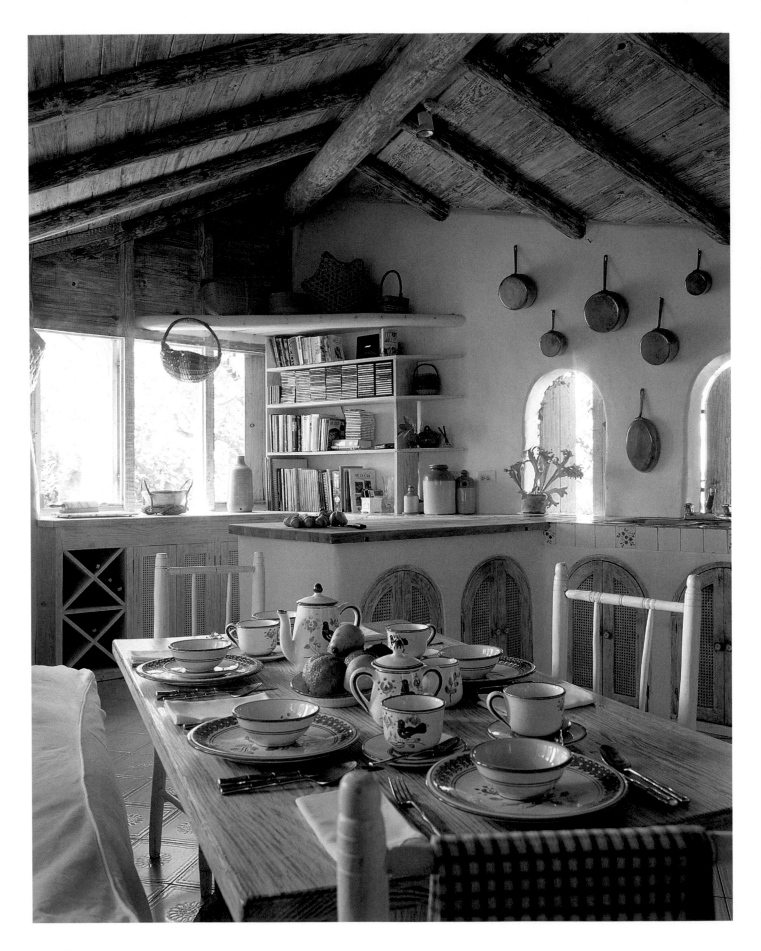

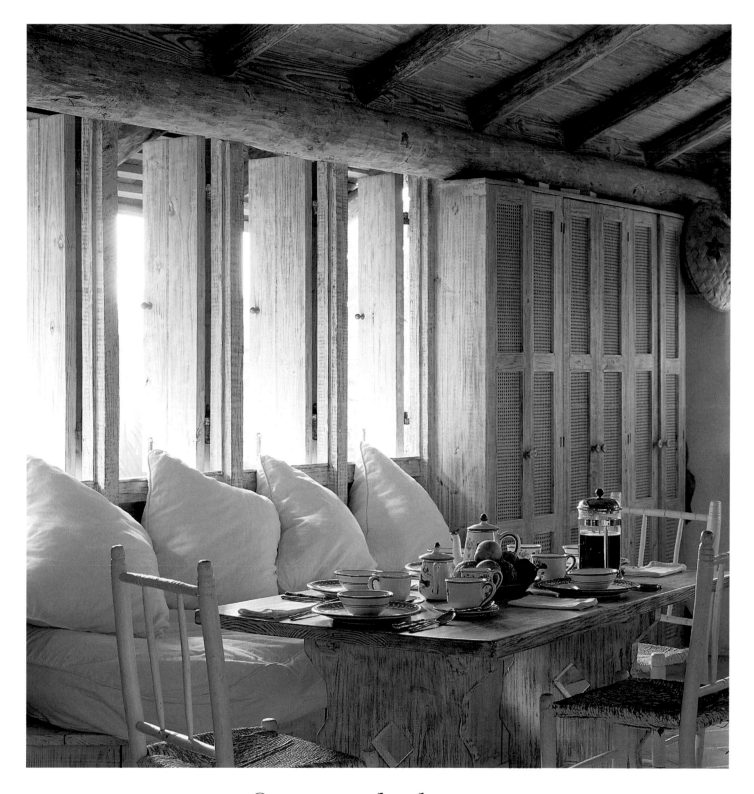

Open to the breeze

In order to keep the interior as cool as possible, this kitchen in the Caribbean has windows on three sides and is open to the roof. Here, as in the rest of the house (see page 68), the decoration is very simple: 'with such a profusion of dense vegetation all around, and the spectacular backdrop of blue sea and sky, additional pattern and colour would have looked messy and confusing,' says interior designer Judy Johnson. The cupboard doors – made of limed wood to match the room's structural woodwork – have openwork panels which are attractive and practical in a humid climate.

Painted gingham

'A complete jumble of old and new,' is how William Yeoward describes the blue-and-white china which fills the dresser in the kitchen of the 1830s village schoolhouse which he and interior designer Colin Orchard have turned into a country home. The kitchen has an extrovert, rather French character emanating from the large-scale 'gingham' handpainted onto the walls. 'It was the only way to get a bold enough scale and the right sort of texture,' says Colin Orchard. Inevitably, life centres around the Aga, so the table is placed conveniently nearby. The blue-painted chairs are copied from a French country classic. (The schoolhouse drawing-room is on page 36 and a bedroom on page 194.)

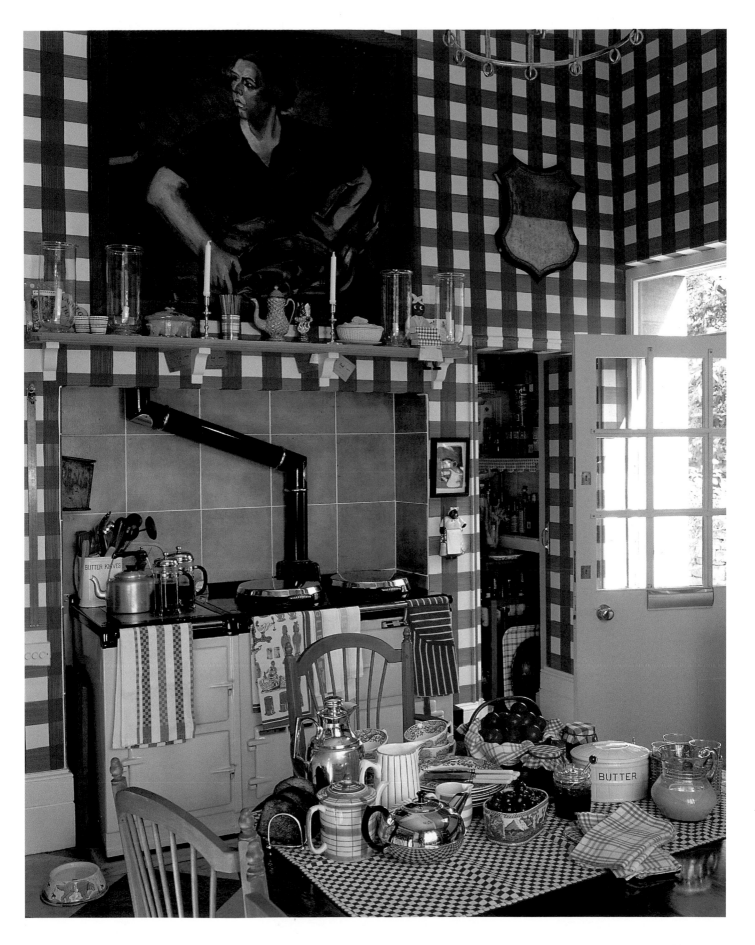

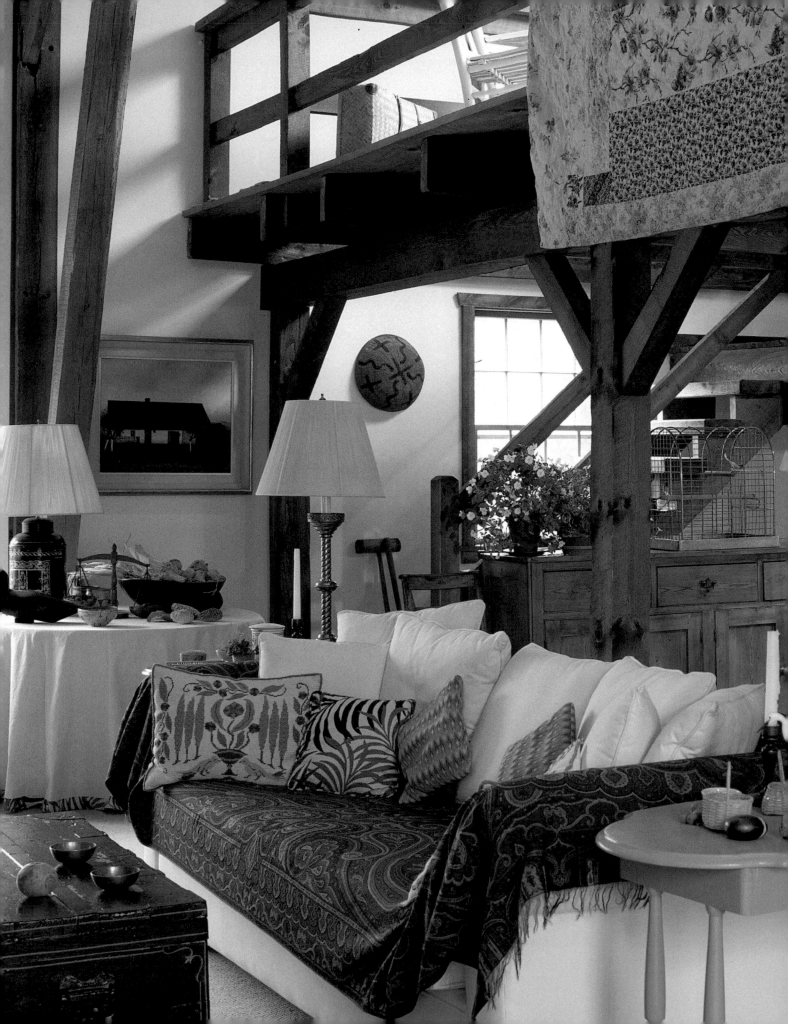

OPEN-PLAN

An open-plan layout is not a universal solution: it only works satisfactorily for people whose characters and lifestyles are relaxed. However, when well designed and well suited to the users, an open plan is enjoyable, adaptable and functional. Incorporating the kitchen within the general living-area is a particularly good arrangement for a holiday home where lots of people come and go, and where there is no rigid routine for meals, as it enables conversation to be maintained between whoever is cooking and the rest of the family and guests. Two homes with open-plan rooms ideally adapted to casual, country living are the log-cabin in Colorado (page 156) and the 'barn on the beach' in California (page 176). The farmstead on an Australian sheep station (page 172) is furnished rather more formally but it still has an easy-going, welcoming atmosphere.

Old barns have the sort of space and proportions which adapt well to open-plan conversions. In this layout, the stairs to the gallery and bedrooms are unenclosed, which adds to the room's feeling of openness. The division between the sitting- and dining-area is marked by a large sofa and, above, by an antique patchwork quilt. On the sofa, a nineteenth-century Paisley shawl is used as a throw. The room was decorated by Anne Vincent.

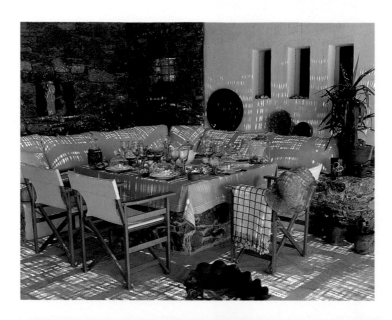

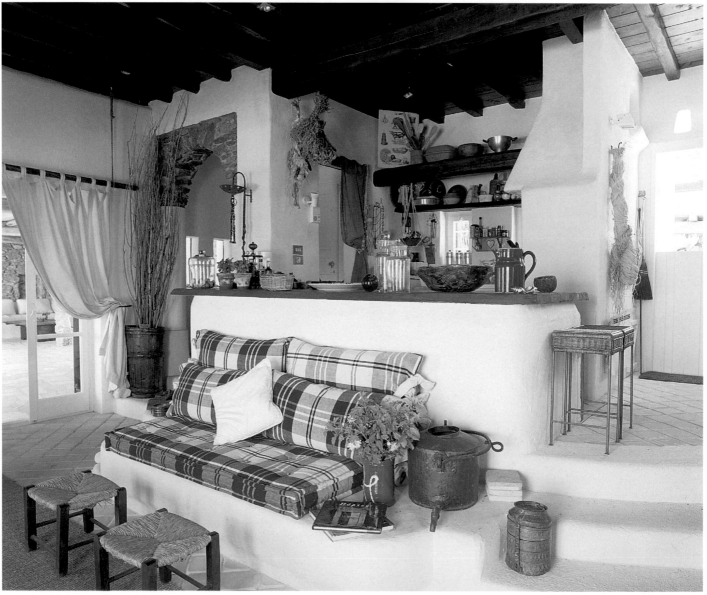

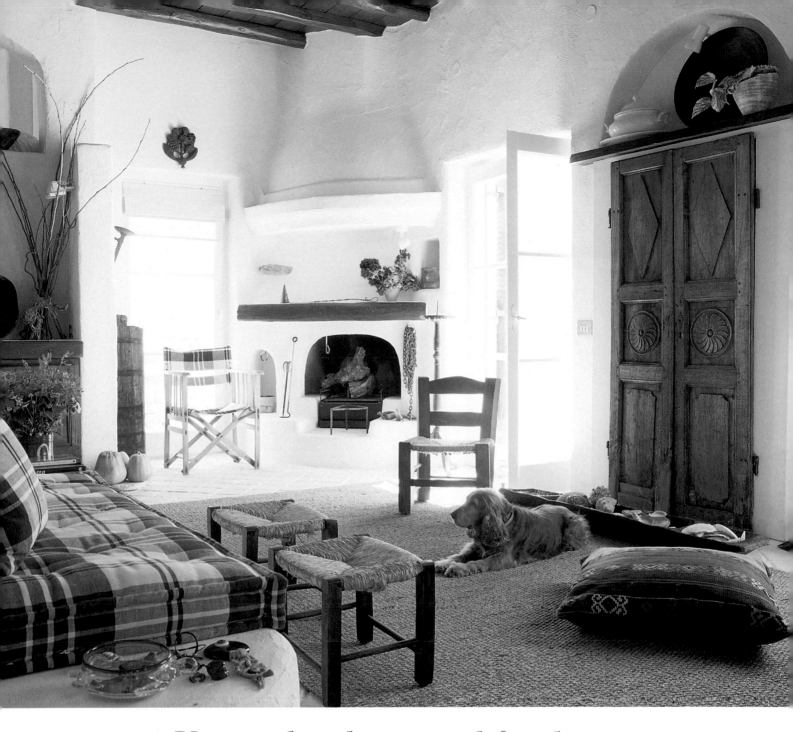

Vernacular shapes and finishes

With its vernacular forms and brilliant-white masonry, Greek-island architecture is well complemented by graphically-patterned textiles. Here, in Evi Minaidis's recently-built house on the island of Mykonos, a bold blue-and-white check fits the bill and has a contemporary flair. The room, which opens onto a sheltered outdoor dining-area (opposite, above) is perfectly arranged for a relaxed, holiday lifestyle: the kitchen has a counter which can be used as a table as well as a worktop; there is built-in seating with comfortable, mattress-like cushions; and an open fire provides a focal point on chilly evenings. The chimneypiece, which is built in three tiers and fills an entire corner, is charmingly idiosyncratic and symbolizes the rural, local character of the house. The room has different floor levels, masonry platforms, heavily beamed ceilings, numerous niches and a combination of small and large windows, all contributing to an animated entity. The colour scheme, chosen to echo the cerulean skies and vivid hue of the Aegean sea, is enhanced by natural-coloured matting. The curtains are hung from poles suspended simply on ropes. Throughout the room are decorative, ethnic objects, collected by the owner on her travels. >

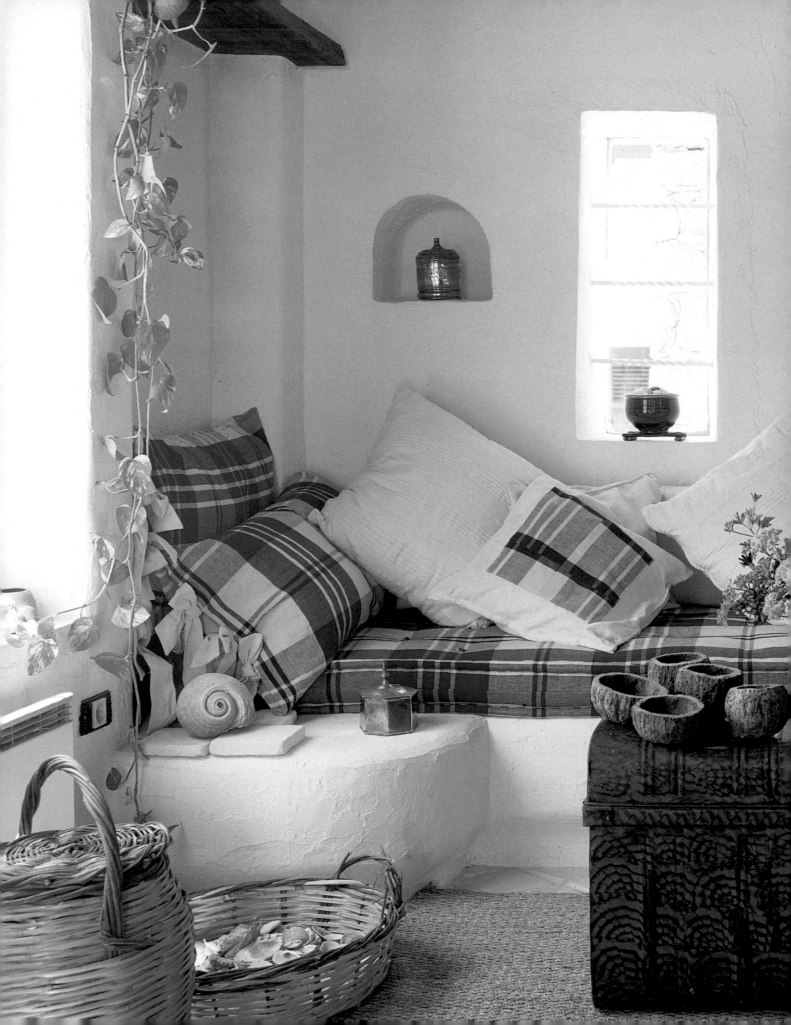

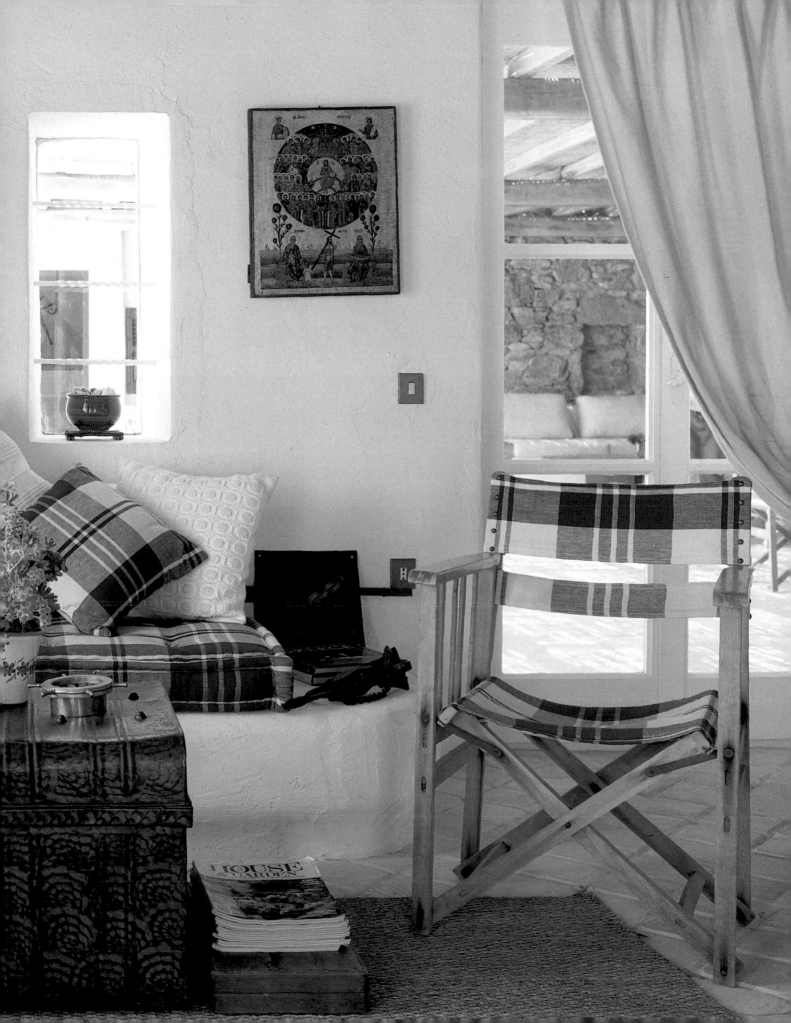

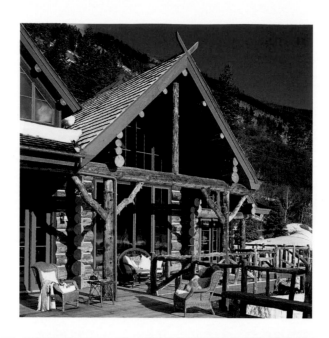

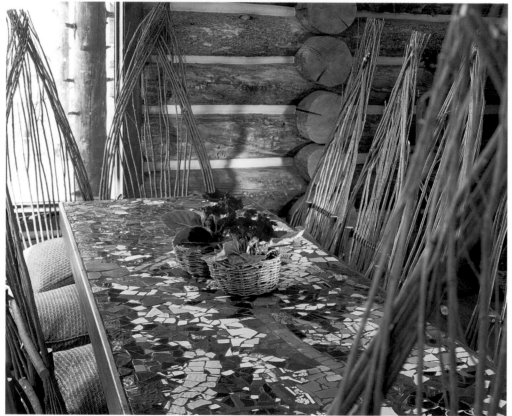

Totemic construction

For a house in a thickly wooded mountain location, timber is the totemic building material. North Star Lodge, situated in a valley just east of Aspen in the Colorado mountains, is a grand example of nature-friendly architecture, with wood used for decoration as well as construction. The scale is big, with some of the doorways six metres (20 feet) high, but the vernacular concept is humble in origin. It was Holly Lueders, a New-York-based designer of interiors, furniture and fashion, who suggested to her client, Dick Spizzirri, that the house should be built in American-West mountain style, using lodge pole pines and spruce. No trees were to be felled for the project, however – only timber reclaimed after >

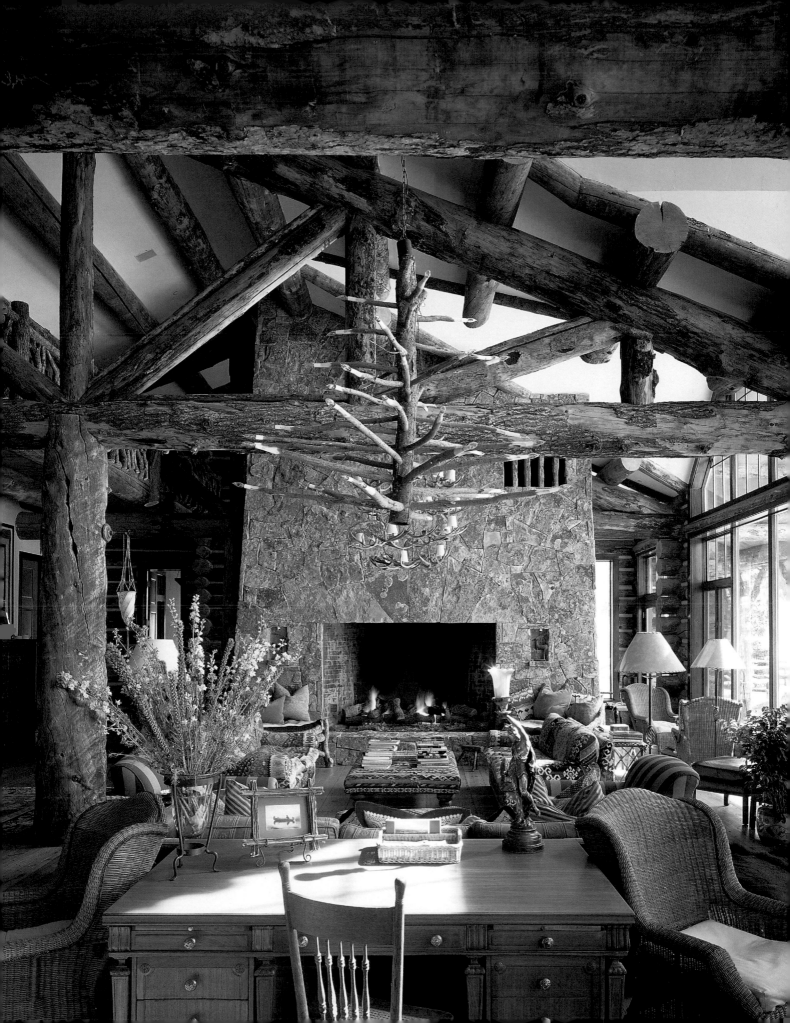

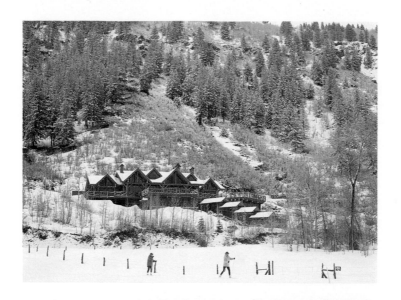

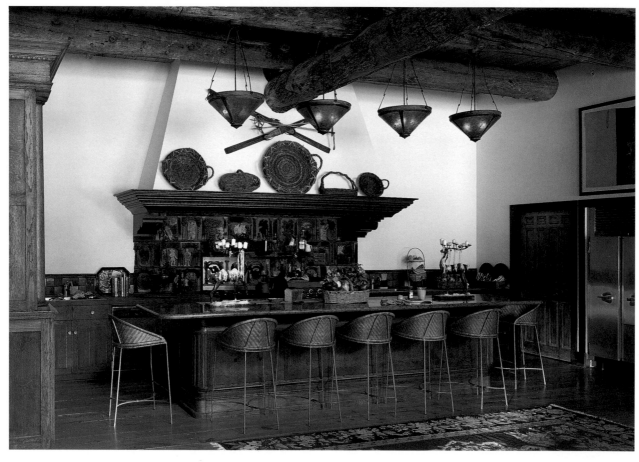

< forest fires or destroyed by beetles was to be used. The main internal space – the 'Great Room' – is multi-functional, combining kitchen, dining-area and sitting-area. It also includes a minstrel's gallery which, when the house is full of family and friends, is used as a 'tree-top' bedroom for children. This is reached by a rustic, spiral stairway. The Great Room's sitting-area is dominated by a vast stone chimneybreast and is lit by a wood-and-antler chandelier of equally impressive proportions. In the dining-area, the chairs have backs made of tied willow branches, and the table has a mosaic top made by Holly Lueders using fragments of tiles. The kitchen area has a nineteenth-century counter from a dry-goods store, but the *pièce de résistance* is behind the hob – a series of 'Tiles of the New World' by Henry Mercer, a leading figure in the American Arts and Crafts movement and founder of the Moravian tile factory in Pennsylvania. Holly Lueders had the tiles remade from the original moulds which had lain untouched for half a century.

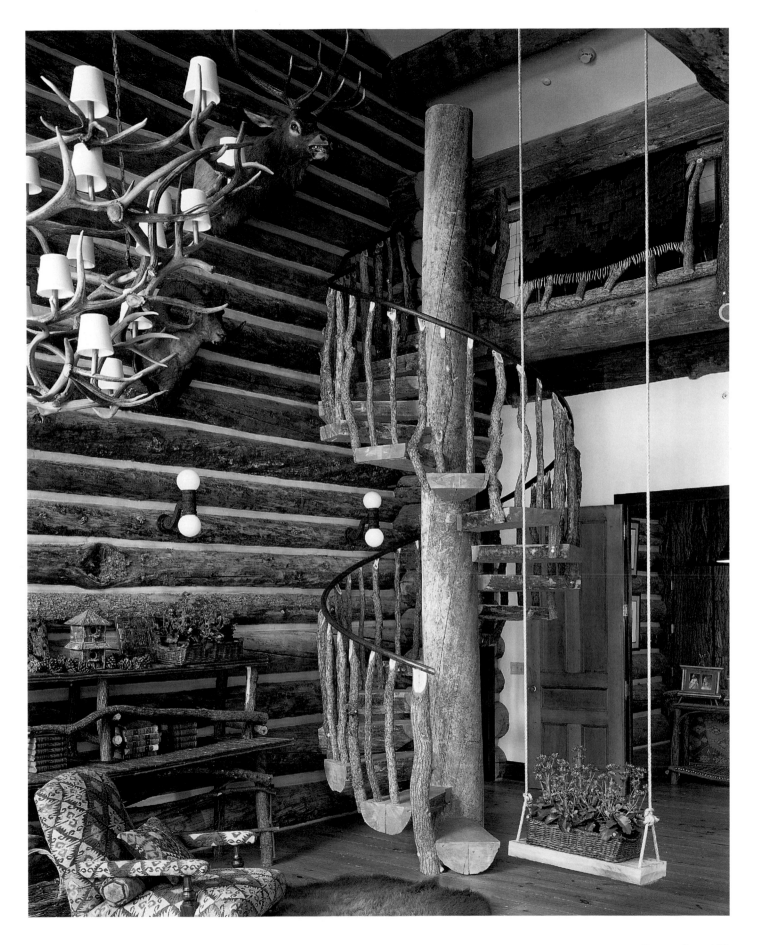

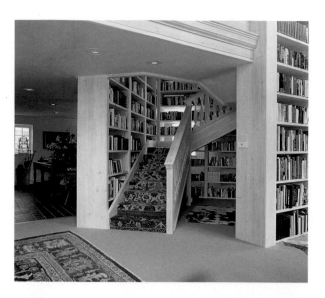

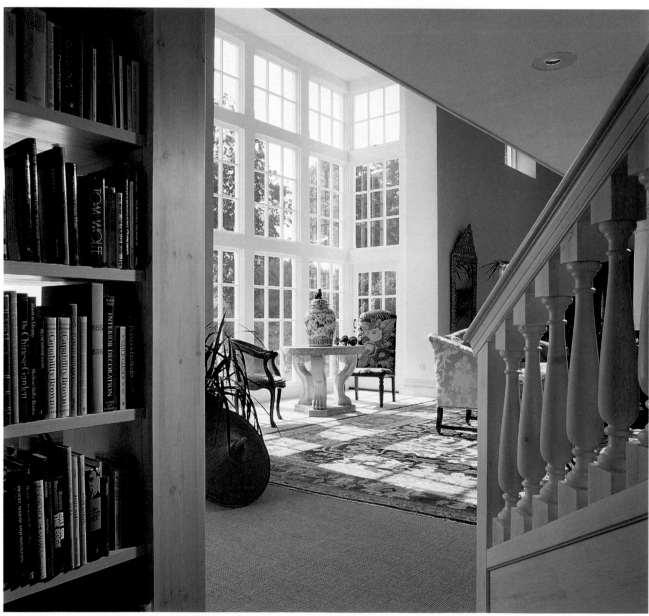

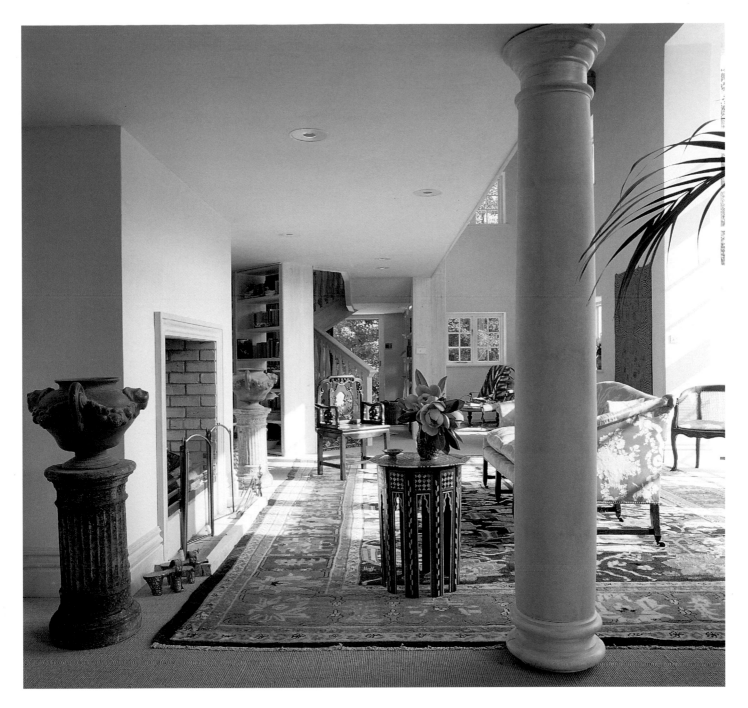

A tower of books

When American novelist Roberta Latow moved to Wiltshire, she took on a ruin which was romantically sited but, as it turned out, unrescuable. Forced into starting afresh, she and her architect, Sir Anthony Denny of Verity & Beverley, used materials meticulously salvaged from the ruin to build a new, open-charactered house with double-stacked windows through which light streams to the very core of the interior.

'As I write indoors most of the time, I need a light atmosphere and one where I can wander round and not feel confined.' One of Roberta Latour's main concerns was to avoid the potential claustrophobia of a traditional library. Sir Anthony Denny devised a staircase within a tower of books which is eminently practical as there is good access to the shelves at all heights. Around the staircase-library at >

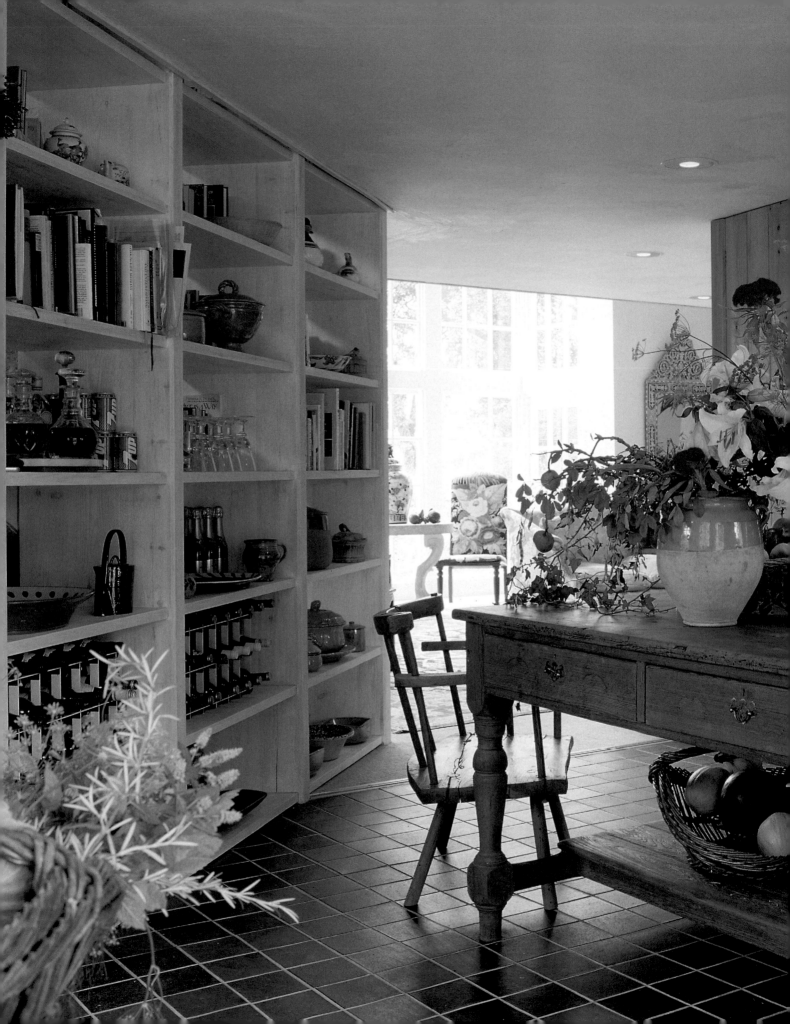

< ground level are disposed, in a free-flowing progression, the sitting-area, dining-area and kitchen. Furniture is widely spaced out in order to maintain the airiness of the architecture. On the upper floor is the study (above), where storage is catered for in rows of decoratively covered box-files in open shelving – again avoiding any feeling of claustrophobia. Ample storage is essential in every house but its possibilites as a decorative as well as a functional feature are rarely as well considered as they are in this interior.

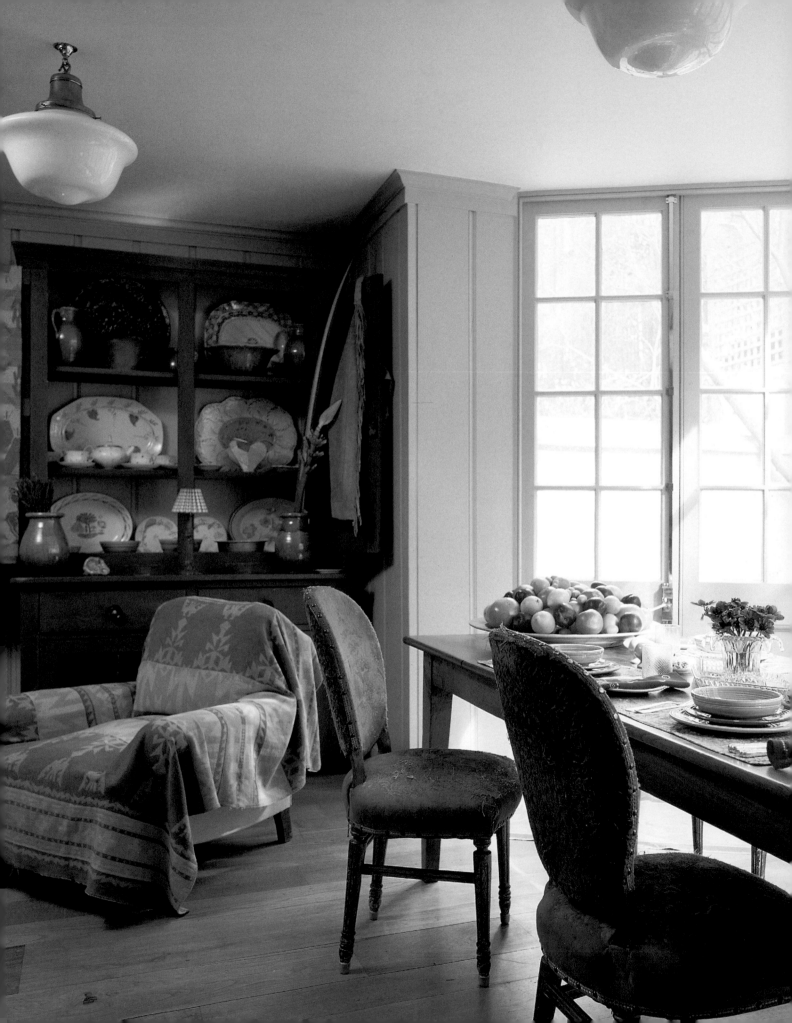

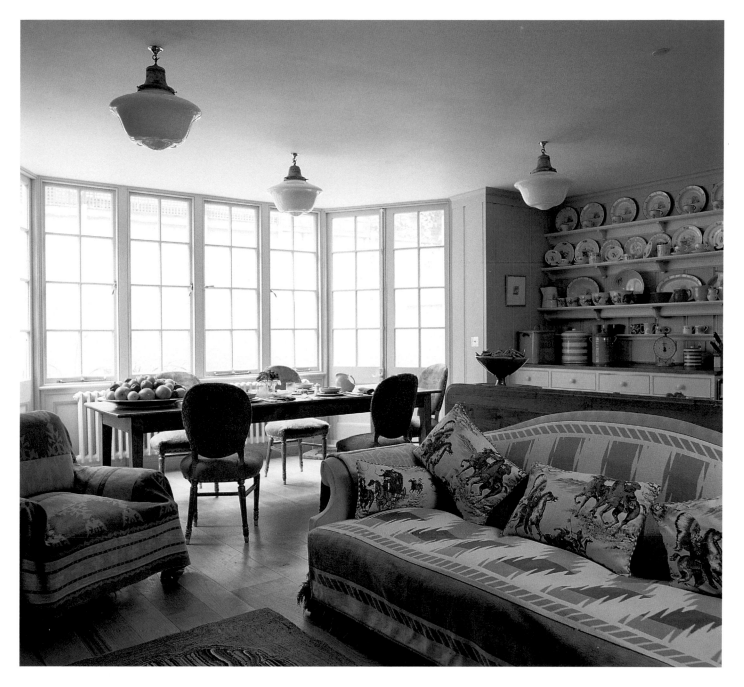

Zestful china and Wild West emblems

A web of six small rooms and pantries in an Edwardian house in Chelsea was untangled to make this large, family-orientated space which trebles as kitchen, dining-area and informal sitting-area. The colours, finishes and general ambience of the room are highly individual and far less

town-like than the location would suggest. The walls are faced with painted wood boarding which is wider than usual and has good depth of relief, giving a satisfyingly robust effect. The zestful china, patterned rugs and cowboy cushions all reflect Carlyn Hunter's interest in Fifties >

< design and in the artefacts and tokens of the Wild West. The rugs which are draped over the seating and hang on the door of the dresser are typical Red Indian designs made in the States at the Beacon and Pendleton Mills and originally sold at trading posts. Opposite the window bay, with its long, country table, is what appears to be a large free-standing cupboard with wooden doors, but in fact is a deft piece of disguise. The door at left conceals a broom-store; the one at right hides a refrigerator; and the door in the centre opens into the larder. In the middle of the room, separating the kitchen from the seating-area (which cosily includes a fireplace) is an enormous, French butcher's block.

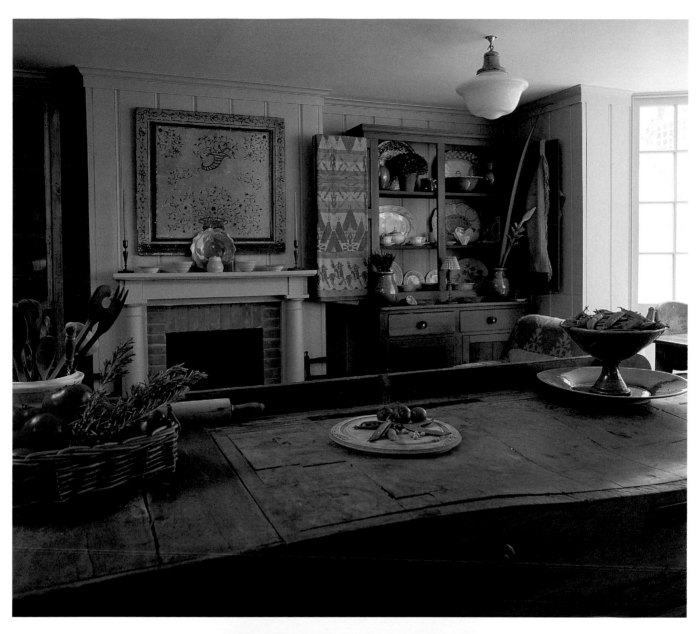

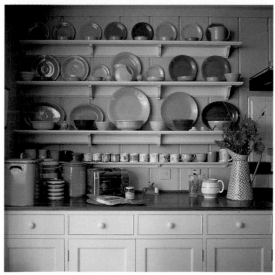

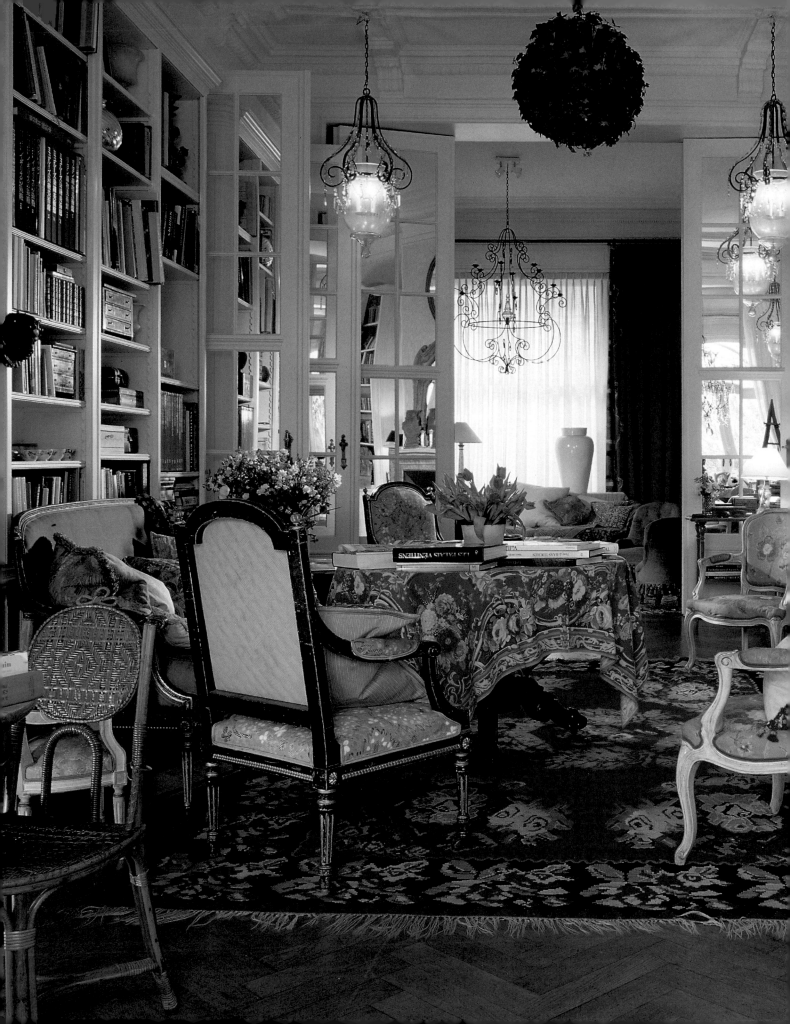

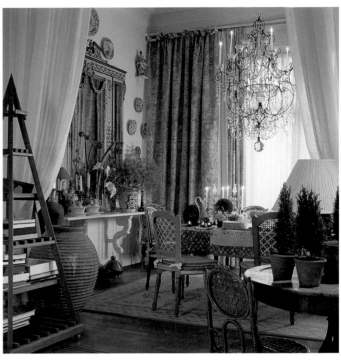

Surrounded by colour, inspired by Delft

For textile designer Isabelle de Borchgrave, creating patterns is a full-time way of life. Not only does she spend her working hours amidst decorative fabrics, but at home she surrounds herself with lively colours and motifs. The ground floor of her country-style house in Brussels was already open-plan when she moved there, and she chose to keep that layout but to define specific areas by using different colour schemes. The main sitting-area is furnished as a library, with large bookcases to either side of the fireplace. Red predominates in the Bessarabian rug and nineteenth-century-style cloth. A pyramidal *étagère* marks the division between this part of the room and the dining-area which is >

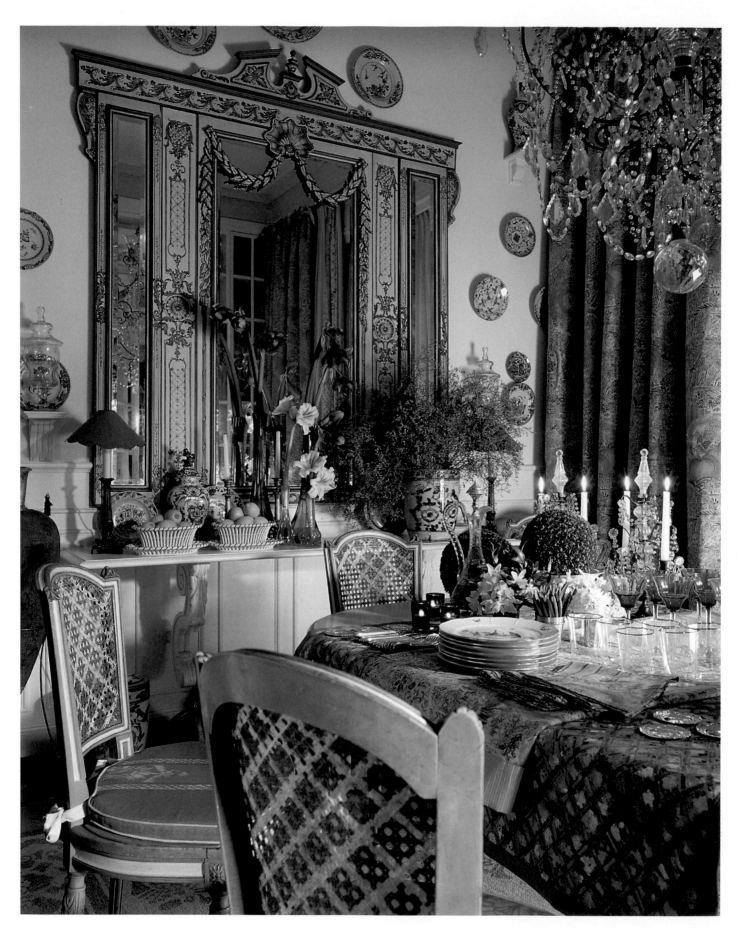

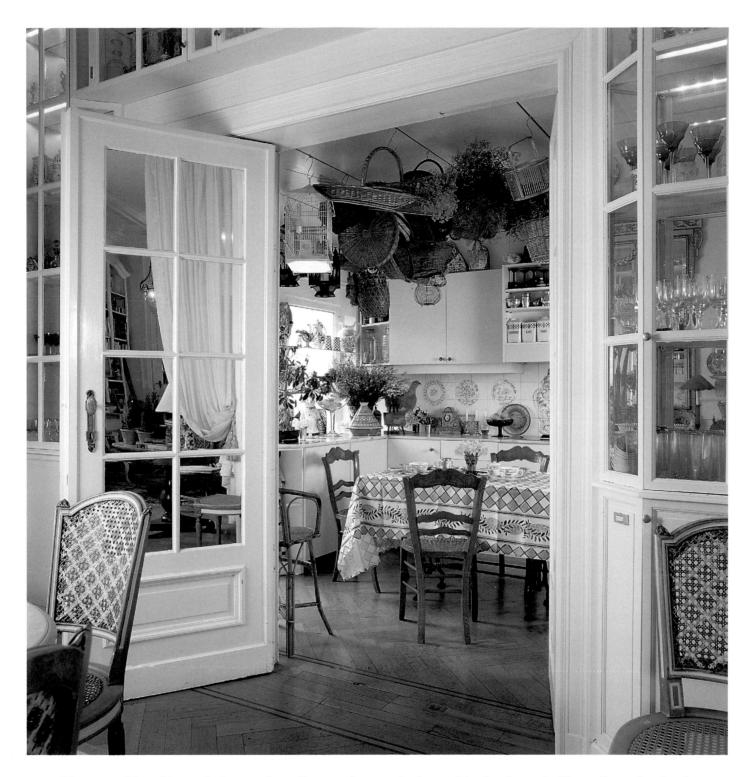

< a sparkling ensemble in blue and white, with a collection of Delftware being the leitmotif. The spectacular mirror, with its painted Delftlike surround, reflects the delicately-swagged chandelier. Next to the dining-area is the kitchen, which can also be used for family meals. The walls are faced with blue-and-white tiles hand-painted by Isabelle de Borchgrave, and hung from the ceiling are baskets, bird-cages and dried flowers – all conspiring to a country image.

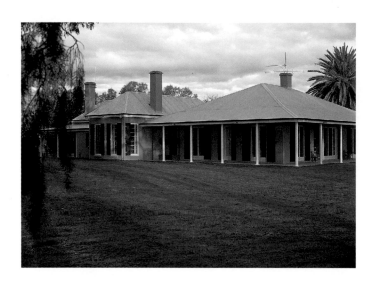

The challenge of a sheep station

Living in a house on a sheep station in New South Wales, Australia, has unique challenges, not least how to keep the place cool. John Coote, commissioned by John Waring to rebuild an old homestead, came up with a plan which aligned the front and back doors to allow a through draught, and which created a grand 25-metre (27-feet) long living-area from a series of small, separate rooms. Now, air circulates freely between the different functional zones of the interior and, in addition, air conditioning has been installed unobtrusively above the timber tongue-and-groove ceiling. At the far end of the room is the kitchen, divided from the dining-area by an English-oak counter. Next to the dining-area is an informal sitting-area, which in turn leads into a more >

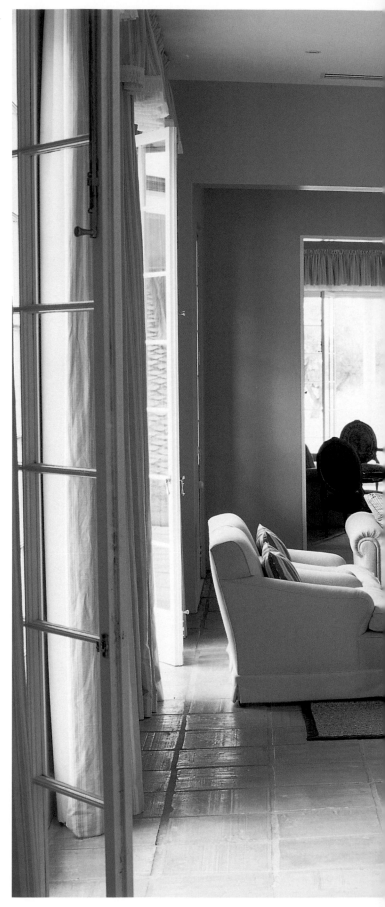

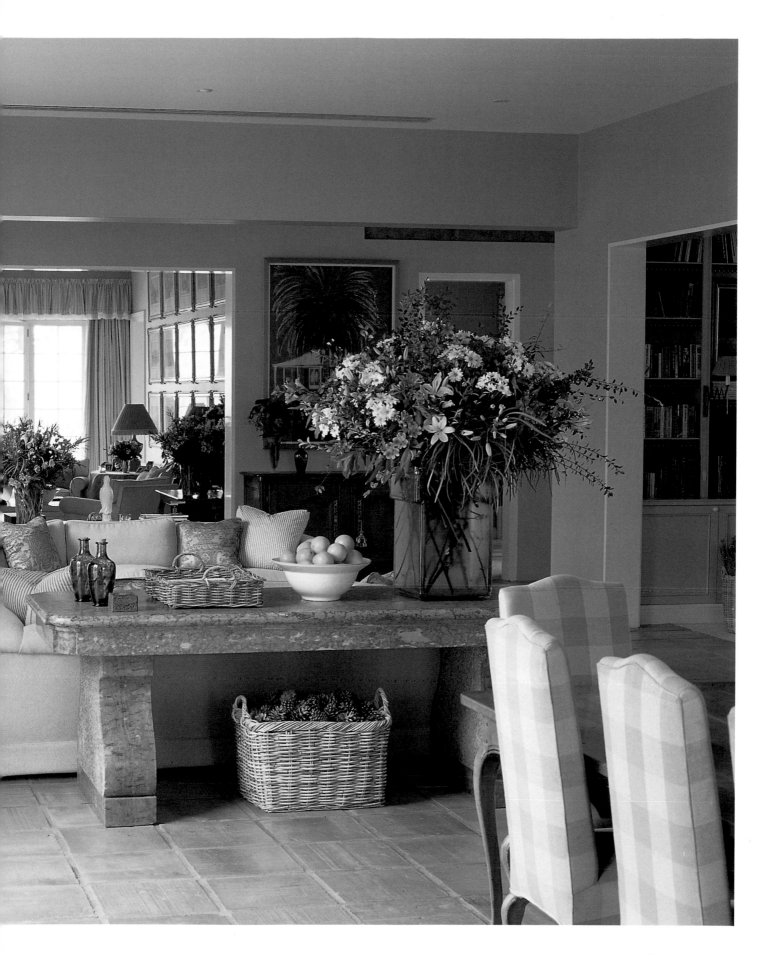

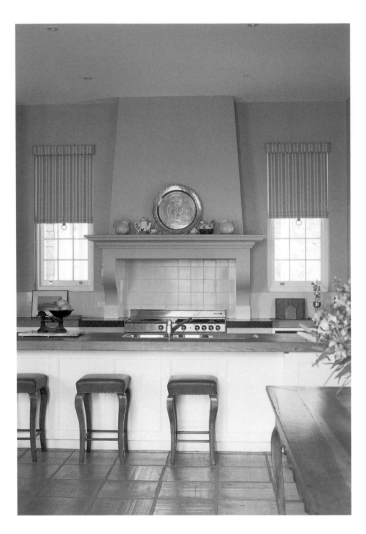

< formal 'drawing-room' area and a television area. Much of the furniture is French provincial fruitwood which, along with a handsome seventeenth-century marble table, gives the room a Mediterranean feel. The room's colour scheme, derived from the sandy shades of the landscape seen from the sequence of French windows, is underpinned by three different floor-coverings – handmade clay tiles, seagrass rugs and wool carpeting.

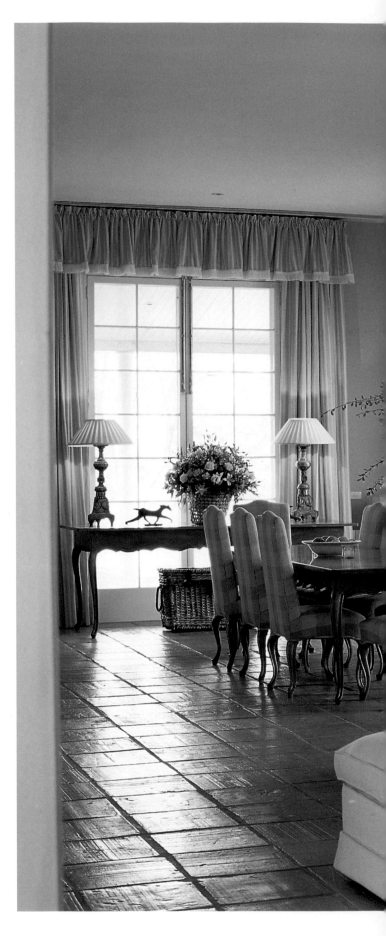

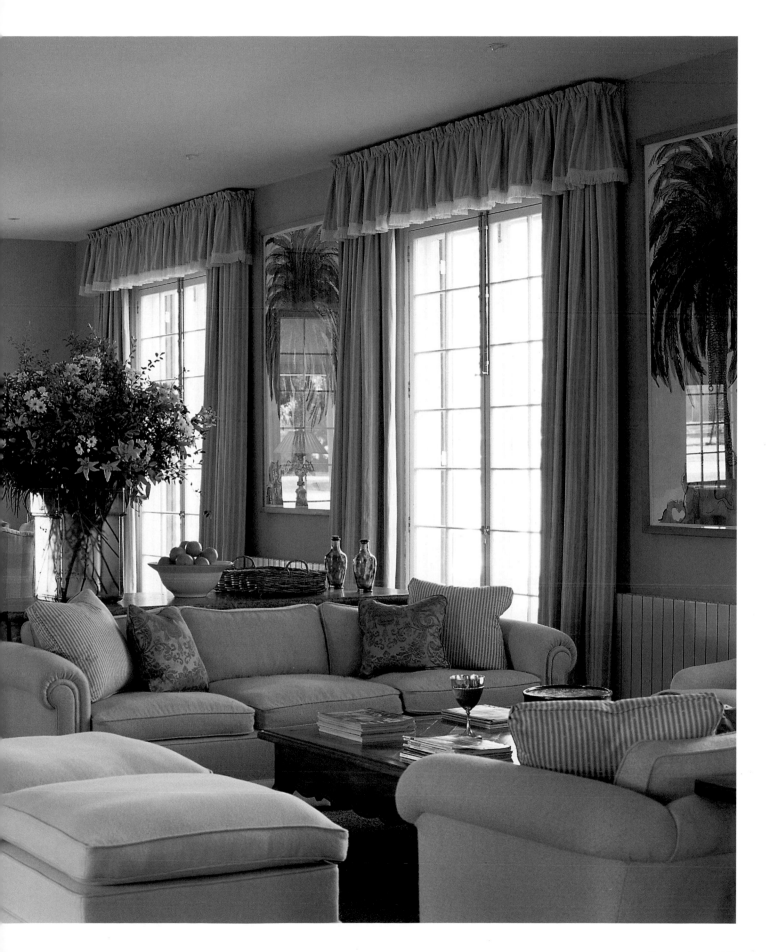

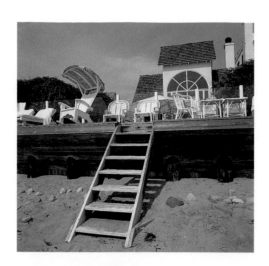

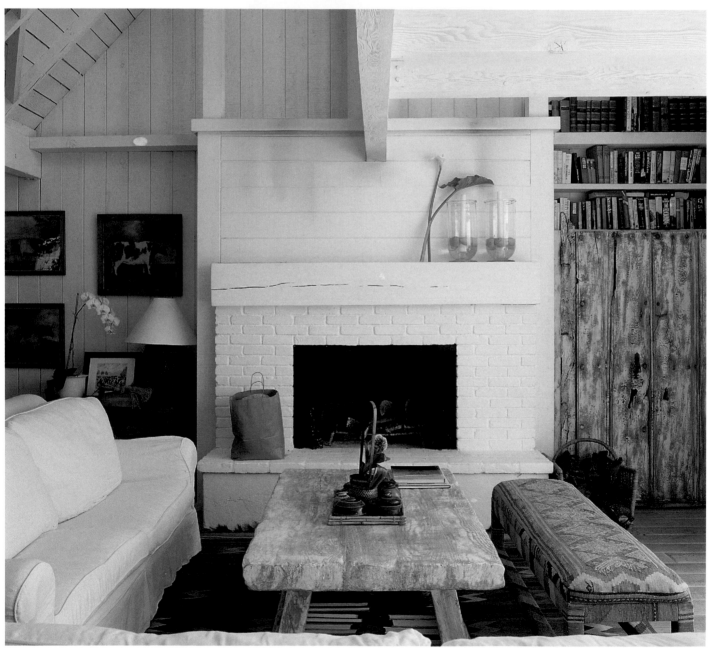

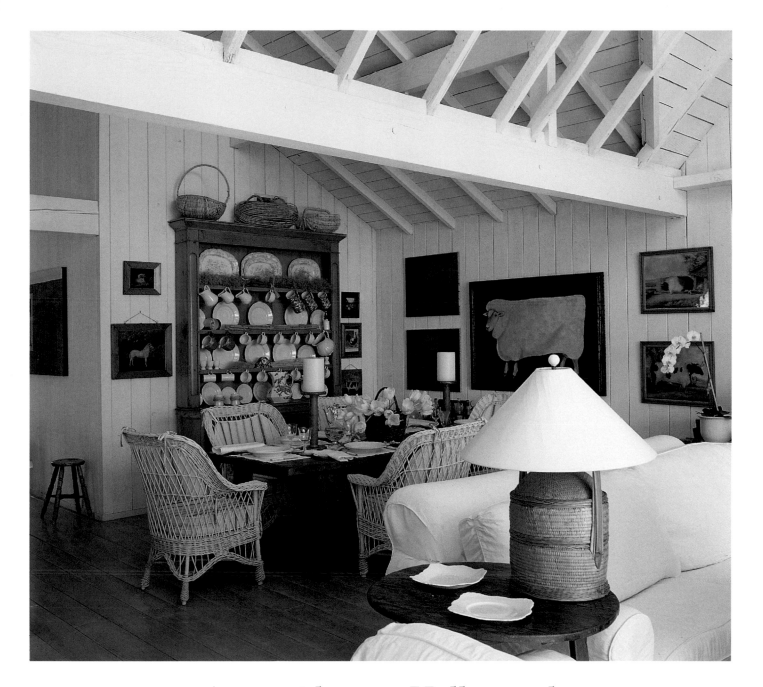

An antidote to Hollywood

What was once a poky little seaside cottage and garage at Malibu, Southern California, is now the 'barn on the beach' that Dot and Barry Spikings had always wanted – the perfect antidote to their Hollywood life. Dot Spikings, of interior-design company Barefoot Elegance, opened up the whole place to create a large, unconstricting living-area. As a busy film producer, Barry Spikings has a hectic schedule and entertains a constant stream of visitors, and both he and his wife have 'a love of chat', so it was important that the room would adapt to the demands of his working life as well as to the quieter, more relaxed lifestyle which the couple seek when they are on their own. There are no boundaries between the dining-area and kitchen, so guests can gossip with the cook. Perched above the sitting-area is a gallery >

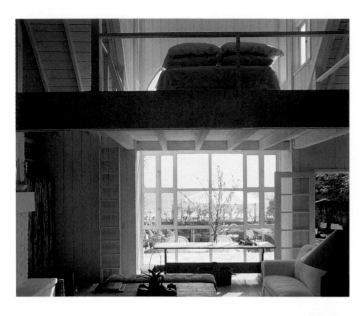

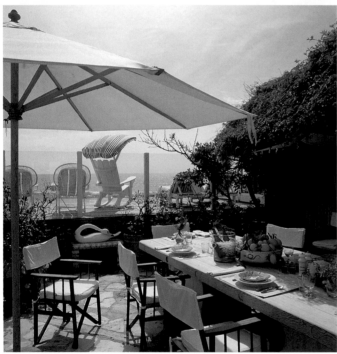

< which doubles as an extra bedroom and has a large, semi-circular window with a fabulous view. For the decoration of the cottage, Dot Spikings drew on her experience of living in the Caribbean: she was well aware of the effects of harsh sunlight on fabrics, the damage caused by salt from on-shore breezes, and the general wear-and-tear of an indoor-outdoor existence. She opted for durable materials and for colours which reflect the surroundings: white and pale sand with varying shades of blue. The effect is crisp and easy, with naïve paintings adding to the rustic charm.

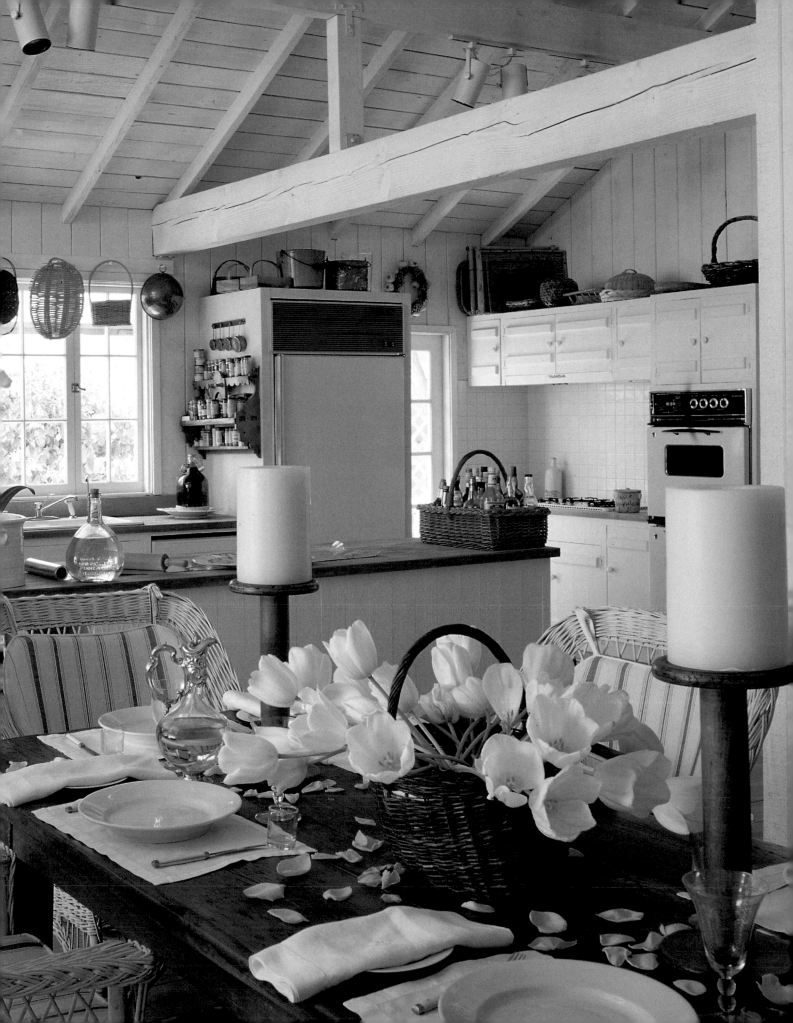

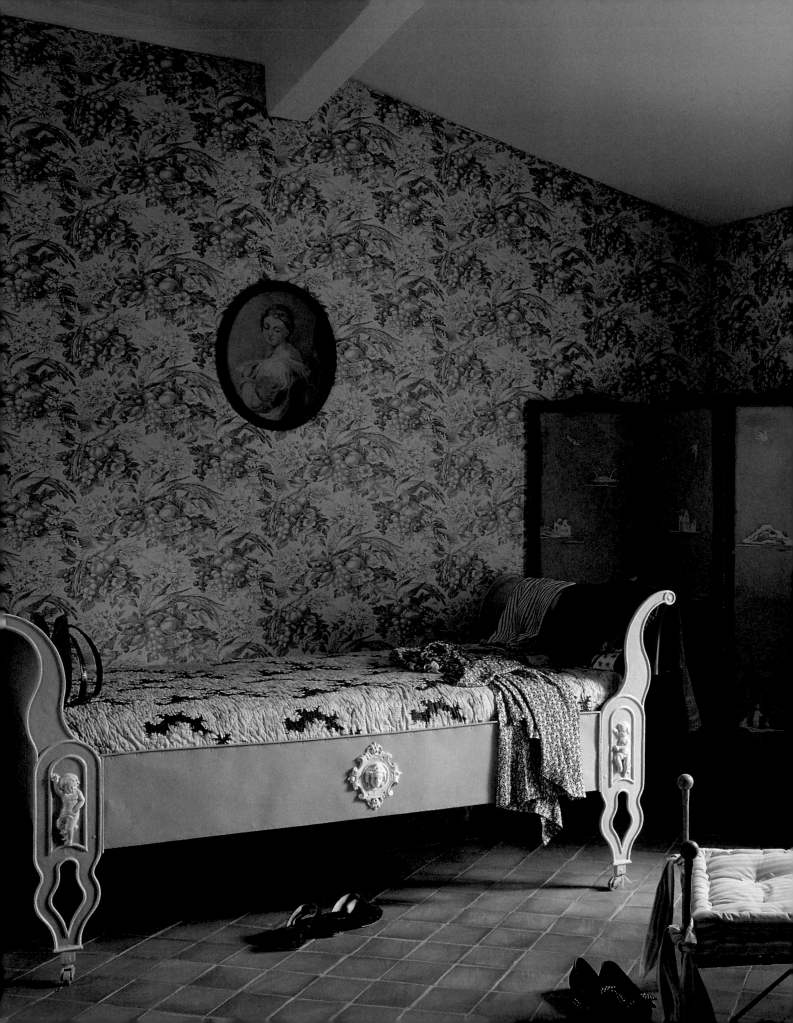

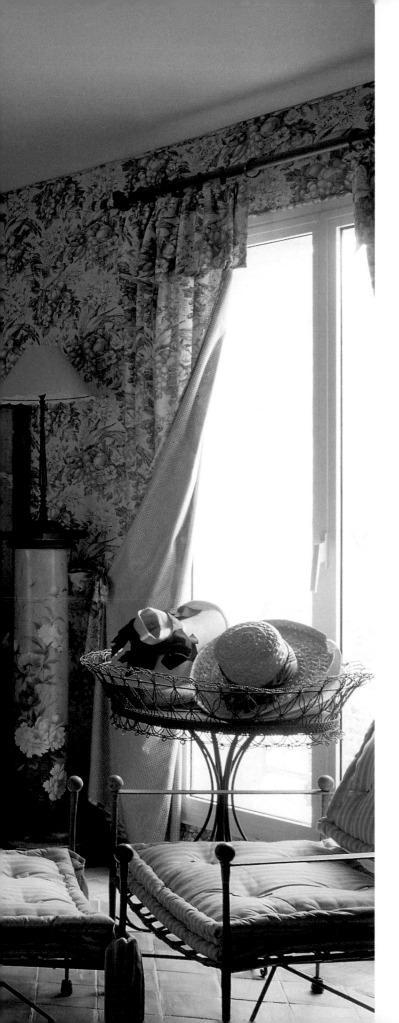

BEDROOMS AND BATHROOMS

Of all the rooms in a rural home, the bedroom is the one which has the most romantic appeal for town-dwellers who long to live in the country. To be able to sleep in a room with the windows wide open, hear the birds in the morning and never a passing car... that is true bliss. The surrounding landscape may even be the inspiration for a 'green' style of interior design: it would be difficult to imagine a more naturalistic or original bed than the one in a mountain cabin shown on page 200. This takes country decoration to the limit in its use of natural materials for a fantastical, twiggy headboard and footboard. Rather less startling, but nevertheless having great panache, is the red-and-white bed designed by François Catroux for his house in southern France (page 202). John Saladino's bedroom (page 196) is an exercise in contemporary sophistication and restraint: a tailored assembly of unfussy furniture and finishes. The room in Jenny Hall's house (page 192) also has a modern edge and uses a similarly neutral palette.

Strictly speaking, this is a dressing-room but it can double as a bedroom if needed. An exuberantly patterned blue-and-white fabric is used on the walls and for the check-lined curtains to form a consistent background for individualistic furniture. The room is in Catharine Warren's house, which is also seen on pages 32 and 112.

Bedrooms and bathrooms 181

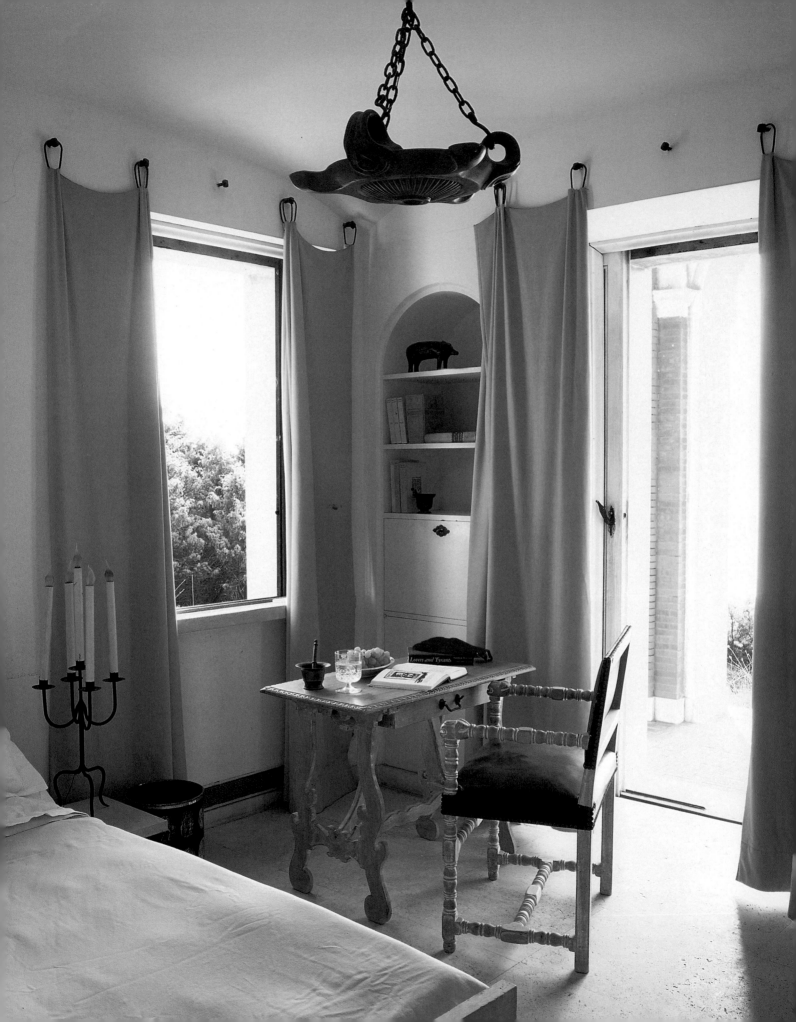

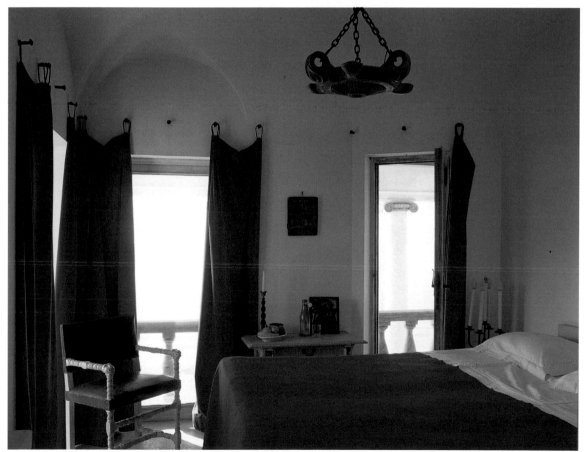

Borrowings from the Ancients

Nothing could be more basic nor more effective than the curtain treatment in these bedrooms in a house on the coast south of Rome. It comprises panels of fabric in intense colours, hung from black iron rings. Large-headed pins are driven into the wall so that the rings can be looped over them when the curtains need to be closed. It has a simplicity

reminiscent of a room in Ancient Greece or Rome, and indeed the entire concept of the villa (see page 50) is based on classical themes. The terracotta chandeliers are made along the lines of Roman oil lamps, and the walls of the bathroom have an antique finish in which the plaster is tinted with earth pigments, then waxed.

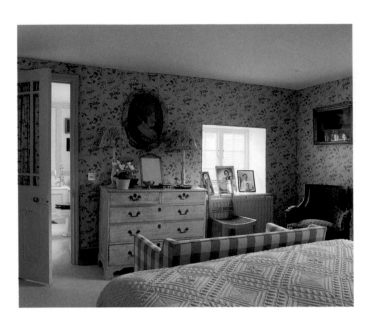

A hint of France

Although this bedroom in a seventeenth-century house in the West Country has walls lined with English chintz, there is a Frenchness in the colouring and in the treatment of the cupboards where fabric is gathered behind chickenwire. The unusual bedhead, made from a piece of eighteenth-century carving inset with mirror, reflects crisp white pillows and a bedcover of Pembroke squares. Through a fabric-backed door re-iterating the design of the cupboards is a bathroom with painted panelling in shades of peppermint green chosen to harmonize with the chintz. The house (more views of which are on page 144) was decorated with advice from Charles Beresford-Clark.

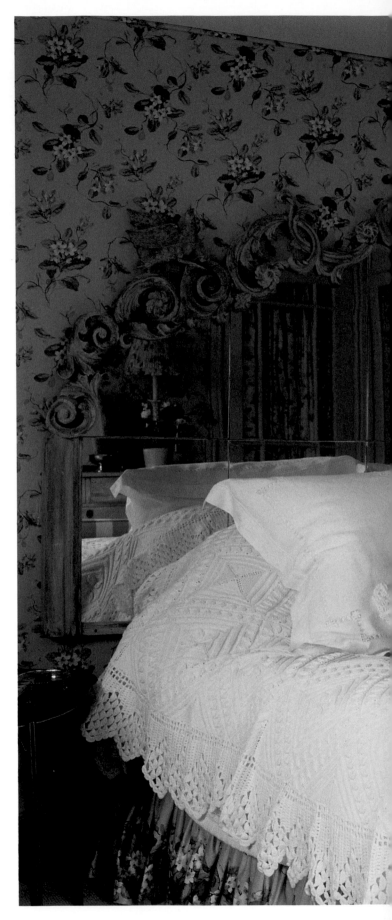

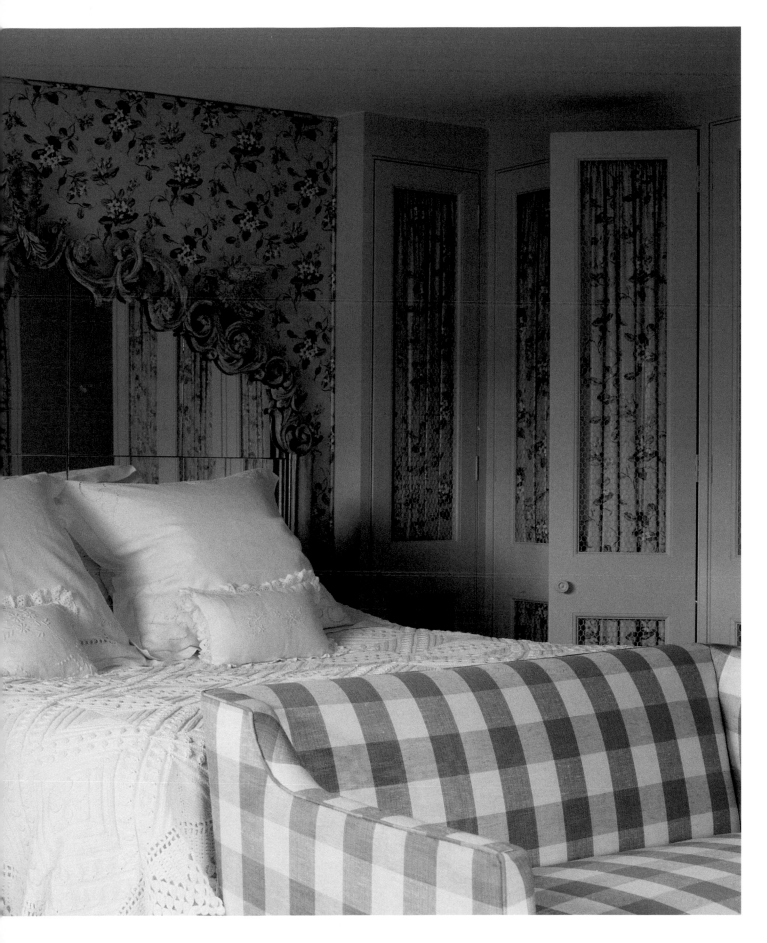

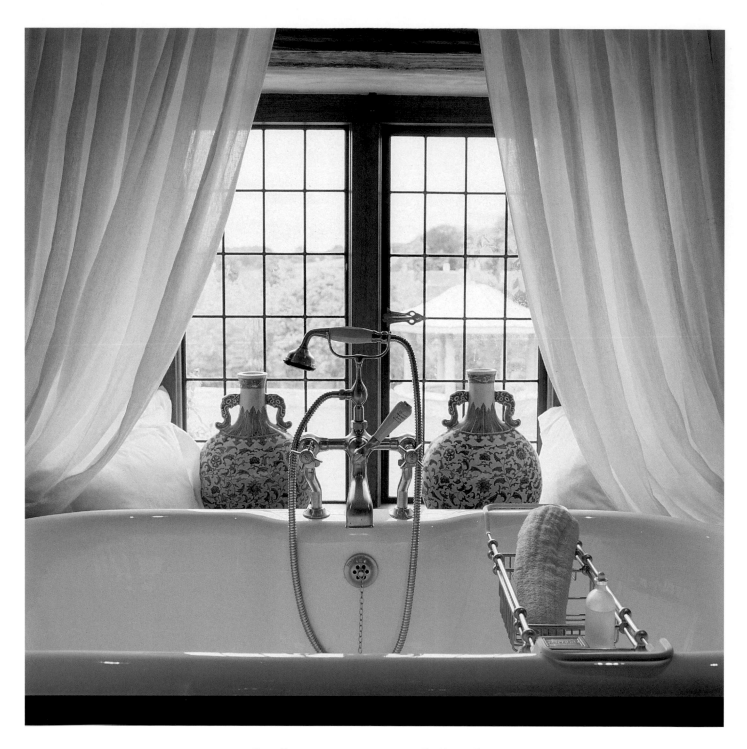

Cohesion and light

Interior designer Alison Henry and her property-developer husband spend most of the year in an apartment in Hong Kong, but when they are in England they live in a very different environment – a rambling, stone-built house in Gloucestershire. They have brought cohesion and light to the building which, previously, had a rather gloomy interior. Alison Henry likes the balancing effect of symmetry, and it shows here in the main bedroom where porcelain pots are lined up in diminishing sizes on a beam. The porcelain is also a reminder of her oriental base. The room's neutral colouring is a restful foil for the graphic lines and warm tones of the roof timbers and four-poster bed. The unpainted doors, with their large iron hinges and handles, are made in a traditional vernacular style. Even the bathroom has symmetry, with the bath placed directly in line with the window and fitted with a central tap.

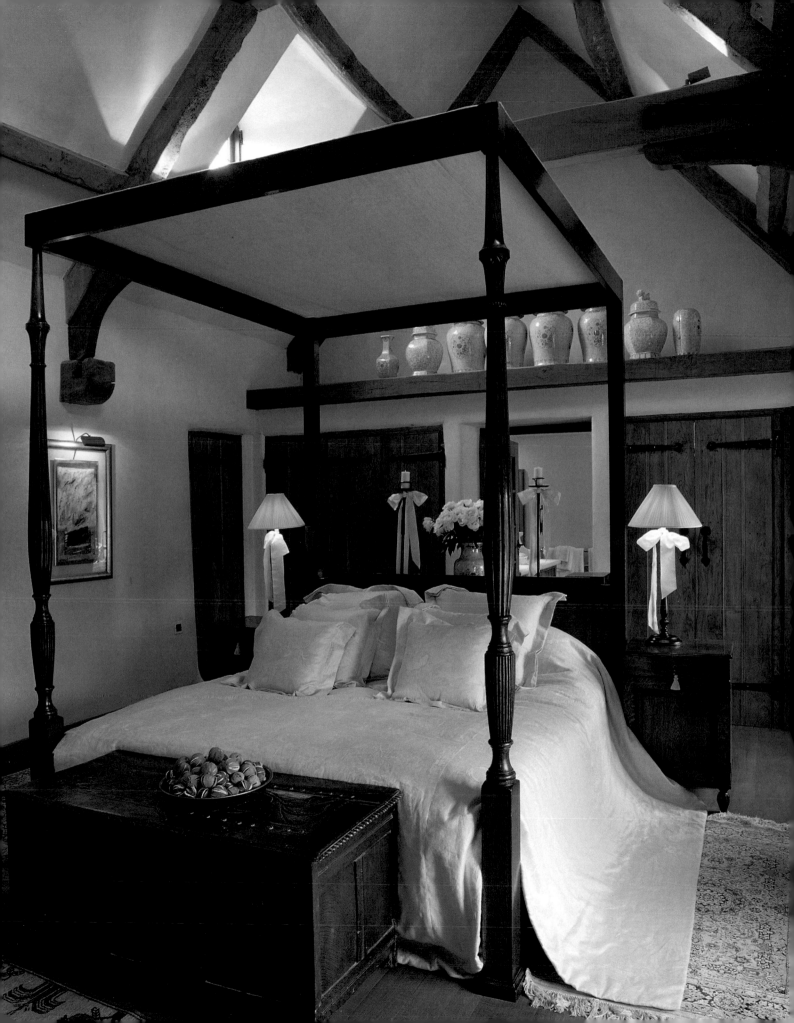

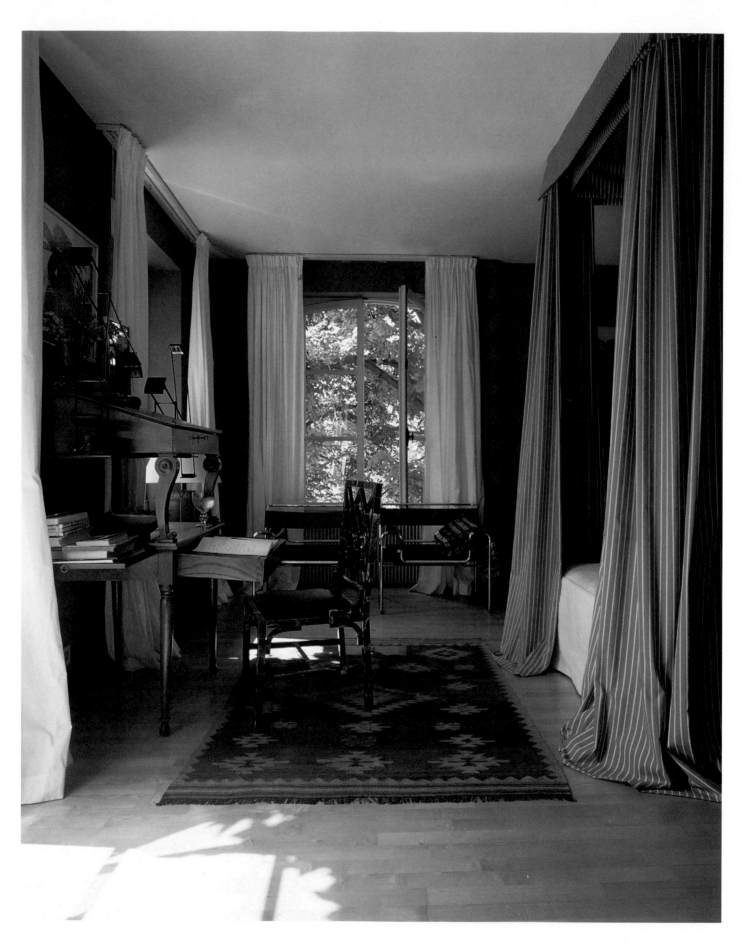

188 Bedrooms and bathrooms

Strong pinks offset by white

Decorated in shades of burnt terracotta, paprika and hot pink, Yves Taralon's bedroom has windows on three sides overlooking the garden. The striped bed-hangings are matched by pink edging on white pillows. The windows here and in the adjoining dressing-room, seen above, are curtained unfussily with plain white cotton. The furniture includes tubular-steel chairs, designed in the 1920s by Marcel Breuer, and a traditional 'column-style' bedside cupboard. (The sitting-room in the same house is shown on page 28 and the dining-room on 102.)

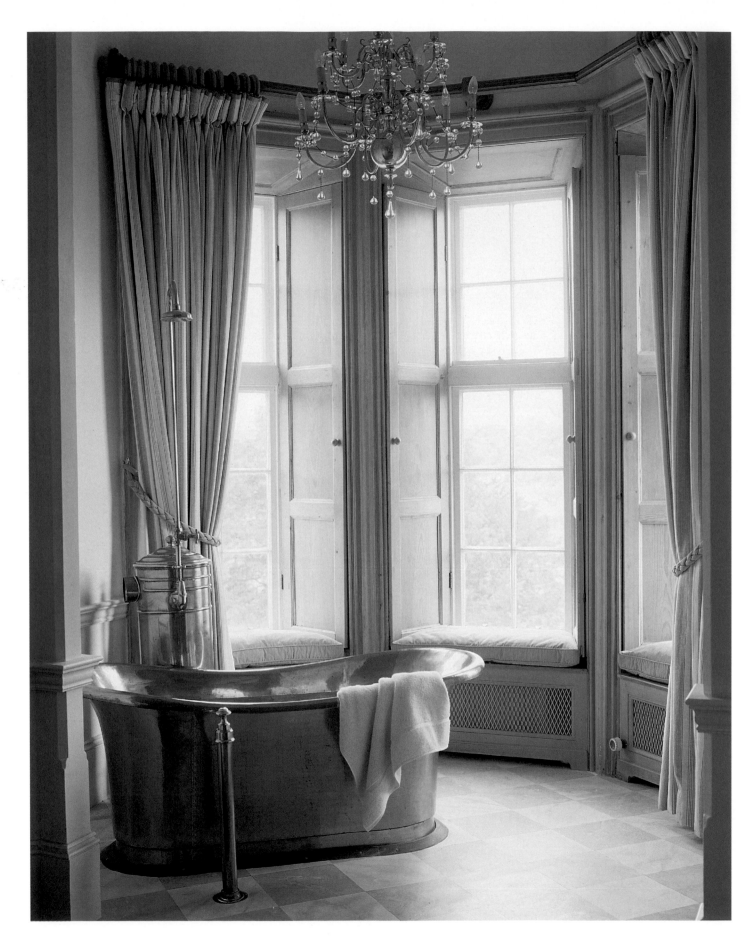

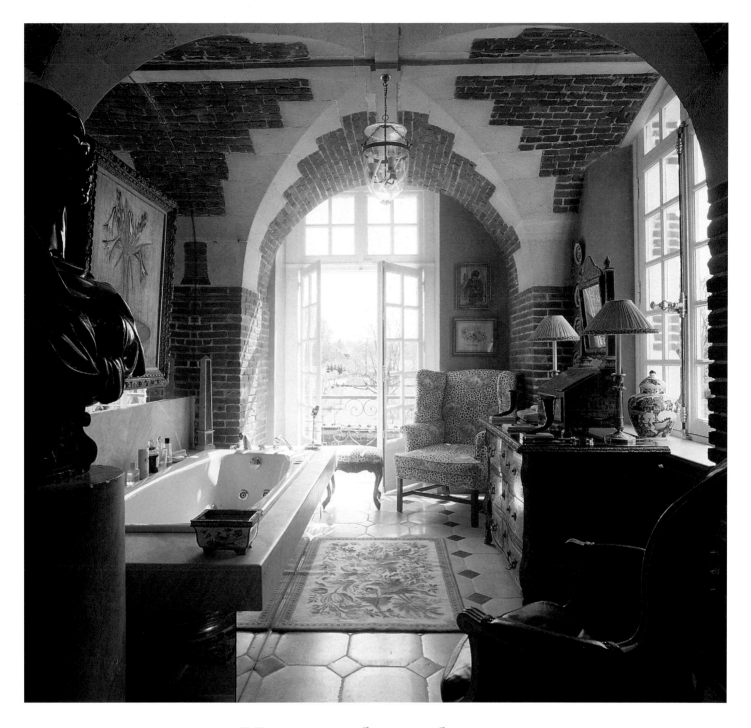

Historical attributes

The bathroom seen above is in the former guardroom of a chateau in Normandy and was decorated by Tommy Kyle and Jerome Murray. The brick-and-stone vaulting – similar to that of the colonnade in the seventeenth-century Place des Vosges in Paris – has been left in its natural state, making a truly stupendous, unconventional setting for a bathroom. With French doors opening onto a balcony overlooking the garden, and with upholstered chairs, the carapace-like interior has the comfort and tranquility of a summer sitting-room. The bathroom shown opposite is in Luttrellstown Castle near Dublin and also has historical attributes with a French connection. The deep, copper bath dates from the early nineteenth century and came from France. Modern plumbing, efficient heating and a light style of decoration make the room agreeable to use and to look at. Details, such as the blue piping on the wing chair and the plaited tie-backs for the curtains, are well judged for what is essentially a functional, but nevertheless comfortable, room.

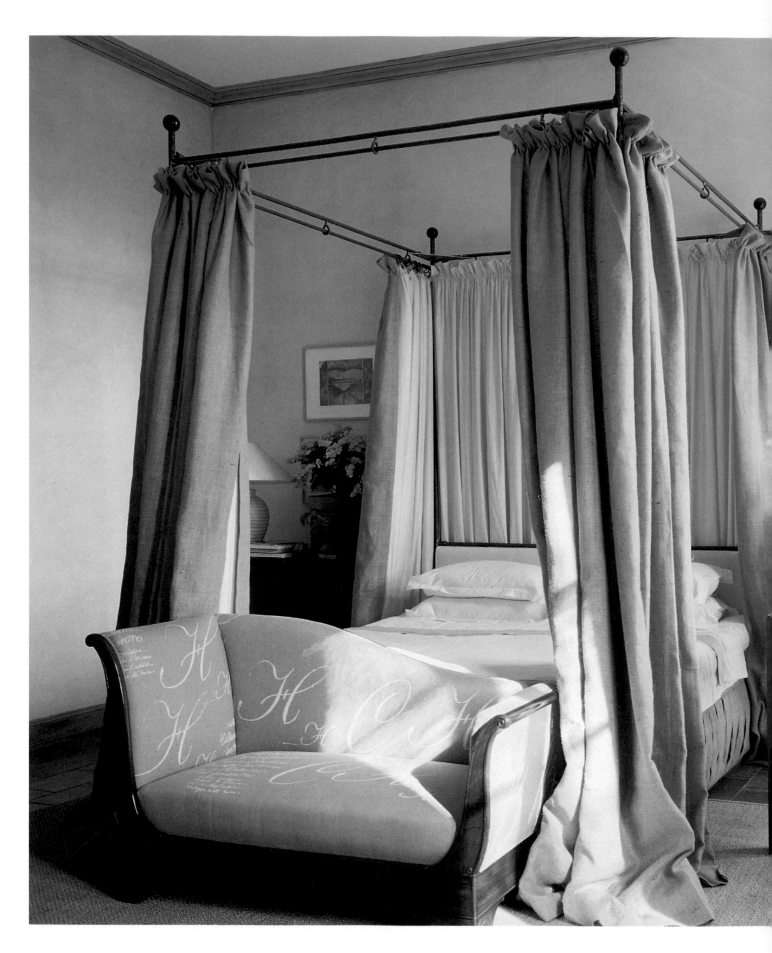

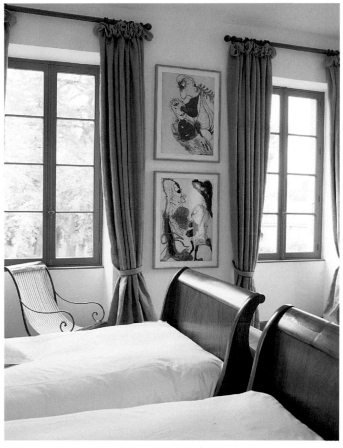

A change of style

Fussy decoration and all that goes with it – lots of rich textiles, cushions and 'things' – is a style Jenny Hall has used and enjoyed in the past but now feels would be an inappropriate choice. For her house in France (see, too, page 114) she decided on something much simpler and more contemporary. She commissioned Claude Loraschi, the local blacksmith whose work normally involves mending tractors, to turn his skills in another direction and forge this elegantly skeletal iron bed which is hung with Bangladeshi sackcloth. In another bedroom (above), which is furnished with a pair of pale-wood *bateaux-lits*, the window curtains are also made of sackcloth.

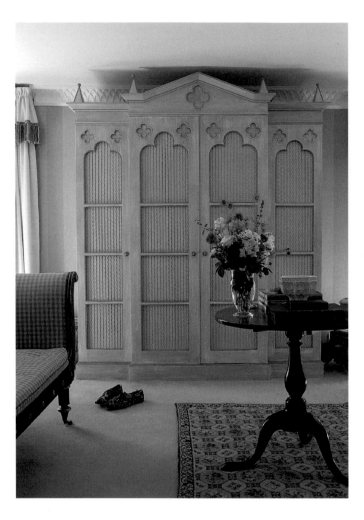

Co-ordinating elements

In a period house, a free-standing cupboard of an interesting shape looks more attractive than modern, built-in wardrobes. Here, doors pierced with quatrefoils and tall, narrow arches give a gothic air to the handsome, painted cupboard, which co-ordinates with the architectural style of the Victorian building (see pages 36 and 148). The windows and bed are hung with different fabrics but there is a link in the heavy fringe on the gathered pelmets. At the foot of the bed is an elegant and unusually diminutive Regency sofa; seen to its left is a Morris & Co 'Rossetti' chair which retains its original 1860s paintwork.

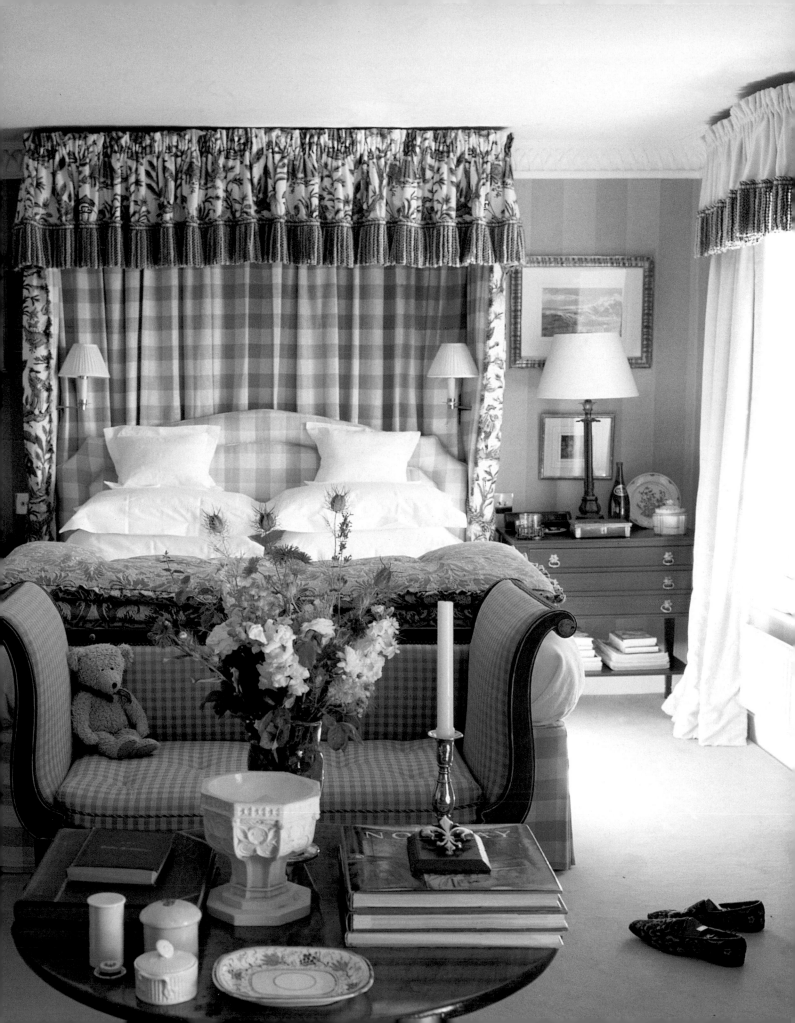

The colour of popcorn

Without much colour or pattern, and with virtually no curtains, this room designed by John Saladino is comparatively plain but has aesthetic warmth and comfort. Upholstered in palest fawn fabric, the six-panel folding

screen behind the bed brings to the room a large area of soft texture without detracting from the restrained harmony which characterizes the design scheme. In fact, texture is one of the room's most seductive and important elements: the

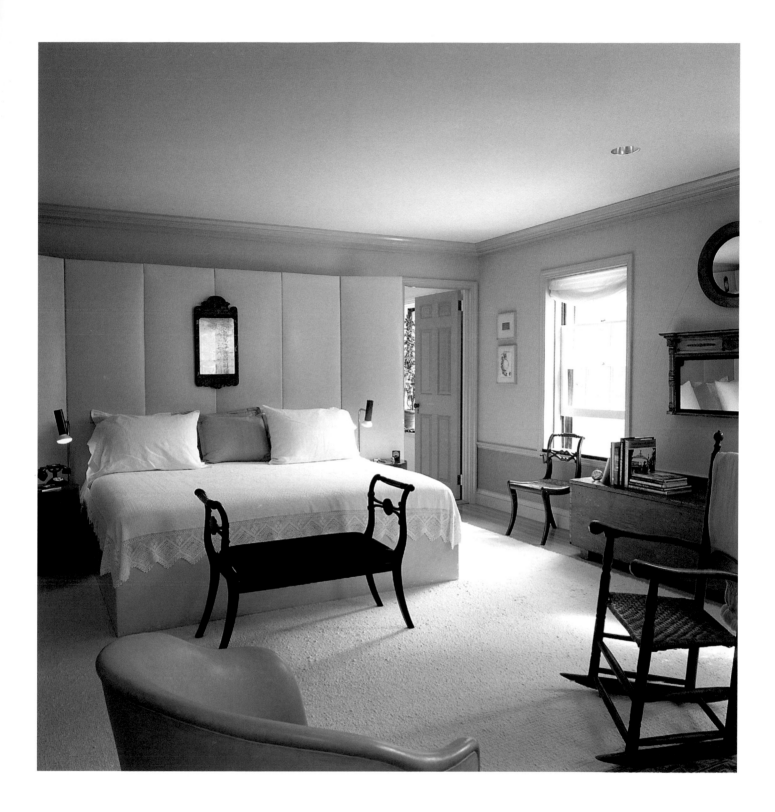

self-patterned Marseilles bedcover is edged with lace, and the specially woven carpet, in a colour which John Saladino refers to as 'popcorn', has a pleasingly irregular surface. The 'popcorn' complements the pale teal on the upper part of the

walls and the slightly darker shade used for the dado. Against one wall is a writing-table beneath a quartet of architectural drawings in a formal grouping. (Other rooms in the house are shown on pages 58 and 106.)

Nostalgic imagery

Pretty cotton *toiles* are a feature of this house in France decorated by an English owner, Fiona Inchyra. A red-and-white floral design is the linchpin of the unaffected, fresh character of the main bedroom. Used very simply – there are no elaborate pelmets or heavy drapes – and seen in juxtaposition with plain walls and a stripped wooden floor, the fabric gives the room a naive charm. An old-fashioned radiator perpetrates a nostalgic image, while the main bathroom still has its orginal claw-footed bath and pale-blue-and-white floor-tiles.

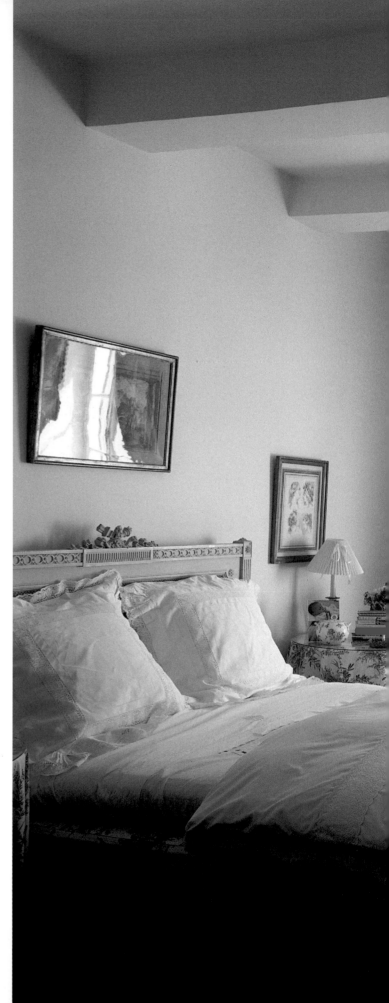

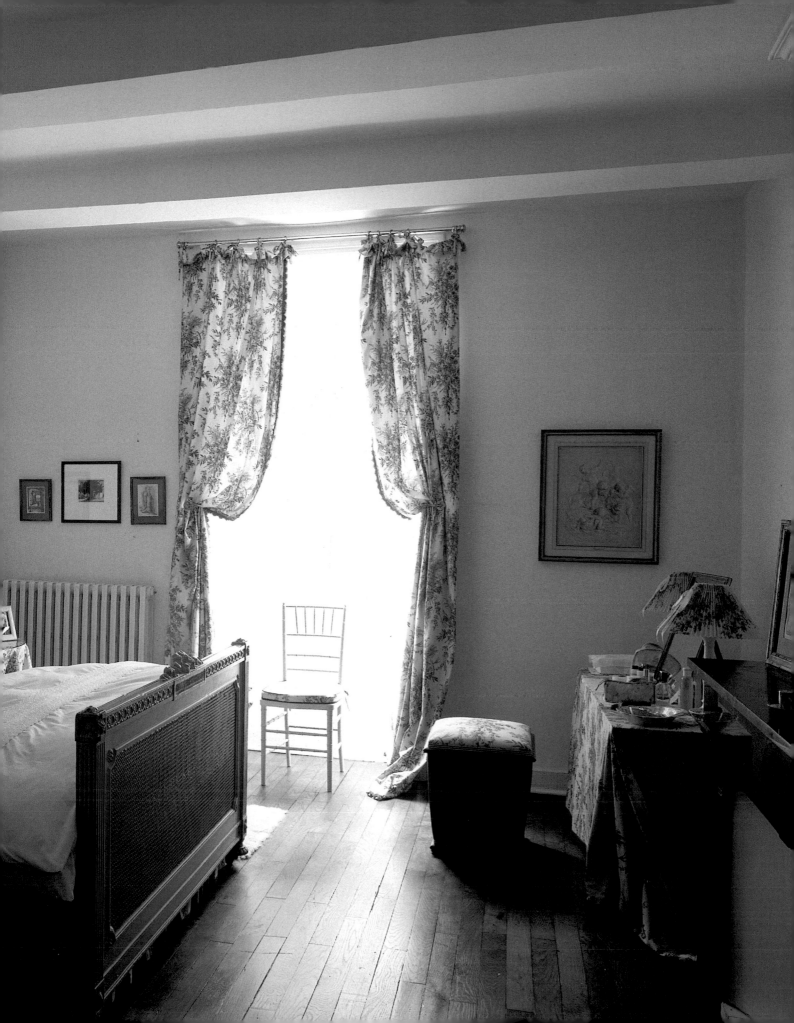

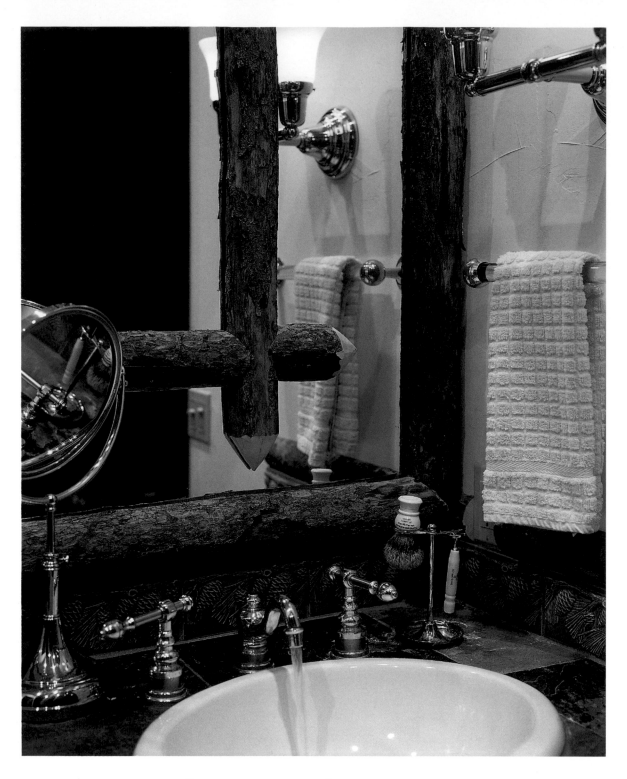

Living with nature

Here is a lesson on how to live with nature and still be a sophisticate. In what must be the ultimate of ultimates among log-cabins – North Star Lodge near Aspen in Colorado (see page 156) – the bedrooms are especially amazing. A team of carpenters constructed and carved vast applewood beds, then Holly Lueders whimsically perched

brightly coloured birds amidst the branches. Woollen bedcovers, with charming borders and central panels based on folk patterns, were specially made in Hungary. The detailing in the bathroom shown above, which has a whirlpool bath and inset basin, matches the rusticity of the bedrooms yet conveys a luxurious cosiness.

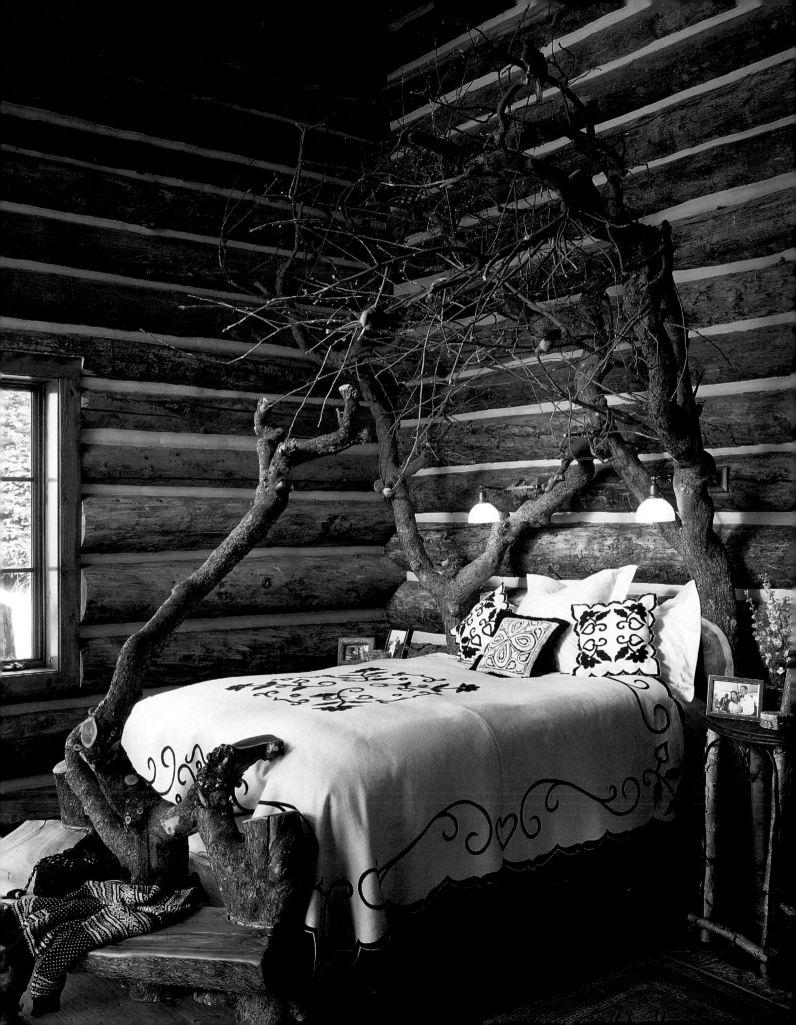

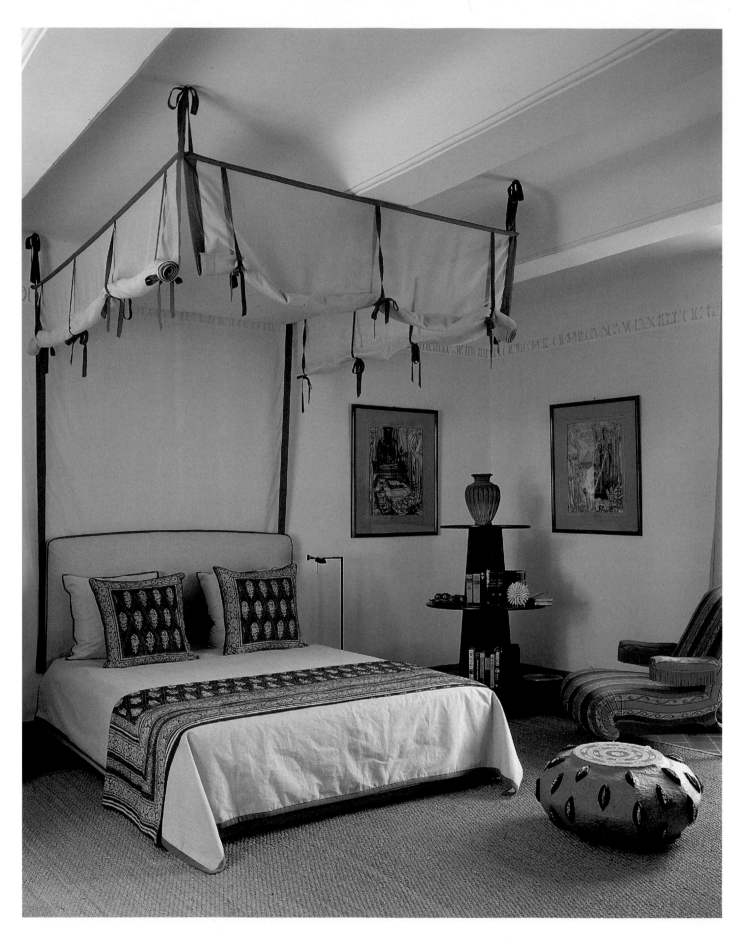

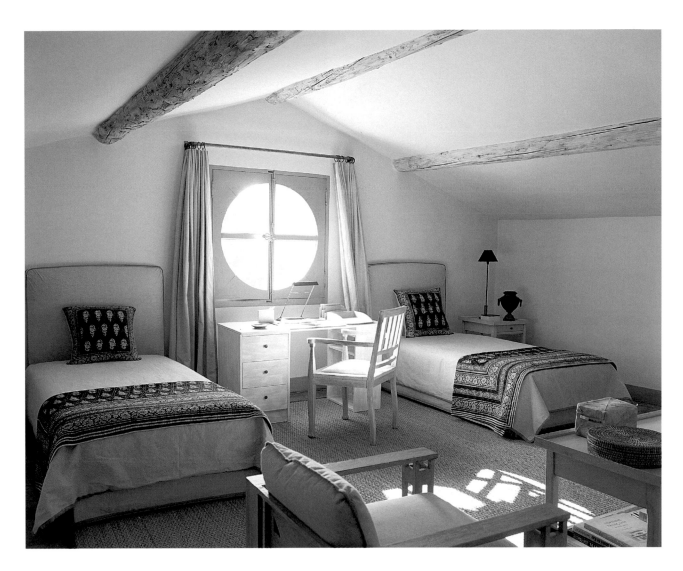

Immaculate detailing

Even when François Catroux adopts a simple line in decoration, the result is never mundane. The two bedrooms shown here are in his house in Provence (see page 74) and both are typical of the way in which he gives interest to a room by immaculate, tailored detailing. The bedcovers and bedheads, for instance, are plain but have a narrow edging which picks up the room's colour scheme. And note the proportions of the head-boards for the single beds: they are unusually high and thus have greater visual interest and comfort. In both rooms François Catroux has used traditional Provençal fabrics to give a lively dash of pattern. But the really masterful touch is in the red-and-white room where the bed curtains, suspended from the ceiling, are held up by the simple and highly original application of ribbons.

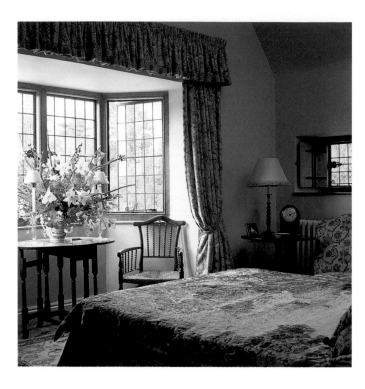

Traditional themes in a new setting

Giles Vincent's scheme for the interior decoration of this bedroom in a new extension to a late-Georgian cottage (see, too, pages 110 and 132) is not pastiche, though it does have a mellow look. The rose-patterned curtain fabric has a subtly faded appearance; the bedcover and cushions are made from antique tapestries; and the walls are painted a dusky yellowy-green. The bathroom with warm sienna-coloured paint and early twentieth-century kilims, has an equally established air. In such a spacious setting, there is the sybaritic opportunity to position the bath in the centre of the room and to have an open fire.

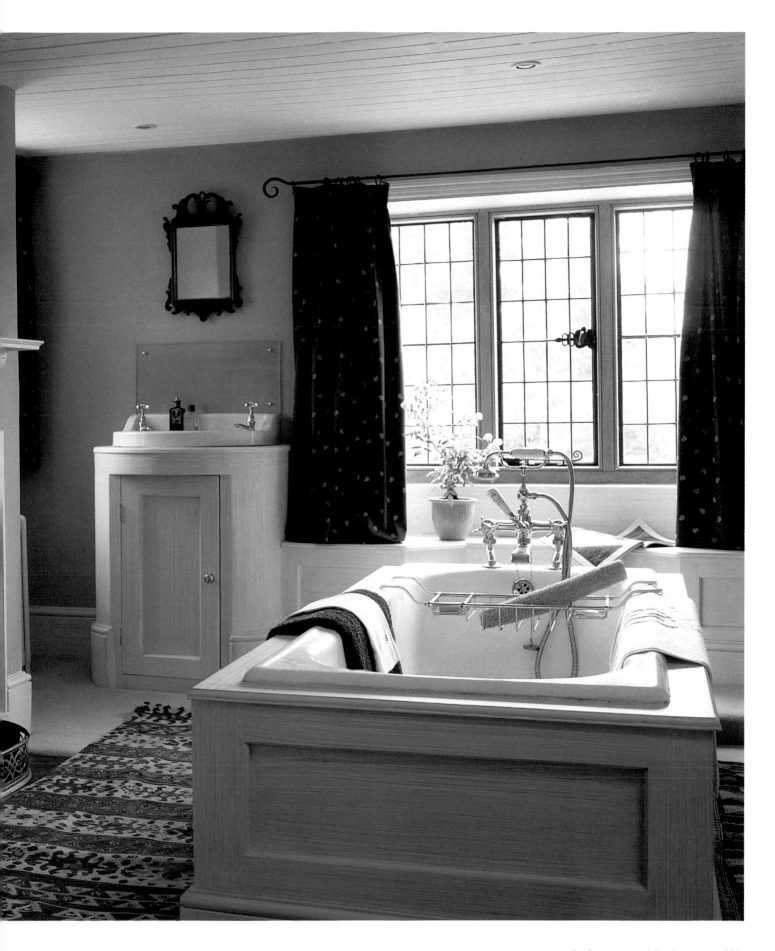

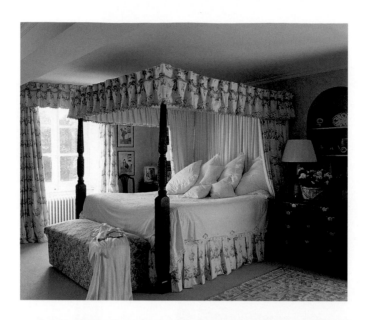

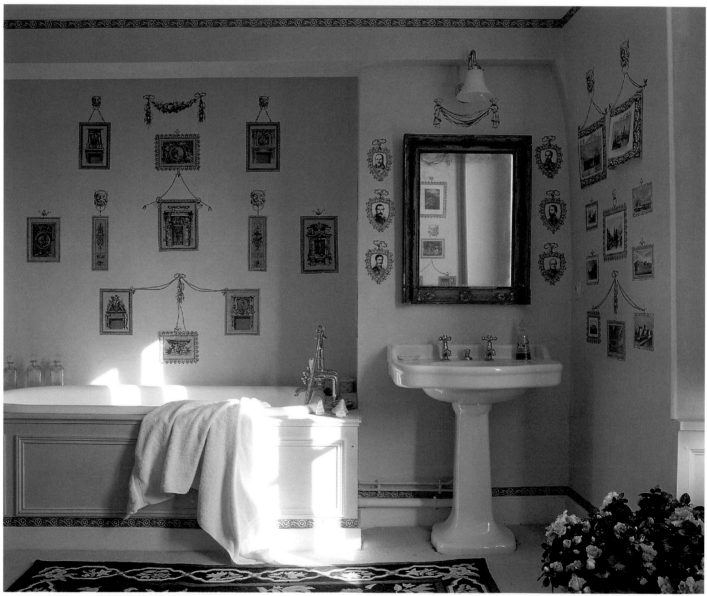

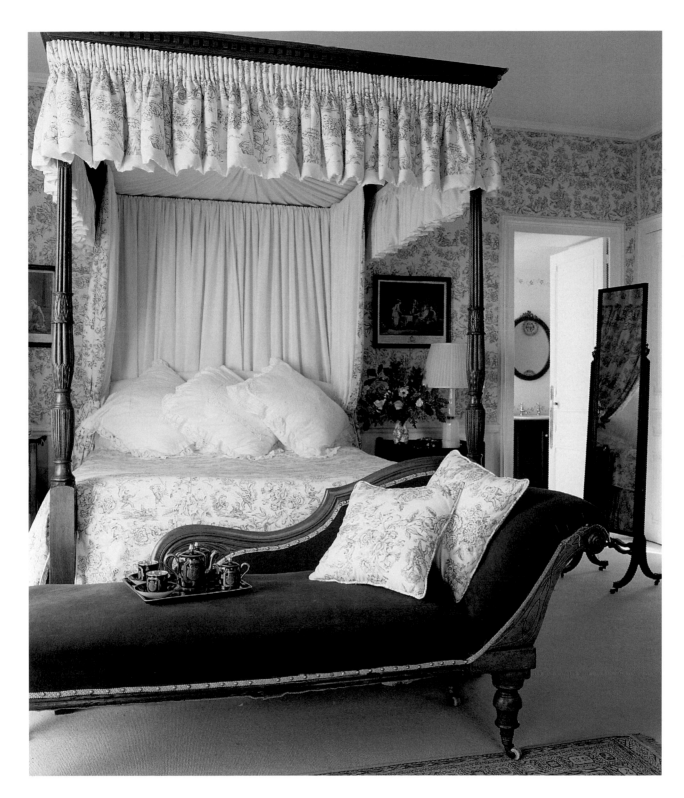

Supremely comfortable

One way to make a bedroom look fabulously comfortable is to use masses of plump cushions. Decorated by Katya Grenfell, these two rooms have piles of feather pillows with exquisite white cotton slips. The bed-hangings are light and pretty, and they have plain linings, creating an impression which is grand but restrained. In the room shown opposite, chests-of-drawers are practical alternatives to bedside tables. The bathroom in the same house has traditonal-shape fittings and is arranged as a print-room with black-and-white engravings pasted on to yellow walls.

GARDEN ROOMS

A room which links the house with the garden, and which combines the feel of the outdoors with the shelter of the indoors, is a year-round asset. In the deepest countryside, where external vistas are extensive and totally uninterrupted by other houses, this hybrid of a room is heavenly. However, even in less remote areas, a garden room has enormous attraction and, if furnished in a comfortable way, provides practical living-space. It is especially suitable for informal dining – as can be seen on page 218. Another example of this use of a garden room is the spectacular, vaulted space on Majorca (page 214) where the vernacular construction is a rugged background for smart, contemporary furniture. In the room on page 220, there is greater emphasis on plants: the ambience of a traditional conservatory is combined with the function of a dining-area.

A black-and-white stone floor is unbeatable in a room where there is an outdoor feeling and the furniture is grand. Here, in the Renaissance wing of a French chateau, decorated by Tommy Kyle and Jerome Murray, the decorative objects include a classical bust, gilded side-table, lacquer clock and oriental pots – plus a modern painting. Above this eclectic mix is the original, painted ceiling with a ravishing pattern of flowers and fruits.

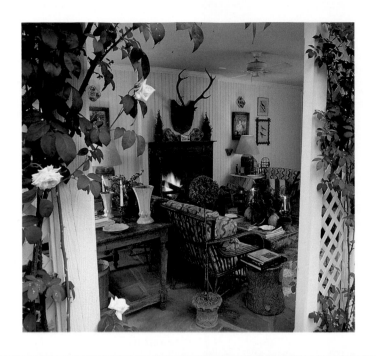

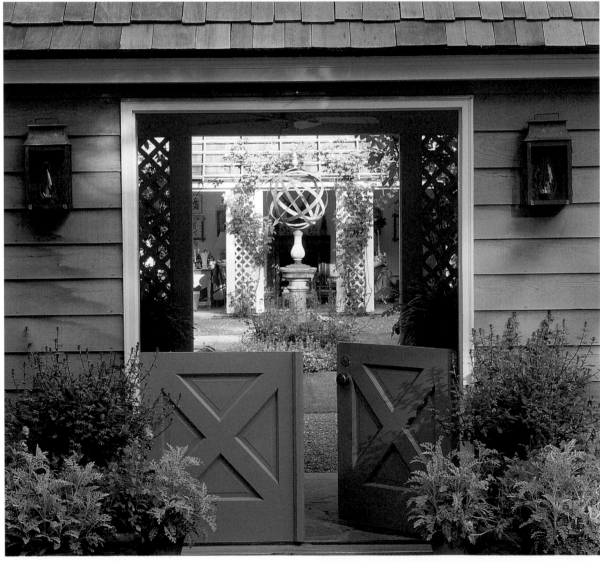

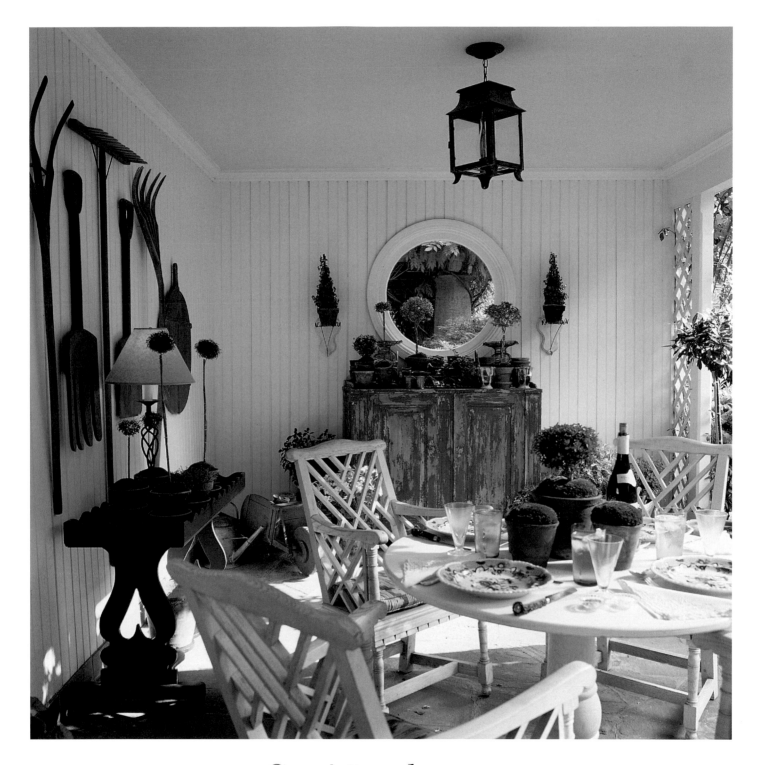

Catching the sun

At David Easton's house in New York State, there are two wings facing each other across the garden (opposite, below). Each wing has an open-sided loggia. One of the loggias (shown opposite, top) looks east to catch the morning sun and has a fireplace for use on cool evenings. A favourite summer workplace, it is also a semi outdoor sitting-room which complements the drawing-room in the main house,

(shown on page 84). The west-facing loggia (above), used mainly for lunches and, at the end of the day, for drinks, has a circular opening in the far wall. The unglazed 'porthole' looks onto the garden but gives the impression of a mirror. Quirky plants sit atop the rough-painted cupboard, and a collection of old wooden farm implements from Pennsylvania makes a stylishly linear assembly against the boarded walls.

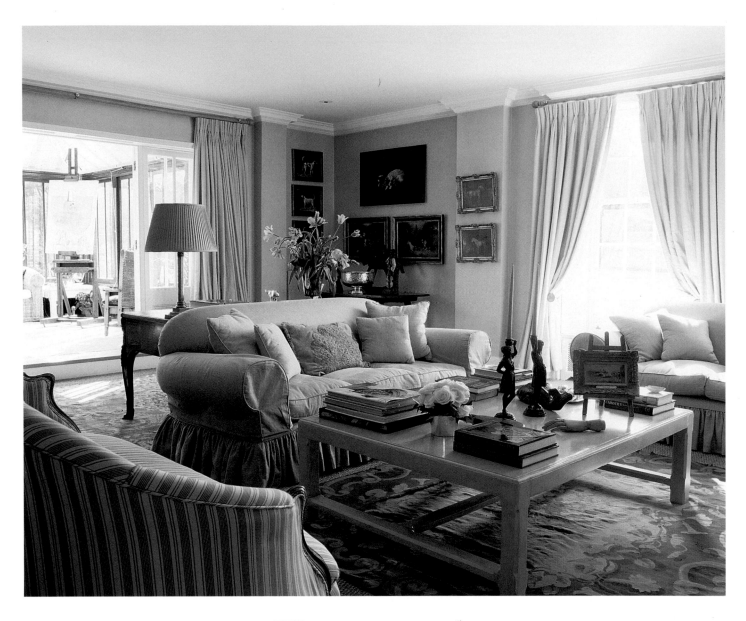

Warm neutrals

Natural colours and textures work well in a context where a room opens directly into a conservatory. This drawing-room has an updated country-house look which is traditional in essence but simplified and more eclectic. Although there is little pattern, there is considerable variety in the room's other elements, especially in the artworks which range from sporting and animal pictures in one corner to a dramatic work by Anthony Christian above the fireplace (see page 2). The colour of the French limestone chimneypiece is a perfect mid-tone between the canteloupe paint finish on the walls and the glazed linen which covers the sofas. The new conservatory has been sensitively added to integrate the room with the garden and give additional living-space. The wicker sofas have rounded lines relating to those of the sofas in the main room, and their colour matches the roof-blinds. The refurbishment of the house was carried out with advice from architect Christopher Smallwood and interior designer Lars Bolander. (The hall is shown on page 18.)

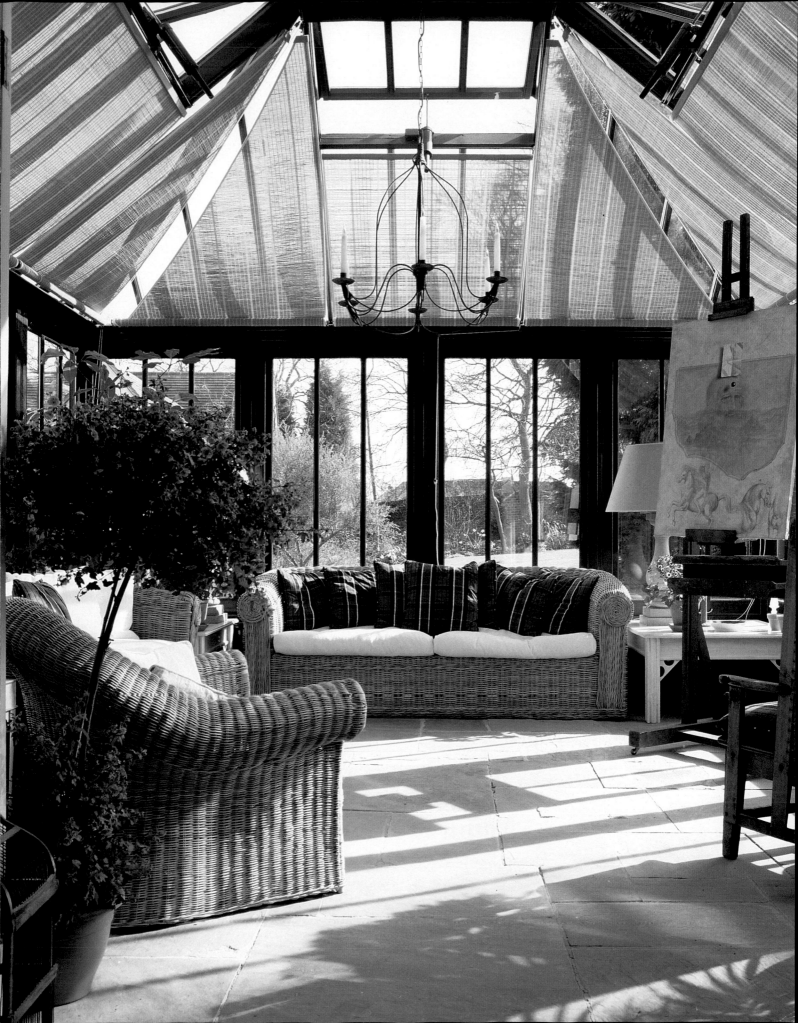

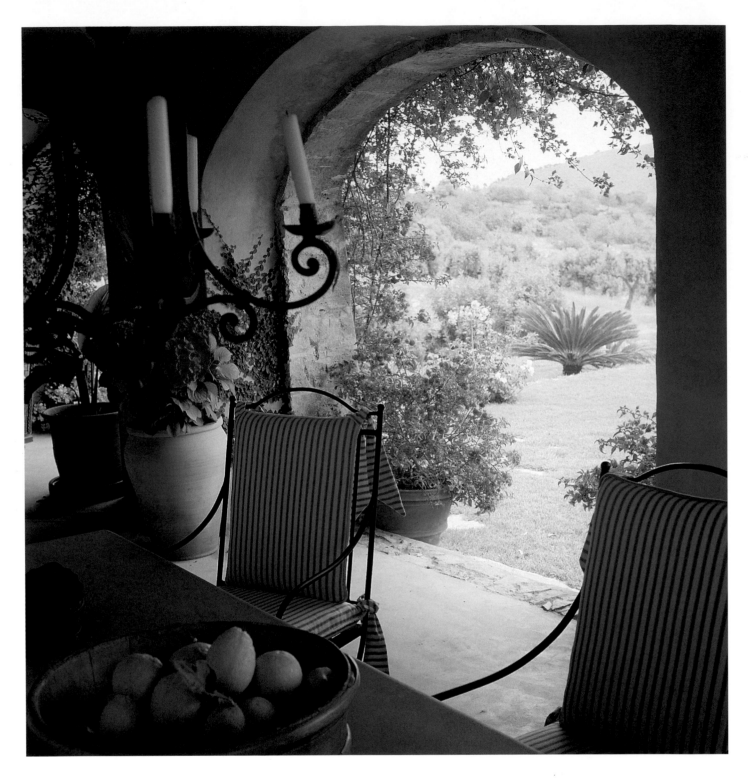

Majorcan summer

The vaulted, summer living-room of Nona von Haeften's
four-hundred-year-old house in Majorca was converted from
a wagon-shed which opens onto the garden via a series of
broad arches. One end has comfortable seating grouped

round an unusual and amusingly designed fireplace with a
long stone shelf and carved side-panels depicting elephants.
The central area of the room is furnished for dining and has
a long stone table supported on scroll-shaped pedestals. This

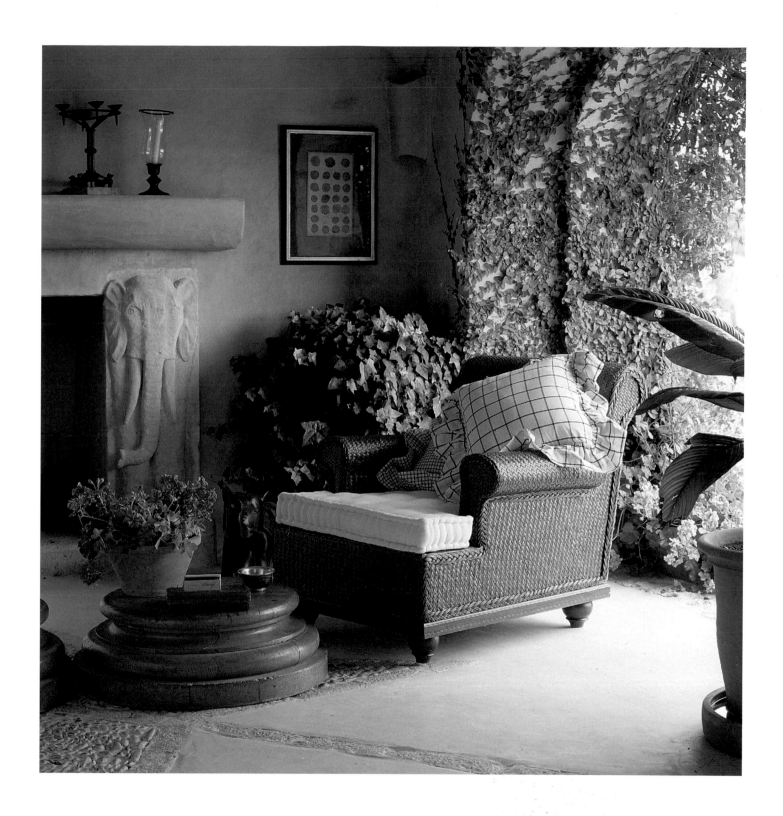

is partnered by high-backed chairs made in wrought-iron to a design by Holger Stewen. Metal is a durable, apt material for a semi-outdoor vernacular setting of this sort, but it also has a present-day fashionableness. Cushions made of pink-and-white striped cotton with wide ties are jaunty additions. Using traditional local techniques and materials, the floor is divided up by a criss-cross pattern of rough cement and an inlay of pebbles. >

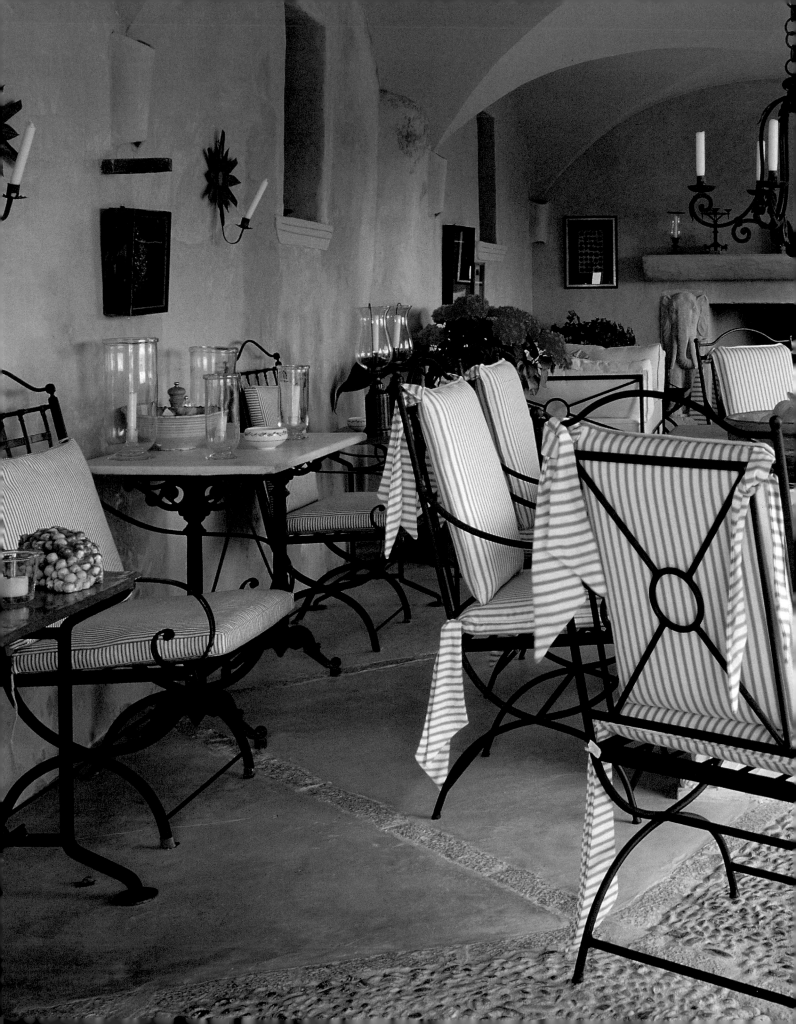

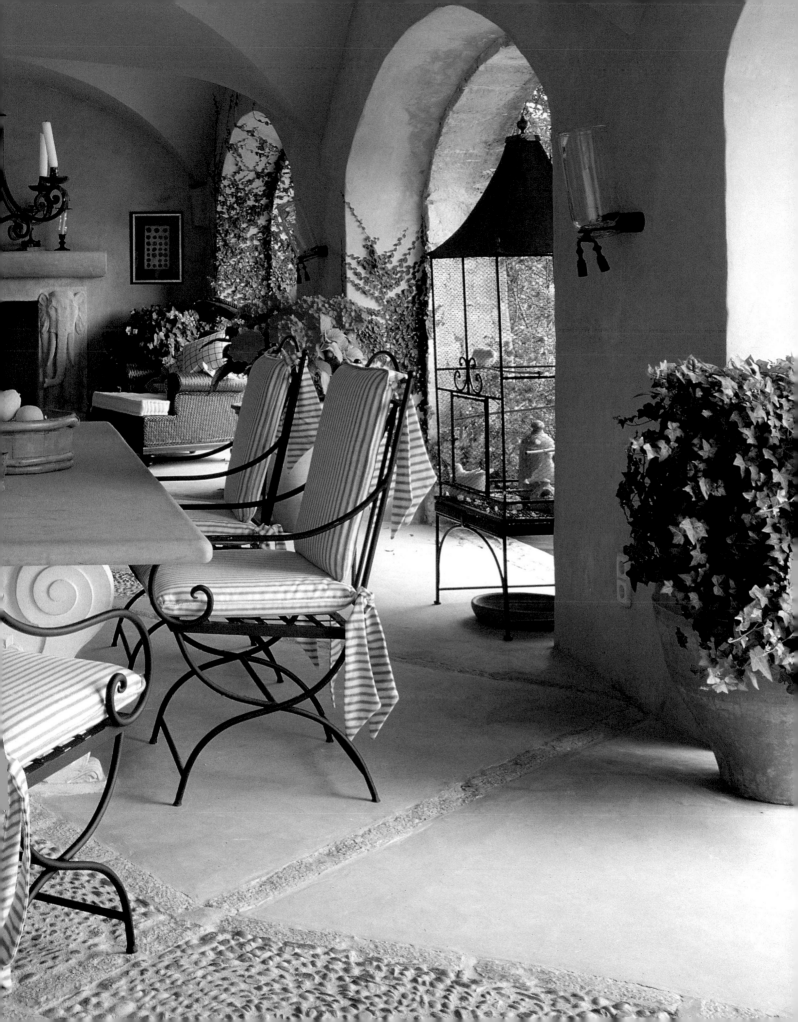

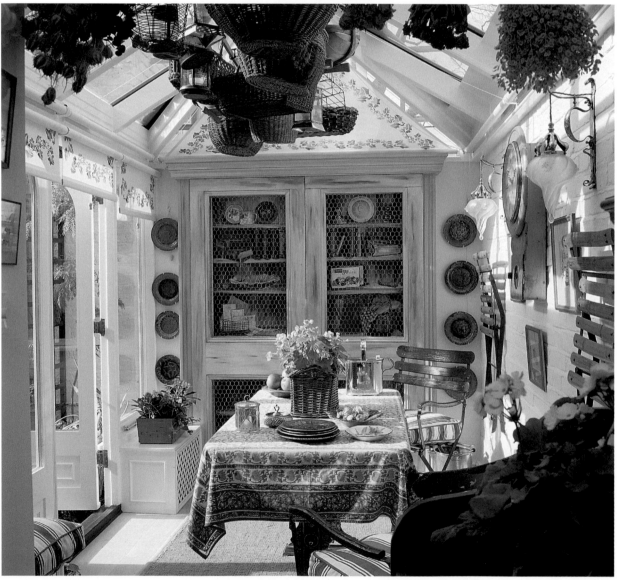

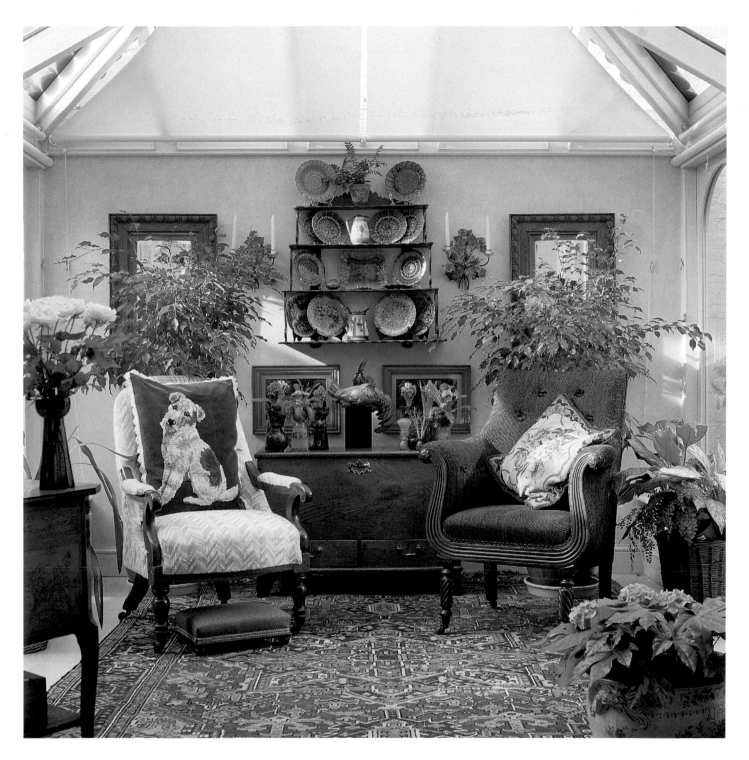

One house, two conservatories

When Jan Colls remodelled her 1960s home she opened up the interior and ingeniously extended the rooms by adding one conservatory off the kitchen (opposite) and another off the sitting-room (above). The first, which was designed by Jan Colls to use as a dining-area, has a *trompe l'œil* cupboard painted by Michelle Pearson, with jolly allusions to the family's love of sweets and decorative bits and pieces.

The pediment and roller blinds are edged with a stencilled border of leaves. The sitting-room conservatory has comfortable chairs and a symmetrical arrangement of green 'leaf' plates on hanging shelves flanked by a pair of Victorian mirrors. Both rooms, which are on opposite sides of a small courtyard (opposite, top), evoke the country in their decoration, though they are in London.

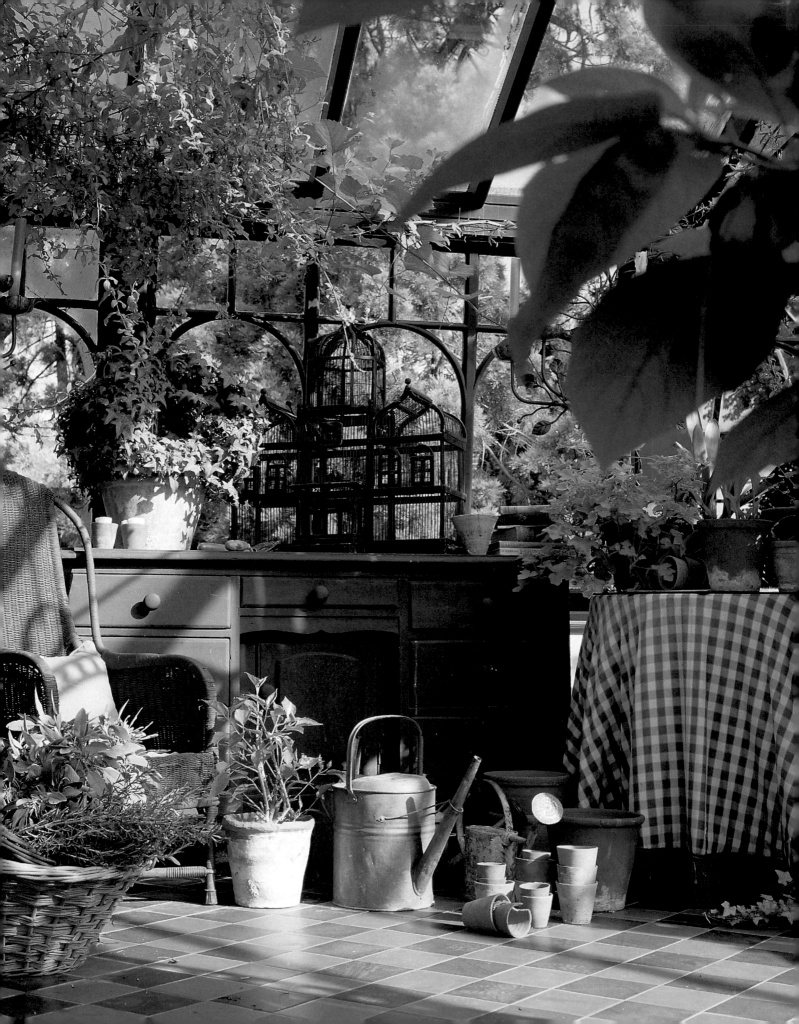

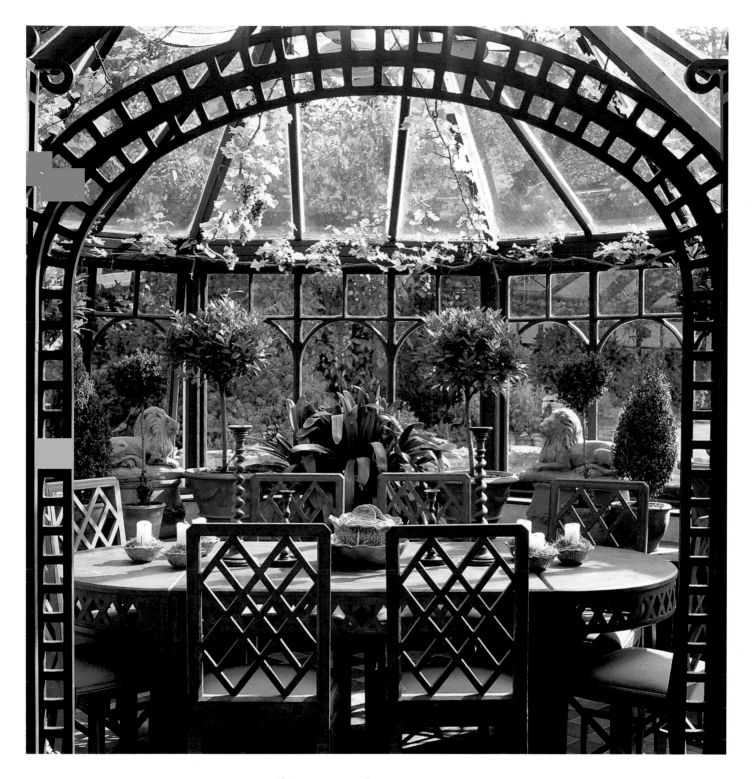

Green harmony

Painting the framework of this conservatory green has made the glazing bars seem less apparent and had the effect of melding the interior with the exterior. This is a much-used extension of the garden, with some of the plants bedded straight into the ground, and cuttings grown in old terracotta pots. In the more formal part of the room, there is a practical, good-looking table made in three sections so that the semi-circular end pieces can be separated off. It has a trellis skirt which matches the diamond pattern of the chair-backs. The furniture was designed by Nessa O'Neill.

Modern classicism

These two rooms are in a new house in Sussex designed by John Simpson (see page 66) and relate to different parts of the day. The breakfast room (above) faces east to take advantage of the morning sun and has full-height, sash windows giving access to the garden. The elegantly severe furniture was specifically designed by John Simpson to suit the classical style and manageable scale of the building. The conservatory (right), which benefits from the afternoon and evening sun, acts as an informal dining-room and is curtained with a striped fabric in green and white which is smart but does not conflict with the room's casual indoor-outdoor aspect.

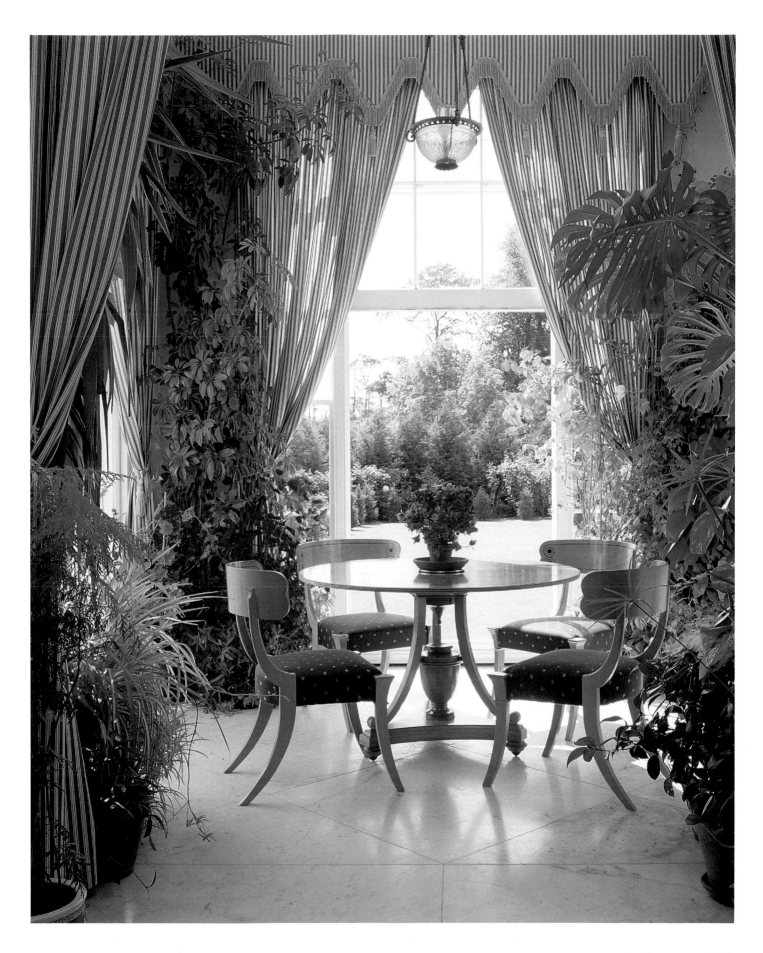

Acknowledgements

Peter Aprahamian: 97, 164, 165, 166, 167

Tim Clinch: 8, 10 (below left), 14, 36, 37, 39, 74, 75, 76, 77, 114, 128, 129, 148, 149, 186, 187, 190, 194, 195, 192, 193, 202, 203, 206, 207

Andreas von Einsiedel: 11, 16, 17, 28, 29, 30 31, 44, 45, 48, 49, 66, 67, 68, 69, 70, 71, 80, 81, 82, 83, 98, 102, 108, 109, 116, 117, 118, 119, 124, 125, 130, 136, 137, 146, 147, 160, 161, 162, 163, 168, 169, 170, 171, 188, 189, 214, 216, 217, 218, 219, 220, 221, 222, 223

Gavin Kingcome: 2, 3, 18, 72, 73, 100, 101, 144, 145, 152, 153, 154, 212, 213, 184, 185

Tom Leighton: 104, 105

Marianne Majerus: 86, 87, 142, 143

Robin Matthews: 24, 25, 26, 27, 46, 47, 140, 141

James Merrell: 10 (top left), 42, 43,

James Mortimer: 138, 139

David Radcliffe: 90, 91, 99, 191, 208, 209

Trevor Richards: 19, 40, 41, 92, 93, 95, 110, 111, 132, 133, 204, 205

Fritz von der Schulenberg: 21, 22, 54, 55, 56, 57, 78, 79, 88, 94, 96, 115, 135, 150, 176, 177, 178, 179

Keith Scott Morton: 20, 34, 35, 58, 59, 60, 61, 84, 85, 106, 107, 120, 121, 122, 123, 196, 197, 210, 211

Christopher Simon Sykes: 6, 32, 33, 46, 47, 112, 113, 126, 127, 180, 198, 199

Tim Street Porter: 156, 157, 158, 159, 200, 201

Petrina Tinsley: 172, 173, 174, 175

Simon Upton: 50, 52, 53, 182, 183

William Waldron: 62, 63, 64

Some of the photographs are by courtesy of The Interior Archive.

Many of the rooms illustrated in this book are from features researched originally for
House & Garden by Lavinia Bolton (Locations Editor), Sally Griffiths and Amanda Harling.
Gemma Imi assisted in collating them.